CLOTHING GANDHI'S NATION

CLOTHING GANDHI'S NATION

HOMESPUN AND MODERN INDIA

Lisa Trivedi

INDIANA UNIVERSITY PRESS
Bloomington & Indianapolis

This book is a publication of

Indiana University Press
601 North Morton Street
Bloomington, IN 47404-3797 USA

http://iupress.indiana.edu

Telephone orders 800-842-6796
Fax orders 812-855-7931
Orders by e-mail iuporder@indiana.edu

Library of Congress Cataloging-in-Publication Data

Trivedi, Lisa.
 Clothing Gandhi's nation : homespun and modern
India / Lisa Trivedi.
 p. cm.
 Includes bibliographical references and index.
 ISBN-13: 978-0-253-34882-1 (cloth : alk. paper)
1. Swadeshi movement—History. 2. Khadi—Political
aspects—History. 3. Khadi—Economic aspects—History.
4. Khadi—Social aspects—History. 5. Nationalism—
India—History. I. Title.
 DS480.45.T77 2007
 954.03'5—dc22

 2006100894

1 2 3 4 5 12 11 10 09 08 07

To Gunvantrai and Hasumati Purohit

for the purity of your hearts

Nations are not formed in a day; the formation requires years.

Mohandas K. Gandhi,
Hind Swaraj, or Indian Home Rule (1909)

CONTENTS

ILLUSTRATIONS

ACKNOWLEDGMENTS

For any project there are many beginnings. I would like to think that this project began in college, when my advisor urged me to travel in India with an uncle who is a former freedom fighter and labor leader turned social worker. That advice dramatically changed my future. History, which I had always enjoyed, came alive; its implications took on new, deeper meaning. Traveling with my uncle for four months across northern and western India and interviewing freedom fighters provided an opportunity for me to "discover India" and to put real faces on the history of the Indian nationalist period. My father's eldest sister offered another beginning for this project a few years later. An educator and social worker, my aunt took the time to teach me how to spin thread on a *charka*, or spinning wheel, much like the ones used during the nationalist era. There was something about learning this very basic skill that moved me from thinking about swadeshi and khadi as an idea to understanding khadi as a material fact of nationalist politics.

I have accumulated many debts over the years that I have been working on this project. Most recently at Hamilton College, I have benefited from a community of scholars, especially my reading group, who have sustained, challenged, and enriched my work with their criticism, their good humor, and a fair share of libation. In particular, I should mention Thomas Wilson who has provided me with critique and guidance, as well as friendship and encouragement. At the University of California, Davis, Barbara Metcalf, Susan Mann, and Thomas Metcalf offered detailed criticism and advice; their example as scholars and as teachers is a standard to which I can only aspire. Several students of South Asia at the University of Chicago, including Nayan Shah, Faisal Devji, Sudipta Sen, Laura Ring, and Rizwan Ahmed, provided me with an intellectual home when I needed it most. In northern California, the beloved Empire Studies Reading Group brought together students and faculty from Berkeley, Stanford, Davis, and Santa Cruz. Without this community, my training would have been much poorer. To Rachel Sturman,

in particular, I must express my deepest gratitude for her friendship and her razor-sharp mind, which she so generously shared on our many drives between Oakland and Davis. And, finally, it should be said that had I not been a student of Susan J. Tracy and Joan B. Landes at Hampshire College, I am quite certain that I would never have developed a passion for history and politics.

In completing this study, I would like to thank the Fulbright Foundation for supporting my initial research in India in 1996. At various points, the University of California, Davis, provided support through a Pro-Femina Research Award, a Humanities Research Award, and a Graduate Fellowship. I would also like to thank the staffs at the former Satyagraha Ashram, particularly the institution's director, Mr. Amrut Modi, and its archivist, Mr. Durgaprasad Trivedi, and the Textile Labour Association. I would also like to acknowledge the assistance I received from the staff at the Nehru Memorial Library and Museum, and its former director, Dr. Haridevji Sharma, as well as the staff of the National Archives of India in New Delhi. Finally, I would like to acknowledge the staff of the Maharashtra State Archives, Bombay, for their help. Without their professionalism and expertise, this research might not have been completed.

Hamilton College and, in particular, funds established by Richard and Patsy Cooper, allowed me to extend and deepen my research both in India and in Great Britain. In Britain, the archivists of the Oriental and India Collection have been particularly kind in helping me navigate their materials. In Bombay, the great skill and goodwill of the staff at the Maharashtra State Archives incurred my incalculable debt. I would like to acknowledge the reference and interlibrary loan librarians at Hamilton College, who made it possible for both a dissertation and a book to be completed in the woods of central New York. Without the diligence of Sharon Williams, Robin Vanderwall, and Marianita Amodio, all at Hamilton College, this would be a much less successful book. I am very grateful for the detailed reading and criticism that the reviewers of this manuscript provided and for Indiana University Press, particularly Rebecca Tolen and Miki Bird, who guided the project through production. Of course, any shortcomings are entirely my own.

Part of chapter 2 was published in the *Journal of Asian Studies* and part of chapter 5 appears in the collection *How Empire Matters: Imperial Structures and Globalization in the Era of British Imperialism.*

Aside from these professional debts, of course, there are many personal ones. My family, both in the United States and India, has supported my work in big and small ways. In India, the Acharyas, Bhatts, Joshis, Purohits, Shahs, and Trivedis provided not only home away from home, but helped me to real-

ize India as my own. They have demonstrated a great deal of patience with an independent, American-born niece and cousin. I am also thankful for the guidance of Lalit and Madhu Shah of Ahmedabad, and also for the friendship of Shaan and Tiki Zaveri, Maushumi Shah, Parag Shah, Roopal and Sauren Shodan, and, especially, Paras Shah. Friday evenings have never been better than at the Retreat. Doris and Herbert Nelson, my maternal grandparents, taught me many important lessons in life, most significantly how to work and to try things that challenge one's know-how. My parents, Navin and Karen Trivedi, my sister, Sara, and Don and Anita Grant humored me over the many years it took to complete this project by indulging my obscure interests and expressing their deep confidence in me. Most of all I am grateful for the example that Kevin Grant has provided me as a student of history, a teacher, and a colleague. Not only has he provided detailed feedback on every part of this project, he has done so enthusiastically and gently, when need be. I am grateful for his patience and support for my work, which has sometimes come at the expense of his own. Finally, Anita and Neil have been completely indifferent to the completion of this book, and they have, thus, made my life all the richer.

INTRODUCTION

This is a book about an ordinary object and its transformation into a national symbol in modern India. Khadi, or home-spun, home-woven cloth, had been produced and worn in India's villages long before the twentieth century. At the outset of the period of mass nationalist politics in the early twentieth century, however, khadi acquired new significance as a fabric of not only the village, but also the nation. Mohandas Gandhi promoted khadi as both a commodity and symbol of the swadeshi movement, which sought to establish India's economic autonomy from Britain as the basis of self-government. In just a few years, people across the political spectrum adopted khadi as a material and visual symbol, wearing clothes and bearing flags of this simple cloth to represent various, and sometimes disparate, political programs and goals. This book demonstrates how nationalists and common people used khadi to construct a common visual vocabulary through which a population separated by language, religion, caste, class, and region communicated their political dissent and their visions of community. By the time that India's independence was won, khadi had been inextricably woven into the fabric of India's life. As one sees today in government subsidies for khadi, in the use of khadi as the unofficial uniform of India's political leaders, and in khadi's appearance in the commemoration of national events, modern India remains symbolically bound to khadi.

Prior to Gandhi's swadeshi movement, cloth and clothing in South Asia had communicated a variety of social messages, ranging from community identification to political deference. The swadeshi movement drew upon a variety of pre-existing and overlapping discourses about cloth and clothing that one must bear in mind. According to Christopher Bayly, the power and authority of the Mughal emperors (1526–1858) were in part realized through the ritual exchange of cloth. Robes were bestowed upon regional leaders who provided the imperial center of the empire with the troops and taxes that fueled expensive, almost continual periods of war. Through the ritual exchange

of clothing, local leaders were literally connected to the emperor. By accepting the gift of a robe or a sash from the emperor, local elites simultaneously accepted imperial authority and established their roles in the maintenance of imperial power.[1]

The exchange of cloth and clothing was so important in South Asia that East India Company officials adopted its use as they engaged with the Mughal Empire and its elites. The Company established the Clothing Board, which endured from 1816 to 1854, for the purpose of supplying its army and administration with a steady and consistent form of dress. By controlling the clothing that its agents wore, as Bernard Cohn writes, the Company ensured that its agents were properly attired so as to distinguish them as a disciplined force. Their clothing reflected Company rank within an increasingly elaborate state structure in the making.[2] When the British state took over the government of India in 1858, it assumed many of the Company's general approaches, including its emphasis on establishing and maintaining rank through dress. However, British concern with clothing was not restricted to those working in the service of the government for very long.

In the mid-nineteenth century, the British endeavored to make sense of Indian society in the interest of more effective administration. As Thomas Metcalf has argued, the British understood India largely in terms of differences among Indians themselves. Clothing played a crucial role in this process.[3] The British came to view the subcontinent as a place of multiple communities defined by various languages, religious practices, and, significantly, styles of dress.[4] The heterogeneity of South Asian peoples was established through the study of native culture, the taking of the first census, and, most pertinently for our study, the depiction and definition of the styles of dress associated with different peoples of the subcontinent. In this critical regard, mid-nineteenth-century studies like J. Forbes Watson's *The Textile Manufactures and the Costumes of the People of India* suggest that India displayed such heterogeneous styles that she could not be conceived as a single people or nation. The use of clothing, which began as an effort to ally the British with Mughal authority and later to ensure that British agents were distinguishable from their native subjects, eventually included the prescription of dress for natives who increasingly found employment in Britain's growing government bureaucracy.

If the British first used clothing as a means to master their subjects, they used it later as a way of introducing modes of dress that they deemed morally superior to native attire. The new styles marked a break from the symbolic rhetoric of cloth and clothing in pre-colonial India. Western clothing was increasingly associated with the Crown and the promise of Western progress,

which supplanted traditional native authority. By the nineteenth century, as the memoir of Nirad Chaudhuri tells us, the British turned their attention to the dress of ordinary people as well, targeting native women's clothing that evangelical groups in Britain and India appear to have viewed as risqué and, therefore, as a legitimate subject of reform.[5] As much as the British were interested in the ritual display of power through the clothing and ceremonies of elites connected to the state, by the mid-nineteenth century they were no less interested in the daily dress of ordinary South Asians.

The British, like other colonial powers, looked upon clothing and the presence of material goods in a society as a measure of the civilization of a given people.[6] They therefore considered the "proper" clothing of natives to be a project as fundamental to progress and civilization as the creation of institutions of higher learning and the eradication of native customs deemed "inhumane": tutoring the native population about appropriate dress advanced the project of civilizing Indians. By the close of the nineteenth century, the colonial society peopled by British civil and military personnel, as well as by a new native class of civil servants born of the colonial regime, took on a distinctive appearance. Like the coordinated dress of the Mughal Empire and the East India Company, the relationship between the British government and its subjects was generally delineated along clear sartorial lines. But the lines between "Indian" and "British" subjects sometimes blurred, especially in the subcontinent's growing urban and administrative centers where natives increasingly joined the ranks of the foreign administration and took up its style of dress.

The rapidly expanding importation of British manufactured goods also substantially affected the general public's styles of dress. Clothing had first been imported into India in the 1820s and 1830s. By the second half of the nineteenth century, British administrators recognized the significant influence of their goods on India's traditional textile production. Large amounts of manufactured wares from Britain's Lancashire mills had begun drawing native consumers away from traditional textiles, which had at one time drawn much of the world to India's markets. At the same time, the goods produced in India's industrial textile centers, including Bombay, Sholapur, and Ahmedabad, provided less expensive native alternatives to artisanal goods.[7] Eventually, industrially manufactured goods, whether from Lancashire or Bombay, replaced the locally produced cloth that had historically played a central role in exchange rituals, particularly in times of marriage. Aesthetically, the subcontinent's urban and growing middle classes favored the smooth texture, foreign designs, and modern look associated with mill-made cloth. Western styles of dress and industrially manufactured cloth were tools by which urban

Indian men, in particular, allied themselves with a modernizing colonial project, even if they were not required to do so by their employer.

By the beginning of the twentieth century, however, a crisis was developing over the modernization of dress in India as technology, as well as taste, drew consumers away from previous consumer habits.[8] Nationalists correctly pointed to the emergence of a colonial style of dress and linked the impoverishment of India to the urban and colonial elites' preference for foreign, manufactured goods.[9] By the early 1920s, Gandhi too was linking India's economic dependency on foreign cloth to her political subjugation:

> India cannot be free so long as India voluntarily encourages or tolerates the economic drain which has been going on for the past century and a half. . . . When the East India Company came in, we were able to manufacture all the cloth we needed, and more for . . . export. . . . India has become practically wholly dependent upon foreign manufacture for her clothing.[10]

It was in this context that the swadeshi movement, and khadi in particular, became so significant.

It should not be surprising that a kind of cloth became so central to the symbolic repertoire of modern India. As we have seen, cloth and clothing had for many years been a central feature of authority and a primary marker of difference. India's political subjugation and her dramatic transformation from one of the world's leading producers of textiles into one of the world's consumers made cloth a particularly evocative material object.

In constructing national symbols, Gandhi and his supporters struggled to find a balance between "tradition" and "modernity," recognizing that India needed both to establish its legitimacy by virtue of incorporating tradition and to adapt its culture and economy to compete in the modern world. Toward this end, swadeshi proponents defined the significance of khadi in three distinctive and flexible ways. As an ostensibly traditional product, produced through traditional means, khadi was portrayed as a material artifact of the nation. Moreover, Gandhian nationalists rendered khadi a discursive concept by defining it in terms of the contemporary politics and economics of swadeshi. Finally, khadi became a visual symbol, marking individual people as distinctly Indian, in relation to visual symbols of regional, religious, caste, and class identification. The multiple meanings of khadi made it a versatile tool with which nationalists could tailor swadeshi to suit different political circumstances. Beyond the grounds of the khadi exhibition, the meaning of homespun undoubtedly acquired additional nuances, but the general significance of khadi remained clear. As swadeshi consumers clothed themselves

in homespun and went about their daily lives, they represented their experience of a new community that challenged the political boundaries of both traditional Indian society and the British colonial regime.

A Material and the Visual Orientation

Over the course of the last two decades, scholars in the social sciences and humanities have dramatically reconsidered the ways in which we understand the rise of nationalism. The nation is no longer treated as an inevitable product of sociological factors such as a common language, religion, history, or ethnicity. Instead, the nation has been reconceived, in the words of Benedict Anderson, as an "imagined political community—and imagined as both inherently limited and sovereign."[11] While scholars such as Anderson have explored the ways in which people conceived and envisioned nations in a capitalist world system,[12] more recent studies on the rise of nationalism in the colonial world have traced the development and expansion of colonial administrative practices, including the measurement and creation of institutional infrastructures that enabled surveillance of subject populations. These studies suggest that the activities of the colonial state played the primary role in defining national community in regions as diverse as Africa, Asia, and Latin America.[13]

As important as the practices of the state were in the creation of nations in the colonial world, scholars of Asia and Africa have cautioned against tracing all nationalisms to the historical experience of Western nations and their empires.[14] They remind us that the advocates of anti-colonial and nationalist movements, while influenced by their particular experiences with the West, also derived the particular contours of their new identities from histories that lay beyond their experience with the West. In supporting these critiques, this book raises another, specific concern about current scholarship on nationalism. As one sees in Anderson's work, the historiography of nationalism commonly assumes that the imagining of national community was contingent upon "print capitalism" and rising literacy. While this combination of factors may offer a plausible explanation for the rise of nationalism in Western Europe, it is far less satisfactory in the case of a multilingual and predominantly illiterate society, such as colonial South Asia.

In fact, nationalisms often arose in the colonial world without the benefit of a common written language and rising literacy rates. People in such circumstances nonetheless imagined a kind of political community in the early decades of the twentieth century, although perhaps in none of the "modular"

forms that Anderson and others have proposed.[15] Departing from previous studies of nationalism, I propose that the nation in South Asia was popularly conceived in a discursive field in which visual and printed languages interacted and informed each other. In this project, I join a growing number of scholars across fields who are pursuing the visual as a means of better understanding identity, nationalism, and community.[16] While visual discourses of community were not unique to the modern era and to the rise of the nation state in South Asia, a visual vocabulary of nationhood, as Sandria Freitag has termed it, was quickly disseminated through the modern capitalist economy that had developed in colonial India by the turn of the century.[17] This book explores the importance of visual culture in the rise of mass nationalist politics in colonial South Asia, focusing upon the swadeshi movement between 1915 and 1947.

Most of the relevant scholarship in visual studies has tended to focus on the producers of visual objects and the objects' intended function, rather than on the consumers and the objects' actual use. While understanding the contexts in which goods were produced is certainly necessary, understanding the reception and use of these goods in everyday life is equally important in understanding identity and community. Moreover, the study of consumption reveals an avenue through which non-elite politics and agency were pursued. Consumption and the visual—its symbols and practices—enable us to see how identity and community were contested, negotiated, and defined. Although Gandhi and nationalists employed khadi as a means of challenging colonial rule, khadi's significance was not always tied to the nation that they sought to popularize. Nor was it a symbol strictly modern in its use and display. This study demonstrates how khadi was put to different purposes by Gandhi, nationalist leaders, and a range of other Indians in the period of mass politics in nationalist India.

Given that khadi emerged as a powerful material and visual symbol during the nationalist period, it is somewhat surprising that it has been largely overlooked in the historiography of modern India. There have been at least a half dozen articles on khadi in the last twenty-five years, and many passing references to khadi in studies of regional Congress politics, but there has been no sustained study of the transformation of this ordinary cloth into a powerful political symbol. This oversight can be explained by a variety of factors. Most importantly, khadi's significance has been viewed too narrowly in solely economic terms; accordingly, the swadeshi movement has been treated as an unrealistic and failed approach to economic underdevelopment. An interesting exception to this approach is Manu Goswami's *Producing India*, which examines how nationalists imagined India as an economic space both

temporally and spatially distinct from that imagined by Britons. Goswami takes seriously the process by which shared ideas of territory, history, and collective identity both made possible the imagining of national community and bound its proponents to the communalist conclusions that have shaped the post-independence period in South Asia.[18] Other scholars, meanwhile, have been so critical of Gandhian politics that they may have dismissed swadeshi as a movement that only served the interests of industrialists and the middle classes. Although there is no doubt that khadi was both scarce and expensive during the nationalist period, and was more likely consumed by urban elites than by India's rural population, khadi's significance should not be so easily dismissed. This book elucidates the broad cultural currency of khadi during the nationalist period and beyond.

The neglect of khadi is also attributable to some of the blind spots of the historiography of Indian nationalism, especially its overwhelming focus on the ideology of the leadership of the Indian National Congress and its reliance upon the written word as the primary source for understanding this period. An exclusive focus on ideologies and written words cannot tell us how khadi became such a common symbol across the subcontinent, even though it was never worn by a majority of the population. This focus has also overlooked forms of politics that were not under Congress's complete control, or limited to its ideology. In assuming that our material and visual lives are predetermined by written words, we miss the opportunity to understand how symbols and material objects shape our experiences of the world as well. My approach resonates with that of two recent studies of nationalism: Raja Kanta Ray's *The Felt Community* and Stuart Blackburn's *Print, Folklore and Nationalism in Colonial South India*. Although much less ambitious in its scope than Ray's study, this project also assumes that national community is something that remains "in the making" and that is related to emotions and mentalities that lie beyond, though not entirely apart from, those of nationalists.[19] Stuart Blackburn pays particular attention to the way that Tamil print culture was used by a variety of actors for overlapping purposes. Drawing these contexts apart from one another allows Blackburn to identify the particular ways that specific texts and ideas came to spread so widely and quickly. Emphasizing khadi's materiality and its visual impact likewise allows us to tease apart visual, material, and literal worlds so that they can be seen as interconnected and complementary. In doing so, our study of khadi resonates with Ray and Blackburn's concern that nationalism be treated as an ongoing process of identify formation through which disparate interests find common avenues of expression.

Also essential to moving beyond the limitations of nationalist histori-

ography is an approach that examines the everyday appearance of khadi in nationalist India. Interestingly, studies of material culture often unwittingly privilege the production of material goods over their consumption. While the context in which objects are made is critical, the meaning of objects does not cease once they are produced. Meaning is made, or continues to be made, over the course of the lifetime of the object and thereafter. In his study *The Practice of Everyday Life*, Michel de Certeau argues that scholars rely too heavily on models of action that define consumption as passive. He explains the definition of consumption as the result of scholars having defined production as "active." De Certeau treats "everyday life practices, ways of 'operating' or doing things" as central to understanding how culture is composed and not "as merely the obscure background of social activity."[20] My approach to understanding how khadi came to be such an important symbol builds upon de Certeau's. I assume, for example, that consumption is not separable from production, that consumption is not passive, and that consumption as an activity is central to the way people construct modern societies.[21] In adopting this particular aspect of de Certeau's approach, this study emphasizes the ways in which material, visual objects shaped the political vocabulary of modern India.

It is important to acknowledge what this book does not purport to be. This is not a substantive treatment of Gandhi's philosophy of swadeshi. Indeed, some have characterized this project accurately as "a study of a Gandhian movement without Gandhi."[22] This is a fair evaluation, and there are several reasons why the project was conceived in this way. A large and detailed litera-ture, or "cottage industry" to use the phrase of one anthropologist, already ex-ists on Gandhian philosophy to which readers may turn if they are interested in the details and implications of Gandhian thought.[23] My particular concern has been placing Gandhi in a context that acknowledges his significant influ-ence on the nationalist era while evaluating the ways his ideas and politics were taken up and transformed by people in the period for purposes other than those he anticipated or approved. This study is indebted not only to the scholarly directions opened by the Subaltern Studies Collective generally, but in particular to the work of Shahid Amin and Gyanendra Pandey, both of whom made visible the limitations of a nationalist historiography invested in Gandhi.[24]

In resisting a study of swadeshi politics as a hagiographic treatment of Gandhi, I have pursued a couple of strategies that deserve explicit comment. The first was to understand the swadeshi movement through a broad exami-nation of materials from the period. In conducting my research, I quickly moved beyond what is available in the *Collected Works of Mahatma Gandhi*.

This is a rich source, but unfortunately one that is too often used without reference to other resources either within Gandhian materials or beyond. This study departs critically from that of Emma Tarlo's *Clothing Matters,* which makes excellent use of, but is largely restricted to, a reading of swadeshi and khadi from the *Collected Works.* Approaching the subject of khadi in national life without concrete and sustained examination of where and how the cloth was created and used seems to me to be largely missing the point. In addition to Gandhi's speeches and writings on the subject, I have gathered information about the two institutions that promoted khadi and about the people who performed the daily work of the movement during the nationalist era. These records allow me to speak specifically about how khadi was popularized and marketed, and also about the extent to which khadi's adoption reflected negotiations between Gandhian ideals and consumer preferences. Given that khadi was both more expensive than comparable industrially produced goods and difficult to find in the marketplace, more consumers chose khadi quite purposefully. The second strategy was to place the creation of khadi's meaning within the context of government policy by making extensive use of the records of the government of India and its provincial counterparts. Although many of Gandhi's writings reference particular conflicts over the use of khadi, his articles, speeches, and letters tell us very little about local conflicts over khadi or their management by government officials. Understanding the shifting and sometimes contradictory policies of the provincial and central governments at this time is crucial to understanding how khadi's fame was secured.

Finally, it is noteworthy that, when I began my research, I assumed that this would be a regionally focused study on the swadeshi movement in Gujarat. More than one advisor questioned me about the significance of swadeshi and khadi outside Gujarat, the area from which Gandhi hailed. It was not until I was immersed in materials at the Satyagraha Ashram and the Gujarat Vidyapith in Ahmedabad that I started to see the various khadi networks that bound nationalist India. This realization was confirmed further once I started working in the National Archives of India. I was faced with the choice of either examining materials of one region, say, for example, in Gujarati or Hindi, or of examining khadi in its extra-local context. From my review of regional materials about the swadeshi movement and khadi, it became clear that pursuing an exclusive regional study would produce a project tied more closely to the ideas and intentions of Gandhi and the Congress leadership. In the end, I opted for the broader inquiry because it offered a more significant and multifaceted argument about the role that people played in forging the symbolic meanings of khadi in the context of

nationalist India. There remains a need for regional studies of khadi, which I feel confident would provide more nuanced conclusions about contestations over community in particular locales.

This book is organized to emphasize the relationship between political institutions and popular practices. The first chapter recounts the development of Gandhi's swadeshi movement, explaining how Gandhi incorporated khadi and the daily practice of spinning into the program of his ashrams and, by extension, into the Indian nation. The chapter addresses the two nationalist organizations that systematically promoted khadi in the 1920s: the Khaddar Board of the Indian National Congress and the All-India Spinners' Association, which was managed from Gandhi's Satyagraha Ashram. Finally, this chapter explains how the British regime inadvertently facilitated the spread of swadeshi politics, and thus the promotion of khadi, by extending the administrative authority of local Indian officials under the 1919 Government of India Act.

Subsequent chapters discuss different ways in which nationalists and common people transformed khadi into a national symbol. Each of these ways led to the reform of both traditional and imperial cultures, and, moreover, to the demarcation of India as a place where diverse people shared in a mutually supportive community and aspired to self-governance. Chapter 2 explores how proponents of swadeshi politics crafted their promotions of khadi in order to map the Indian nation. They did this both by using visual media to identify home-spun cloth and the practice of spinning with the construction of national boundaries, and also by using khadi tours and exhibitions to acquaint the population with a nationalist geography of India. Chapter 3 explains how people donned khadi to refashion their appearance, representing a new Indian body that was distinct from bodies clothed in accordance with custom or imperial dictates. Chapter 4 discusses how people enacted a new national calendar to visually signal the breakdown of colonial control over time and to anticipate the ascendancy of a nation. Finally, chapter 5 demonstrates how people used the display of khadi, in forms ranging from hats to flags, to fill and mark public space as national space, thereby asserting control within the nation's boundaries. In these various ways, the idea of an autonomous, self-defined India was rendered imaginable, not only through the published political tracts of Gandhi and Congress leaders, but also through the visual vocabulary of home-spun, home-woven cloth. In using khadi to transform how Indian society perceived the body, time, and space, nationalists and common people reinvented a traditional fabric to serve a distinctly modern future, securing for khadi a special place in the national culture of modern India.

CLOTHING
GANDHI'S
NATION

1

A POLITICS OF CONSUMPTION

Swadeshi and Its Institutions

The Congress has placed special emphasis on swadeshi. The foundation of India's freedom will have been laid only when the import of Lancashire cloth has stopped. . . . Our freedom will be won through the spinning-wheel. It is necessary to introduce it in every home. If every person in the country—man, woman and child—takes a vow today to give some little time of his to spinning, within a very short time we may cease to depend on others for clothing our people and save sixty crores of rupees for the country.

—Gandhi, January 1921[1]

In the weeks and months after the Indian National Congress passed the Non-Cooperation Resolution on December 30, 1920, Mohandas Gandhi spoke and wrote passionately about the vital connections between an indigenous goods movement, known as *swadeshi,* and the attainment of *swaraj,* or self-government.[2] The Congress leadership, while supporting the Non-Cooperation Resolution, was not convinced that spinning cotton was either a solution to India's poverty or a strategy that would successfully bring about significant political change. Gandhi's swadeshi approach failed to capture the full support of Congress leadership, but it nonetheless soon became familiar to the broader Congress membership and the wider public.

At the heart of Gandhi's swadeshi movement were the invention and popularization of a nationalist style. The most striking aspect of this style was a form of nationalist dress that was adopted by much of India's predominantly middle-class Congress members, but swadeshi provided more than new ar-

ticles of clothing. It popularized a reformed lifestyle. Patriots did more than wear *khadi* or *khaddar* (homespun) clothing; they slept on khadi bed linens and decorated their homes, inside and out, with the cloth. Even more significantly, because khadi was a tangible object, it easily became within a decade a popular, powerful political symbol used in protests and other gatherings in British India's public spaces. Yet the power of khadi was not confined to those who supported Gandhi's narrow, and sometimes rigid, ideas about community and politics. Instead, even though Gandhi's movement failed to convince the entire Congress leadership or the broader population of British India of the effectiveness of swadeshi politics, it transformed an ordinary country cloth into a material and visual symbol that would be woven into the fabric of Indian politics and culture for decades to come.

Neither the revival of traditional textile production nor the term *swadeshi* was unique to Gandhi's movement; rather, Gandhi adapted international ideologies and the model of an earlier movement that had thrived in the eastern province of Bengal between 1903 and 1908. In the period of mass nationalism in India (1920–1947), Gandhi promoted swadeshi politics through three institutions: the Satyagraha Ashram, the All-India Khaddar Board, and the All-India Spinners' Association. It was in the ashram that Gandhi transformed his swadeshi program from one focused on weaving and hand-loomed cloth to one defined by hand-spinning and khadi. The coordinated efforts of the Khaddar Board and the Spinners' Association made it possible for Gandhi and his supporters to introduce the ashram's experiments to the broader public. Beyond Gandhi's control, the swadeshi movement and khadi were put to a wide variety of uses by people, many of whom did not subscribe to Congress, much less to Gandhian, views.[3] Thus, over the course of the 1920s, khadi itself was transformed from the emblem of Gandhi's utopian politics into a broader symbol that would endure long after the politics of Gandhi and his era.

The Roots of Gandhian Swadeshi

European traders traveled to the Indian subcontinent for spices in the seventeenth century, but it was her cloth, and eventually her cotton, that figured so significantly in India's colonization. In the early eighteenth century, the British East India Company exported calicos and muslins to European and Southeast Asian consumers. The profits from trade with India, when coupled with the influx of Mexican silver, contributed to Britain's industrialization. By the late 1820s, English mills reversed the flow of textiles.[4] Once a great pro-

ducer of cloth, India became a consumer of British manufactured textiles, the prominence of her traditional textile production undone by cheaper foreign goods. Indeed, the British themselves undertook several studies to discover how Indian textile production had been destroyed over the course of the nineteenth century. For these reasons, it is no surprise that the question of native industrial development, and the production and consumption of cotton cloth in particular, figured so centrally in Indian anti-colonial critiques and nationalist politics of the twentieth century.

Gandhi's particular form of swadeshi drew upon a variety of regional, national, and international ideologies. Beginning in the 1870s, Western-educated, native members of the colonial regime became increasingly aware of "the contrast between the prosperous industrialized West and poverty-stricken, famine-ravaged India."[5] They concluded that the increasingly poor living conditions of India's vast population were attributable to the British government that taxed its subjects to cover the cost of administration without reinvesting revenues back into Indian society. As a result, a steady portion of India's wealth was available neither for the services needed by the population nor for the development of the economy. Dadabhai Naoroji, a liberal Parsi, focused public attention on the inconsistencies between Britain's benevolent imperial rhetoric and the practices of British administration in India. As the nineteenth century came to a close, Naoroji's critiques were further supported by the extensive work of Romesh C. Dutt, a Bengali member of the colonial administration. After scrutinizing the records of the government, Dutt argued that the modern technologies imported into India by the British, namely the railways, were not aimed at improving the welfare of India's vast population, but instead at exploiting Indian resources for the benefit of Britain's industrial economy. These critiques of British rule came to be known as the "drain theory," and they provided the basis not only for a short-lived political movement in Bengal known as "swadeshi," but also for Gandhi's later movement of the same name.[6]

Although the direct impetus for the Bengal swadeshi movement of 1903–1908 was the British decision to partition the eastern province of Bengal, this movement was also informed by the anti-colonial critiques of Naoroji, Dutt, and others that had begun to reach the general public in India. When the partition decision was announced in the summer of 1905, the conflicting British and Indian interests exposed by drain theorists in the preceding three decades came to the fore once again. Bengal was British India's largest political unit, with a population estimated at roughly 85 million. As such, India's Home Department argued, it would be more efficiently administered if it was subdivided. This plan, however, struck a tender cord in Bengal, particu-

larly among the educated and urban populations, who were bound closely to one another by culture. In addition, the proposed division would create a Muslim majority area out of the eastern part of the province, thus separating the population along religious lines. The very heart of British India's anti-colonialism would be sundered. Bengali politicians, who had not been consulted, viewed the partition as administratively convenient, if not expedient, for the British government, rather than—as it had been presented—as a plan aimed at improving the administration of Bengal to benefit its native subjects.

Bengal's moderate politicians responded to the announcement of the partition with the same political strategies they had practiced for nearly twenty-five years; they began a press campaign, gave speeches, sent petitions to the viceroy (the top British official in India), and convened two large conferences. Eventually, moderates at a town hall meeting in August 1905 proposed a boycott of British goods with the goal of convincing Bengalis to purchase, instead, *swadeshi*—the goods of one's own country. Yet even as they approved the boycott and developed a range of cultural strategies to draw support, including Bengali poetry, fiction, and song, the moderates hesitated to extend their political strategies beyond government-approved arenas to more extreme forms of resistance. After introducing the resolution for a boycott, one Bengali leader, Narendranath Sen, explained, "Our object is not retaliation but vindication of our rights, our motto is 'Defence, not Defiance.'"[7] Like Gandhi a few years later, Sen saw swadeshi politics as a means to convince British lawmakers to do the right thing.[8] But this strategy was slow to produce results and unable to sustain them.

Yet this early swadeshi movement promoted another form of resistance to British governance, too. For at least a decade before the 1905 partition, a new kind of thinking, called constructivism, had been emerging among the Bengali political elite, who had adopted some of the strategies of the late-nineteenth-century religious reform movements. While accepting the moderate economic critiques of British governance, constructivists sought to transform their country through work at the local level, as opposed to working through government channels and imperial policy. They did not embrace modernity and promises of industrialization as the solutions to India's poverty. Instead, they sought to resuscitate parts of "traditional" society that they viewed as superior in both material and spiritual terms to the "progress" being offered by the West. To restore India's health, they created a variety of institutions, some economically and others culturally oriented. Thus, within the Bengal swadeshi movement were two distinct approaches that would become important to Gandhi's later movement of the same name.

On the one hand were moderate Bengali politicians who aimed their efforts at the highest officials of the British administration. On the other hand were the constructivists who were both skeptical that real change could be accomplished through moderate strategies and convinced that change had to begin at the local level if it were to have meaning for most of India. In the Gandhian institutions discussed later, one clearly finds the resumption of constructivist strategies. If the first swadeshi movement failed to reach its potential because of a failure of leadership, focus, and organization, as Sumit Sarkar has argued, then Gandhi's work apparently succeeded by incorporating "constructivist" elements that overcame some of these shortcomings, particularly the transformation of homespun cloth into a symbol with broad popular appeal.

As significant as the Bengal movement was to Gandhi's thought, it is crucial to recognize the "multiple authorship" of Gandhian utopianism, to use Richard Fox's formulation, which emphasizes also the transnational sources of Gandhi's politics.[9] Aside from his association with theosophists and vegetarians, who shared his skepticism of modern materialism, Gandhi was greatly influenced by the works of Leo Tolstoy and John Ruskin. Tolstoy drew Gandhi's attention to India's village communities, which provided the prototype for the ashram community where Gandhi first put his reformulated swadeshi politics into practice. Ruskin's influence on Gandhi, according to Fox, followed Gandhi's translation of Ruskin's *Unto the Last,* a critique of "capitalist political economy," commercialism, and industrialism. Ruskin argued that these economic strategies would not benefit India as they had Great Britain because of substantial differences between the existing economies of the two countries. Drawing on Ruskin, Gandhi recognized that industrialization was not well suited to India's predominantly rural economy and its underemployed population, which was far more numerous and diverse than Britain's.

Tolstoy's and Ruskin's views were complemented by the ideas of two other thinkers of the era, Edward Carpenter and G. K. Chesterton. Carpenter built upon Tolstoy's idealization of village communities to offer (in his book *Civilization: Its Causes and Cures*) a prescription for modern society that drew upon the presumed strengths of ancient Indian society, emphasizing its spiritual superiority over the materialistic West. He declared that modern Western society should look to the "Wisdom Land," as he called India, as a model for its own reform. For his part, Chesterton argued that India needed to base its future not upon a rejection of Britain but rather upon a positive conception of its own superior cultural heritage. Carpenter and Chesterton opened a way for Gandhi to imagine alternatives to Western-style progress, alternatives that were suited to India's particular circumstances. Gandhi's

revival of textile production and hand-spinning derived from all of these thinkers, as well as from the nineteenth-century drain theorists and the Bengal swadeshi movement. Together, these regional, national, and international influences not only made Gandhi skeptical of Western modernity, they also enabled him to imagine new forms of politics.

Gandhi initially articulated his swadeshi politics in a series of articles that he wrote in 1908 for the newspaper *Indian Opinion* while returning to South Africa from Great Britain.[10] The articles were eventually published together as the pamphlet *Hind Swaraj* (*Indian Home Rule*). Interestingly, Gandhi made only passing reference to indigenous goods, hand-spinning, and khadi at this time; instead, he offered his first sustained critique of modern Western civilization and his first elaboration of the duties of Indians to solve the problems that faced them in the modern world. He acknowledged the roles that Indians themselves played in their political and economic subjugation, and he asserted that

> the English have not taken India; we have given it to them. They are not in India because of their strength, but because we keep them. . . . They came to our country originally for purposes of trade. . . . They had not the slightest intention at the time of establishing a kingdom. Who assisted the company's officers? Who was tempted at the sight of their silver? Who bought their goods? History testifies that we did all this.[11]

Given that Indians had contributed to their state of dependence and subjugation, Gandhi reasoned that they had a role to play in reclaiming home rule. India's political autonomy, according to Gandhi, depended on social and cultural reform—and at the center of this reform were a rejection of materialism and the adoption of handmade goods to the exclusion of manufactured wares. Synthesizing ideas he had gained from local, national, and international sources, Gandhi believed that by returning to local and traditional forms of production Indians would free themselves from the Western materialism that had enslaved them and re-establish traditional relationships at the local level, thus regaining the foundation of meaningful community.

Less than a decade after writing *Hind Swaraj,* Gandhi put his ideas into practice in an ashram, or community, outside the industrial city of Ahmedabad, located in the Bombay Presidency. Like the constructivists of the Bengal movement, Gandhi had concluded that the petitions, protests, and conferences of moderate politicians could not transform the country. The founding of the Satyagraha Ashram in 1917 provided Gandhi with a means to pursue and refine his reformist ideas in the hope that he could apply them

to the larger community. Like his earlier ashrams in South Africa, Satyagraha ("truth force") Ashram was initially quite simple, made up of canvas tents and a single tin shed, which served as the shared kitchen. The land on which the ashram was built was unsettled and full of venomous snakes, which posed a challenge to the ashramites bound by vows not to kill any living creature. Eventually a series of buildings made of wood and mud brick were built, including a school, dining hall, kitchen, library, weaving shed, and good latrines and urinals.[12] But if the ashram's physical landscape was quite simple in its materials and designs, its community was heterogeneous. Members of the ashram community varied by age, education, religion, and life experience.

The ashram's purpose, according to its constitution, was "to learn how to serve the motherland"; it was literally a human laboratory whose aim was to teach people how to live as equals and without fear. Members of the community took vows of truth, non-violence, celibacy, control of the palate, "non-stealing," and "non-possession." Additionally, members were expected to pledge to live by swadeshi, and developing a viable swadeshi program was the ashram's top priority.[13]

What precisely did Gandhi's earliest conception of swadeshi entail? The Satyagraha constitution, a document drafted by Gandhi, explains that the consumption of manufactured goods threatened at least four ashram vows: truth, non-violence, celibacy, and non-possession. For this reason, members were expected to give up manufactured goods, whether made in Britain, Japan, or India. But more importantly, members were expected to develop a means for bringing swadeshi to India's villages. In practical terms, this meant not only avoiding foreign products but also producing traditional goods.

Gandhi's swadeshi program at the Satyagraha Ashram clearly reveals his debt to Indian constructivism. His early ashram experiments, too, had included the weaving of cloth for the needs of the ashram community, and one of the first and largest structures built in the Satyagraha Ashram was the *vanatshala,* or weaving shed, whose swift construction and size reflect the significance of swadeshi as a priority of the ashram—as does the fact that Gandhi originally lived in the vanatshala.[14] Maintaining the vow of swadeshi, however, did not initially entail hand-spinning, nor did Gandhi and his community originally place emphasis on khadi in particular.[15] Significantly, when the Satyagraha Ashram was established, it was hand-loomed weaving, not hand-spinning, that was at the center of Gandhian swadeshi politics.

Yet by the end of 1917, Gandhi admitted that the ashram's commitment to swadeshi was amounting to very little.[16] The community had attracted several families of weavers and was able to produce a limited amount of cloth from thread spun in one of Ahmedabad's Indian-owned mills, but

it could not yet meet its own clothing needs. Moreover, dependence upon mill-spun yarn detracted from the spirit of swadeshi. Gandhi wrote that he wanted to institute the daily practice of spinning in the ashram, but no one in the ashram community possessed a *charka,* or spinning wheel, and he was initially unable to locate either a wheel or someone who knew how to spin thread because spinning had all but died out in the surrounding area. When Gandhi met Gangaben Majmundar while presiding over the Second Gujarat Educational Conference in Broach,[17] however, his swadeshi program found new possibilities.

Majmundar had dedicated herself to social and educational reform after becoming a widow,[18] and she and Gandhi discovered a shared interest in promoting indigenous industry in India. Gandhi recounts their first conversation in his autobiography, telling us that although Majmundar was uneducated she possessed practical knowledge and common sense that had enabled her to arrive at creative solutions to the problems that she had faced in her life. He praises her for having chosen not to withdraw from society after her husband's death, as social convention dictated, but to devote herself instead to the oppressed classes. Clearly impressed, he credits her with prompting him to reconsider swadeshi as a form of political resistance and as a means of reconstituting the nation.

Majmundar offered to locate a spinning wheel for Gandhi and teach him how to use it. A short while later, she arrived at the ashram with a charka she had found in a neighboring state and taught Gandhi while his nephew, Maganlal, worked quickly to replicate the spinning instrument. In the months that followed, one by one, the members of the ashram learned to spin thread. As Gandhi recalls in his autobiography, the first members of the community to learn to use the charka were three women, "Shrimatis Avantikabai, Ramibai Kamdar, the widowed mother of Sjt. Shankerlal Banker and Shrimati Vasumatibehn."[19] (One of Gandhi's women followers would later characterize the movement as "a women's association,"[20] for although members of the ashram were expected to spin daily, the bulk of the responsibility for spinning fell largely upon the female members of the community, who participated in fewer political activities outside the ashram than the men.) By the end of 1918, the cloth produced in the ashram was both home-spun and home-woven. Only a year later, the ashram community produced enough khadi to meet the needs of its members and others. Although we do not know how the cloth was marketed, it appears to have been made available to the public in Ahmedabad. The use of khadi as a material product of the Gandhian swadeshi movement had been born.

This evolution in the practice of swadeshi within the Satyagraha Ashram

made it possible for Gandhi to reconceive swadeshi politics broadly, and eventually to transform khadi into an important political symbol. Following the introduction of hand-spinning in the ashram, swadeshi became more than a boycott of foreign goods; it became a moral system of labor and consumption for the nation. Gandhi continued to advocate the economic autonomy of India as a prerequisite of her political freedom. He wrote, "India's economic freedom depends on the spinning-wheel and the hand-loom. . . . Without economic freedom the very hope of freedom of any other kind is futile."[21] Acquiring the skills and the tools necessary to produce hand-spun, hand-woven cloth allowed Gandhi to do more than downplay industrially manufactured goods, whether foreign or indigenous; for the first time, he could proffer the local production and consumption of handmade goods as a path to India's liberation.

Contemporary critics often ridiculed Gandhi for refusing to embrace industrialism, but Gandhi was more interested in re-establishing relationships of interdependence between people at the local level through swadeshi politics than he was in developing factories that promised national economic independence, but also impoverished workers. Unlike modern industry, swadeshi offered India an economic approach located in the villages, where people could draw upon community support. Although community networks also existed in India's industrial centers, Gandhi viewed the life of factory workers as unhygienic, corrupt, and exploited. Expounding upon his conviction that local interdependence was the key to home rule and freedom, Gandhi explained, "Swadeshi is that spirit in us which restricts us to the use and the service of our immediate surroundings to the exclusion of the more remote."[22] He argued that only the restoration of local, village economies would reverse India's growing impoverishment and its political subjugation. Hand-spinning became crucial to his larger vision of swaraj because he considered textile production to be the most significant traditional industry of India. Gandhi's vision for regenerating India through the revival of hand-spinning both marked a substantial break from previous Congress policy and produced a tension between those who supported village and small-scale production as the bases of community and those who viewed cities and industrialization as the foundation of India's future.

Before the Indian National Congress and the wider Indian public could explore the tensions between hand-spinning and industrialization, however, Gandhi launched the "non-cooperation" movement in 1920. Histories of this period generally explain the movement as a reaction to a series of escalating political tensions in India produced by several related events. First among these was the introduction of the Rowlatt Acts of 1919, which extended

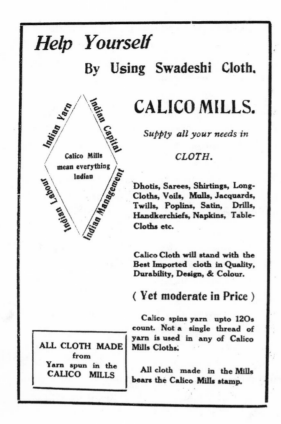

Figure 1.1. Calico Textile Mills advertisement, Bombay Swadeshi League catalog, 1930

wartime restrictions on civil liberties. Second was the Jallianwallah Bagh massacre, in which several hundred Indians were gunned down, allegedly for having disobeyed the orders of the local government, which had forbidden assemblies without permission. Third was the appointment of the all-British Hunter Commission, which was convened to investigate the massacre. There is no doubt that the repressive Rowlatt Acts antagonized the Indian population, which had expected rewards and reform for its loyal support of Britain during the Great War, or that the massacre and the makeup of the Hunter Commission drew substantial criticism from a wide spectrum of moderate political figures.

The Congress's Non-Cooperation Resolution and its incorporation of swadeshi into its political program, however, were not a response to these issues alone. Rather, the direct impetus for Gandhi's decision to begin his first mass political struggle was the decision of the British and their allies to

dismember the Ottoman Empire and, in so doing, part its leader from his religious and political authority.[23] Thus, the non-cooperation movement and swadeshi politics were launched in alliance with Khilafatists, those Muslims who opposed the destruction of the Ottoman Caliphate following Turkey's defeat in World War I. With their support, Gandhi persuaded the Congress to join in the political movement by adopting the Non-Cooperation Resolution at a special session in August 1920, undoubtedly bringing greater public attention to his own activities and, particularly, to his new swadeshi politics. Hand-spinning left the confines of the Satyagraha Ashram and became a feature of the Congress's institutional framework with the founding of the All-India Khaddar Board, which was created to oversee the development of swadeshi and the promotion of khadi nationwide.

It must also be said that, in this tumultuous era of Indian nationalist politics, the British unwittingly facilitated the spread of the swadeshi movement. They did so under the terms of the Government of India Act of 1919, which put into practice the Crown's post–World War I policy of establishing a responsible government in India. In 1917, a dark period of the war for Britain and its allies, the secretary of state for India, Edwin Montagu, had famously declared that Britain would make political concessions to Indians with a view toward India's eventual self-governance. Toward this end, Britain instituted the administrative system of dyarchy under the Government of India Act, giving Indians significant authority at the provincial and municipal levels while the British retained executive authority over the military, taxation, and crucial branches of government. Municipal authority was also enhanced indirectly by the inclusion of greater numbers of Indians, both as candidates standing for election on municipal bodies and as voters electing their municipal representatives. Thus, although historians commonly dwell upon Indian nationalist dissatisfaction with dyarchy, the status of municipal corporations received an unforeseen boost from the reforms of 1919, and dyarchy actually benefited the swadeshi movement by providing sympathetic local officials with new authority to support and promote swadeshi and other forms of politics, including legal picketing, processions, and hoisting the nationalist flag. Such authority was particularly important because it allowed local Indian officials to use khadi symbolically and legally to lay claim to public space, a point to which we will return.

Two critical periods define the institutional history of Gandhi's swadeshi movement. In the first half of the 1920s, the Congress embraced the swadeshi program, eventually tying Congress membership to daily spinning and the use of khadi. By mid-decade, however, swadeshi was significantly challenged by a variety of critics both within Gandhi's circle and beyond. Congress's sup-

port for swadeshi politics began to evaporate as the organization continued to advocate swadeshi as a principle in its platform but withdrew its efforts to popularize khadi. Consequently, in 1924, Gandhi founded the All-India Spinners' Association to assume responsibility for the production and sale of khadi.

Under the direction of the Spinners' Association, swadeshi politics in the second half of the 1920s attracted new supporters by significantly widening the definition of "swadeshi" and the scope of its program. Despite its tumultuous beginning and the limitations of Gandhian ideology, the swadeshi movement eventually found popular support that transformed khadi into the single most important symbol of the modern Indian nation. Over the course of a decade and a half, khadi emerged as a symbol through which people otherwise divided by language, region, religion and caste could imagine themselves as part of a national community.

The All-India Khaddar Board and the Spinning Franchise

True swadeshi is that alone in which all the processes through which cotton has to pass are carried out in the same village or town. The town in which this is done will prosper and win its freedom.

—M. K. Gandhi[24]

By the time that the Indian National Congress adopted the Non-Cooperation Resolution, Gandhi and his supporters had begun to transform the traditional meanings of swadeshi. Bengal's *Amrita Bazar Patrika* covered a speech Gandhi gave in Calcutta in September 1921: "At the time of the partition of Bengal restrictions, if any, were confined to the boycott of foreign clothes. By foreign clothes it was meant clothes manufactured in London, but allowance was given for the use of goods manufactured in Japan. The present swadeshi cult meant total boycott of foreign clothes of all descriptions and it was restricted to only hand-spun clothes."[25] With the development of hand-spinning and the production of khadi in the ashram, Gandhi was poised to pursue India's regeneration in his own distinct way. All industrial cloth was to be considered foreign to India, regardless of who owned the means of production or who worked in the mills.

Six months later, having recognized the popular appeal of khadi, the

Congress Working Committee created the All-India Khaddar Board, allowing the organization to manage and benefit directly from swadeshi politics. The Khaddar Board's first report explained that its purpose was to promote khadi in each province "by way of loans and technical advice and to make available to each province the experience of other parts [of the country] and to collect and disseminate useful information."[26] Having initially supported the swadeshi program with 858,000 rupees in 1921, the Congress contributed no less than Rs. 390,000 in 1922 and Rs. 655,000 in 1923. The papers of the Khaddar Board indicate that between 1923 and 1924 the board was able to fund efforts to the tune of Rs. 3,000,000.[27] This sustained financial commitment to the swadeshi program transformed the movement's scope. The program of spinning familiar to the residents of the Satyagraha Ashram was now pursued on a national scale.

The Khaddar Board comprised three distinct but interrelated divisions: technical instruction, production, and sales. Each division played a particular role in the popularization of khadi goods, and the Congress Working Committee approved separate budgets for each.[28] A Khaddar Board meeting in January 1924 made clear that the board, and the Congress more generally, had accepted Gandhi's belief that production should be organized at the local level. Minutes of the meeting explained, "Every Province should endeavor to develop to the fullest extent its potentialities for the production of khaddar and aim at clothing its population as far as possible with khadi produced within the province itself."[29] Departmental duties were defined so they could "give full play to the principle of de-centralisation, allowing each centre to adapt its organisation to suit special local needs and conditions."[30] It was important to swadeshi proponents that production not be overly centralized, in contrast to systems of modern industrial production. Although the Congress wanted to focus its efforts on popularizing the swadeshi ideal, it wanted to do so while encouraging the self-sufficiency of communities and interdependence at the most local level. Replacing the consumption of foreign goods with native industrial goods was not enough; the Khaddar Board aimed to alter the ways that cloth was both consumed and produced. Thus the board's primary role was to oversee the distribution of financial resources and technical knowledge to local organizations and businesses across British India.

The Congress Working Committee appointed an Executive Committee headed by one of Gandhi's closest associates, Jamnalal Bajaj,[31] to direct the progress of the three Khaddar Board divisions and prepare regular reports on the movement. The board was particularly keen to involve local entrepreneurs by convincing them to invest along with the Congress in local stores and production centers. At monthly intervals, the board convened to

discuss the applications for support that they received from individuals and groups across the country who wanted to begin selling or producing khadi. Such support was provided not only in the form of loans, which were to be repaid, but also in the form of grant monies—ranging from Rs. 500 to Rs. 100,000—and khadi goods themselves. Proposals were not always generously supported, as competition for the limited funding made available by the Congress was stiff.[32] The Khaddar Board's decisions seem to have been guided both by the nature of the assistance that was requested and by the ability of a particular institution or region to sell khadi.

Once the board approved monies, it relied upon stores to run autonomously. The Khaddar Board might act as a facilitator, but did not, in general, directly oversee these businesses. In the case of khadi depots, which combined sales of goods with production, the board generally played a more substantial role. Depots supplied spinners with all the raw materials needed to spin thread and coordinated the collection of thread and its weaving. In areas of intense swadeshi work, larger depots located in urban areas assumed responsibilities for rural work in surrounding areas and were often referred to as khadi centers.

While the Congress attempted to bring swadeshi politics under its control in the early 1920s, Gandhi and his followers in the Satyagraha Ashram continued to play an important role in the movement. The Khaddar Board established the Department of Technical Instruction at the ashram for the purpose of training khadi workers from various parts of India. Gandhi's nephew, Maganlal Gandhi, who already supervised the daily functioning of the ashram community, was given the responsibility of creating and overseeing the curriculum by which khadi volunteers would be trained. He was also charged with the task of recruiting the best prospective students from around the country. On July 1, 1922, a new school to train swadeshi workers, called the Akila Khadi Vidyalaya, accepted its first class of khadi students at the ashram.[33] Maganlal Gandhi became the backbone of the khadi program and swadeshi politics, remaining a major organizer of the movement until his sudden death in 1928.

The Vidyalaya was, in many ways, the heart of Gandhi's swadeshi movement. It transformed middle-class students who had no direct experience in textile production into an army of dedicated khadi workers. Ideally, these volunteers would leave the urban context of their training and spread out across the subcontinent, not only propagating the political message of swadeshi, but also teaching the rural population how to revive the home production of cloth. Provincial Congress organizations interested in starting khadi production centers were asked to apply to the Vidyalaya on behalf of specific vol-

unteers who wanted to carry out such work. Those selected by the Vidyalaya moved to the Satyagraha Ashram for six months, during which they learned every aspect of cloth production. On an annual budget of approximately Rs. 25,000 provided by the National Congress, the ashram community provided instruction, housing, and board for about fifty Vidyalaya students at a time.

The purpose of the school was to create a reliable, well-skilled, and well-equipped cadre of khadi workers by providing comprehensive instruction in textile production. Students were expected to be able to grow and identify different varieties of cotton, as well as clean, card, and gin the cotton, important processes without which quality thread could not be spun. The curriculum then turned to spinning. The quality of khadi depended upon finely and evenly spun thread; well-spun thread produced softer, more durable cloth. Students also learned weaving and dyeing. At the end of their training, they learned how to instruct others in the use of a carding bow, spinning wheel, and handloom by practicing on incoming volunteers. With this training, graduates were prepared to establish khadi centers around the country.

The range of skills taught at the Vidyalaya were captured by Pranlal K. Patel, a young Ahmedabad-based photographer who was interested in a wide range of subjects, including the nationalist agitation, life at Satyagraha, textile mill workers, and tribal peoples. Patel captured some of the Vidyalaya's production of khadi in a series of photographs taken not of the ashram's adult *satyagrahis* or the Vidyalaya's pupils, but of ashram children, who learned khadi production alongside their parents. The first of these photographs focuses upon five girls undertaking the various tasks necessary to prepare raw cotton for spinning (figure 1.2). In the background are several spinning wheels. The girls work on the floor, side by side, first ridding the cotton of seeds and other imperfections before rolling it into long pieces that would be bundled and sent to spinners at khadi depots across the country or given, perhaps, to the spinners who appear in Patel's next shot. In this photograph, a girl and a boy, probably no more than ten years of age, sit behind spinning wheels, transforming small bundles of cotton into thread (figure 1.3). After filling the spindle on their charka, they carefully unwind the thread. In doing so, they accomplish two things: they strengthen the thread with a second winding, and they twist it into larger bundles for the weavers.

Patel's series also contains two images that demonstrate the weaving of khadi in the ashram (figures 1.4 and 1.5). In the background of the first photograph is a row of the charkas with which Gandhi is so commonly associated. In the foreground is a row of teenage girls, each of whom sits at her own short loom. These looms produced narrow khadi suitable for shirts, *dhotis,* or towels, but certainly not for saris. The second photograph was taken

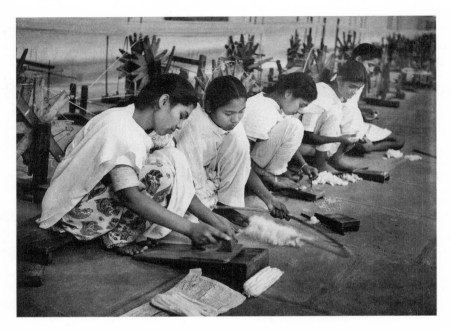

Figure 1.2. Ashram girls prepare cotton. Photograph by Pranlal K. Patel, used by permission.

in the ashram's main khadi shed. Here are captured the high ceilings of the ashram buildings, as well as the spare interiors. Large bundles of khadi thread hang above two young women weaving on full-sized looms; these women are differentiated from younger subjects in these photographs by their saris. The larger looms not only prepared wider and longer pieces of khadi, perhaps for saris like those worn here, but also likely produced higher-quality cloth. The young women in these photographs have acquired some skill in order to weave on these looms.

Aside from the various details of khadi production at the ashram, Patel's photographs capture another significant feature of the swadeshi movement: Gandhi's vision of using khadi production as a means of drawing in and reforming all of Indian society. Not only were the students at the Vidyalaya and the members of the ashram community involved in khadi production, but the ashram's children and young adults were also. Together they put into practice Gandhi's belief that it was everyone's responsibility to labor for the nation. The photographs also provide clues about the gender implications of swadeshi politics. In arguing that every Indian should spin at least one half

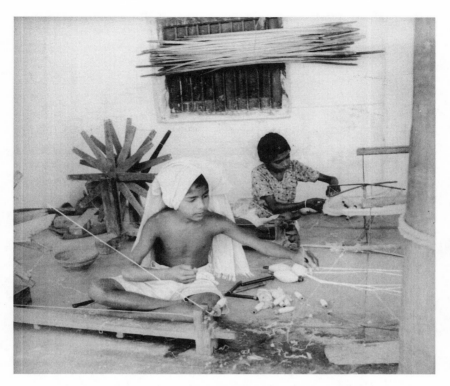

Figure 1.3. Ashram children spinning. Photograph by Pranlal K. Patel, used by permission.

an hour a day, Gandhi's program challenged traditional divisions of labor in textile production. Whereas particular tasks had long been associated with a particular caste or religious group, and with a particular sex, Gandhi sought to reject such distinction. The ashram drew people from a variety of castes and religious groups, as well as *dalits,* also known as untouchables, and tribal peoples. Patel's photographs suggest that male and female members of the ashram were in practice part of khadi production and that children were instructed in all aspects of textile production, regardless of sex. In other words, Patel's photographs show us that in the Satyagraha ashram boys spun thread alongside girls, and girls not only prepared cotton for spinning but also learned to weave.

Graduates of Vidyalaya dispersed to teach their skills in the regions the Khaddar Board had approved for swadeshi investment, but khadi workers were also deployed in rural areas in times of natural calamity. In the aftermath

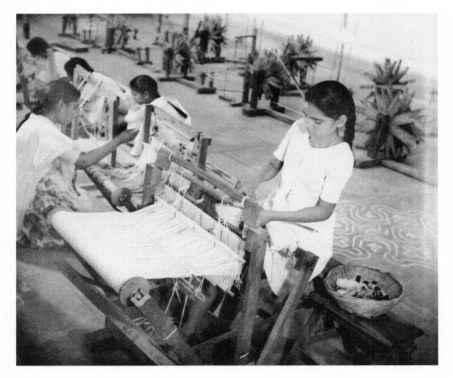

Figure 1.4. Ashram girls weaving on short looms. Photograph by Pranlal K. Patel, used by permission.

of floods, for example, workers brought khadi, cotton, and spinning wheels to villagers who had no other prospect of income. These efforts were aimed at bridging the tremendous gap between India's poor agricultural classes and the urban middle-classes. Under such circumstances, khadi workers were able to introduce khadi and the other products of the swadeshi movement into rural communities that might otherwise have been cut off from the "khadi craze" that overtook many of colonial India's urban centers, where khadi workers were concentrated.

A second division within the All-India Khaddar Board, the production department, oversaw the interprovincial coordination of khadi production and distribution. The department had a healthy budget, roughly equivalent to that provided for technical instruction. Among its chief responsibilities was regulation of quality standards across the provinces. By establishing

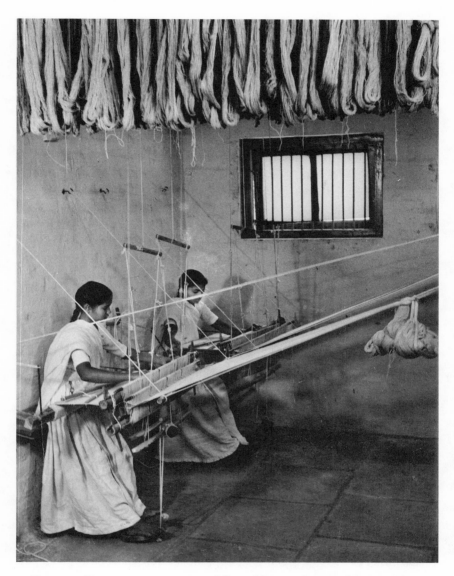

Figure 1.5. Young women weaving on full-sized looms. Photograph by Pranlal K. Patel, used by permission.

nationwide quality standards for yarn and cloth marketed as khadi and khaddar, the production department monitored the quality of khadi cloth for the consumer. It also certified independent businesses as official khadi dealers. This task required a system through which businesses could apply, a process through which the department could award such certification, and a handful of qualified investigators to respond to complaints about specific merchandise. Businesses eventually found board certification so important that it became a regular feature in paid advertisements.[34]

Agents of the production department traveled from khadi center to khadi center, inspecting the work being done at businesses and organizations that received funding from the Khaddar Board. In time, the single most important responsibility of the production department became the testing of questionable goods sold as khadi. In the event that the production department identified a specific business selling mill-made cloth under the khadi or swadeshi label, they initiated public campaigns to discourage consumers from patronizing the business. Persuasion also came in the form of advertisements taken out in local newspapers and of pickets set up outside the shops that violated swadeshi rules. The department also regularly announced inspection results in regional newspapers and political pamphlets. Detecting the so-called spurious khadi was necessary to maintain the legitimacy of the movement, both in the eyes of its potential consumers as well as those of its critics. Like the technical department of the Khaddar Board, production drew a clear distinction between manufactured and hand-spun goods.

Finally, the production department evaluated the market for swadeshi goods in particular locations, sending representatives to local businesses and production centers, and recommending to the Khaddar Board those regions that should be earmarked for khadi work. In the first year of the board, for example, the production department identified several regions that were undersupplied with khadi. When the board subsequently reviewed loan and grant applications from new businesses and institutions, those in areas that had been identified as ripe for swadeshi politics were funded first. Swadeshi proponents significantly expanded their operations in 1924, which saw the establishment of five new centers in Sindh, six new centers in Utkal, and fifteen in Andhra.[35]

The sales department was the third division of the Khaddar Board. It had a variety of objectives for which it received a substantially larger budget than either the technical or the production departments. With an annual budget of approximately Rs. 200,000, or at least eight times that allotted to either of the other departments, the sales department was expected to identify and meet consumer needs. Most importantly, this department had to establish

a system through which it could provide a steady supply of goods to khadi depots and swadeshi businesses at regular, reliable intervals. Khadi depots were the most local manifestation of the Khaddar Board, and they might be relatively large and integrated with a khadi store, as they were in the city of Bombay, or they might be run out of a Congress office or a person's home. Regardless of location, their functions were to provide cotton for spinners, collect the thread that had been spun, and send it on to weavers for the next stage of production. Some cloth was given in exchange for the spinner's labor, while other cloth might be sold in one of many khadi stores or through catalogs. Sales officials needed to know how much khadi was being produced and where, so they could arrange for the cloth to be sent to those regions where demand outstripped local supplies. Moreover, the sales department was responsible for identifying consumer desires and recommending adjustments in the kind of goods available for sale. For example, a khadi institution in South India had convinced women in the community to adopt hand-spun, hand-woven saris because the quality and colors of the cloth reflected local consumer taste. The regional khadi depot communicated their success back to the sales department, which eventually adopted the successful strategy. Eventually, as we shall see, the look of khadi was transformed by regional patterns and colors that were adopted to satisfy consumer preferences identified by the sales department.

Funds for publicity and information about the swadeshi movement were directly approved by the Executive Committee of the Khaddar Board, and the board's records suggest that publicity received the third largest sum in the annual budget, surpassed only by the amount the institution spent on loans and sales. With a budget of approximately Rs. 100,000 per year, publicity for swadeshi was a major expense. The Khaddar Board used this significant sum to place advertisements in newspapers and to print pamphlets for distribution in the vicinity of new sales depots and production centers. Publicity materials were published in both English and vernacular languages, and their audience was clearly literate and often urban, or at least urban-oriented. This focus was consistent with other Congress mobilization techniques that were directed to middle-class people in part because of their potential influence and in part because swadeshi offered a focused critique of middle-class consumer tastes and habits. The substantial annual budget of the Khaddar Board, estimated at 17 lakh rupees (1.7 million rupees), suggests the seriousness with which the leadership of the Congress considered swadeshi politics in the early 1920s.

Despite the financial commitment made by the Congress, however, those involved in the Khaddar Board were not confident about fulfilling the task

before them. Concluding his report to the Congress Working Committee in August 1923, Jamnalal Bajaj admitted that the success of the swadeshi movement ultimately depended upon the general public's willingness to incorporate the philosophy behind swadeshi into their individual lives,

> The production of Khaddar is mainly a cottage industry. Therefore each village and each home must contribute its quota towards Khaddar production, consumption and organisation. . . . As a first step, every son and daughter of India should pledge himself or herself from to-day if he or she has not already done so, to wear only hand-spun and hand-woven Khaddar, to boycott all foreign clothing in any circumstances, to spin daily at least for a few hours, to carry the message of Khaddar to every home and last, but not least, to contribute his or her mite [*sic*] to the Tilak Swaraj Fund earmarked for Khaddar work.[36]

As the leader of the Executive Committee of the Khaddar Board, Bajaj was able to pursue a strictly Gandhian vision of swadeshi politics that privileged hand-spinning over the consumption of indigenously manufactured goods. Yet the emphasis placed by the board on advertising and on political pamphlets suggests that a central goal of the board was to develop and expand a market for khadi goods. Only then would the general public begin spinning regularly, boycotting foreign goods, and wearing khadi on a daily basis. Despite Gandhi's strong anti-consumerism, the movement would only be successful if a broader taste for khadi goods developed.

Within a year of the establishment of the Khaddar Board, government reports emphasized the sudden appearance of khadi cloth in offices and city streets across the subcontinent.[37] At the same time, however, the board began to recognize the unevenness of its successes, and especially the shortcomings of institutions that it had been funding. Many in the Khaddar Board's elaborate network of khadi institutions were unable to break even, let alone turn a profit. While poor business skills and a lack of local enthusiasm may have caused the failure of some khadi depots during this early period, corruption appears to have been the source of problems in many cases. The Congress had been willing to subsidize or even entirely fund businesses willing to sell khadi. Some businessmen appear to have used cash loans from the board for other purposes. As a result, business after business failed to compensate the board as loans came due for repayment, a trend that the board could afford neither financially nor politically. Drastically cutting back on their financing for private businesses, the board forced many businesses to close after they failed to repay their loans, but this meant that the board was unable to ensure a steady supply of khadi in the peak period of popular enthusiasm for

non-cooperation. The very consumers the board had worked so hard to win over were left without supplies of khadi to purchase. Far from providing any financial benefit to producers, the swadeshi movement was failing to provide consumers with a means of participating in the new community Gandhi had envisioned. This was hardly the result for which the Congress and its khadi enthusiasts had hoped.

Just as the board began to confront the unfulfilled potential of their fo-cused efforts, criticism of swadeshi as a policy began to emerge publicly.[38] Critics came from many quarters in society; some were skeptical of Gan-dhi's leadership generally; others were his friends and supporters. Among swadeshi critics were C. F. Andrews and Sarojini Naidu, two of Gandhi's closest associates. Both Andrews and Naidu raised concerns about the aes-thetic consequences of the movement as it had been conceived. Andrews was deeply troubled by the bonfires of goods deemed unworthy of consumption. He was appalled by the way bonfires promoted waste in a country whose average person struggled in poverty, and he was disturbed more generally by the destruction of beauty. Naidu's concerns were closely related. Although she regularly spoke on behalf of swadeshi politics and urged women in particular to take up hand-spinning, Naidu did not regularly wear khadi because she felt it was aesthetically inferior to the traditional textiles of India, which Gandhi had cautioned were too costly for the average person to afford and promoted consumer desire. While Andrews and Naidu's views were not widely known at the time, they each identified problems that had to be overcome if khadi was to attract consumers.

Gandhi's movement also had critics among India's industrialists, includ-ing G. D. Birla and Ambalal Sarabhai, both of whom provided Gandhi with financial support. Birla and Sarabhai rejected Gandhi's aversion to industri-alization, arguing that his position was untenable in the modern world; India was an industrialized country, and its industrial sector was important to the prosperity of the country. In their view, swadeshi should not and could not compete with Indian industry. Instead the definition of swadeshi should be expanded to incorporate industrially manufactured goods as long as they were Indian-made. In addition, Birla regularly challenged economic figures and claims made by khadi proponents in newspaper articles and pamphlets. He took seriously Gandhi's ideas, but also subjected them to substantial scrutiny.

Significant as these criticisms were, it was doubt over khadi's viability as an economic response to Indian poverty voiced by the Nobel laureate Rabindranath Tagore and by the critic Anil Baran Roy, among others, which proved most significant. Given his national prominence, Tagore's views were

picked up in a variety of publications both in the English and the vernacular press. Tagore had two concerns. He accused Gandhi of being unrealistically anti-industrial and of promoting a program that was incapable of addressing the enormous problem of Indian poverty. More troubling than this, however, was Tagore's view that the khadi movement had been adopted without serious reason or reflection. Tagore was a skeptic of nationalism in all its forms and urged Gandhi not to promote nationalism through his politics.[39] Gandhi's responses to Tagore must have been unsatisfying. Replying that he never intended swadeshi to be the sole economic solution to Indian poverty, Gandhi dismissed the poet's broader point as derived from "misunderstanding." There is little evidence that Gandhi took Tagore's criticisms to heart. There is no institutional evidence, for example, that Tagore's private correspondence or his publications about swadeshi produced any reform within the movement. However, Tagore's public criticism of swadeshi must have tempered enthusiasm for the khadi craze, as support within the Congress certainly waned over the course of the 1920s.

Anil Baran Roy, who had already established himself as a scholar of Hinduism, raised his concerns about swadeshi in newspapers in the mid-1920s and later published two booklets that challenged the dogma surrounding the spinning wheel. The most common critique of the swadeshi movement at the time involved khadi's cost relative to comparable goods in the marketplace. Especially in the early years of the movement, khadi goods were substantially more expensive than their mill-made equivalents. Roy explained in a letter to Gandhi that in his region a khadi dhoti, a common form of men's dress made of up to fifteen feet of cloth, cost six times more than one from the mills.[40] This was a particularly difficult reality for Gandhi to face publicly because swadeshi politics were based upon a critique of industrialization—which Gandhi had dismissed because of its inability to transform the lives of the poor. If khadi was so much more expensive, Roy asked, how could one expect the average person to afford it? Gandhi and his associates never responded effectively. Rather than denying that khadi was expensive, they elaborated on the various activities being carried out by workers to lower its cost. On other occasions, they sidestepped the issue altogether by arguing that khadi's cost would not matter when the public took up the swadeshi challenge and produced enough cloth to meet its needs.

In light of the kinds of criticism mentioned above, which began emerging in 1923 and continued throughout the nationalist period, and the poor performance of khadi businesses, Bajaj and his associates focused their efforts on improving the economic viability of their product by changing the way the Khaddar Board had been supporting khadi businesses. At a meeting in

August 1924, the board decided to intervene more directly in the financial management of those institutions it had funded. One change was the fixing of the rates of profit to be made by businesses carrying khadi goods. Khadi stores (known as *khadi bhandars* or *bhavans*) that were affiliated with the Khaddar Board were to be paid a 2 percent profit at the end of the year, while independent businesses would be allowed to keep up to 6.25 percent of the net income from their goods. This would allow the Khaddar Board to collect income from the sale of khadi, thereby recouping its investments while ensuring private investors a predictable profit margin, if somewhat lower than many had anticipated. In order to compensate for the low profitability of khadi, the board reasoned that it would make trade in khadi more attractive by increasing the volume that businesses would sell. How did the board imagine that it would supply so much more khadi? It planned to recruit many more producers.

The change in the Khaddar Board's strategy to resuscitate khadi's popularity corresponded with two new Congress policies on membership and voting privileges. Re-evaluating their own approach to promoting khadi, Bajaj and his associates admitted that by 1923–1924 the Khaddar Board had failed to revive the public enthusiasm for swadeshi politics that had accompanied the non-cooperation movement. Recognizing its limited success thus far in drawing in many more producers of hand-spun cloth, the board's Executive Committee recommended that the program of spinning no longer be confined to the activities of the Khaddar Board and the spinners it trained in the Satyagraha Ashram. As the board's report to the Congress Working Committee explained, it should be "the duty of every Congress member to have a charkha working in his house and thereby set an effective example for the universalisation of the charkha."[41]

The Khaddar Board's statement sparked immediate discussion within the Congress about the place of swadeshi in the political agenda. Although the Congress had previously adopted resolutions affirming the importance of habitually wearing khadi, that was an ideal rather than a daily practice for most members of the party. The tide began to turn in 1924, when the Congress adopted a new policy requiring its members to wear khadi at party functions. Failure to wear khadi was not only looked down upon; it carried a substantial consequence. Those who attended Congress events in clothing other than khadi forfeited their voting privileges at local, provincial, and national meetings.[42] Not surprisingly, khadi quickly became the uniform of Congress members attending official functions. In linking handspun cloth to Congress membership and all of its privileges, the Khaddar Board found a way to promote khadi more widely.

The link between Congress membership and swadeshi politics developed further as the All-India Congress Committee and the Congress Working Committee took up the matter on three separate occasions in 1924. By the mid-1920s, the Congress found itself at a significant crossroads. Many members had been disillusioned by Gandhi's sudden, unilateral decision to suspend the non-cooperation movement following the outbreak of violence in the northern town of Chauri Chaura in February 1922. In the several years that followed, their disillusionment grew into a re-evaluation and rejection of Gandhi's political strategies. Among the critics were many powerful leaders of the period, including both Motilal Nehru, the elder statesman of the United Provinces, and C. R. Das, a prominent Bengali, who together founded the Swarajya Party after the suspension of non-cooperation.[43] As critics increasingly portrayed Gandhian politics as unrealistic, significant divisions developed within the highest ranks of the Congress, jeopardizing the legitimacy of the Khaddar Board and prompting a change in the organization's platform and membership requirements.[44]

Two factions of the Congress eventually agreed on a compromise that took the form, in part, of new franchise rules. In exchange for greater Congress support for swadeshi, Gandhi and his allies agreed to support council entry—the Congress's policy of participation in the colonial government—as opposed to non-cooperation with the British regime. The task of drafting a resolution fell to the Congress Working Committee, which met twice during the summer of 1924. At the end of December, a draft resolution was placed before the entire body of the Congress.[45] In keeping with the principles of mass participation that had led to the lowering of membership dues to 4 annas (a quarter of a rupee), the revised franchise required that Congress membership had to be earned, not just paid.[46] Hand-spun thread donated to the Congress's Khaddar Board was to become part of the price of Congress membership. "Without universal spinning India cannot become self-supporting," the resolution stated. "Therefore: No one shall be a member of any Congress Committee or organisation who is not of the age of 18 and who does not wear hand-spun and hand-woven cloth. . . . and does not make a contribution of 2,000 yards [of] evenly spun yarn per month of his or her own spinning." Furthermore, the franchise resolution continued, "Congress should suspend the programme of non-co-operation as the national programme except in so far as it relates to the refusal to use or wear cloth made out of India."[47] Gandhi and his supporters had agreed to compromise on the issue of council entry, while those who rejected Gandhi's political strategies agreed to support swadeshi. Both wings of the Congress had won.

After a complicated year, the party's general secretaries, Rajendra Prasad,

Saifuddin Kitchlew, and Jawaharlal Nehru, submitted a report to the annual meeting that included a "Congress Unity Resolution." This resolution attempted to clarify the relationship between swadeshi and independence:

> [The Congress] is further of the opinion that such capacity (for vindicating their status and liberty) can . . . only be developed by universalising hand-spinning and the use of khaddar and thereby achieving the long deferred exclusion of foreign cloth; and therefore as a token of the earnestness and determination of the people to achieve this national purpose, welcomes the introduction of hand-spinning as part of the franchise and appeals to every person to avail himself or herself of it and the Congress.[48]

Khadi was not only the key to establishing India's independence from Great Britain in economic terms, it also was viewed as a concrete means through which people could prove themselves worthy of the great responsibility of self-government. Monthly contributions of hand-spun thread offered evidence of self-sufficiency, which Gandhi regarded as the basis of self-rule. Only universal daily labor for the nation would achieve India's independence.[49] Rhetorically, the "spinning franchise" offered a significant opportunity to create a national community, if not through the realization of social equality, then through the attractiveness of the principle of universal labor performed on behalf of the nation. It was, moreover, an important way through which the swadeshi movement could radically increase khadi stocks and meet consumer demand for the goods that they had worked so hard to create. The "spinning franchise" effectively drafted every one of the Congress's members into service for the swadeshi movement. By involving more Congress members in production, the Khaddar Board hoped that it would win more consumers. Moreover, the franchise strengthened the position of khadi as a key material and visual symbol within the anti-colonial struggle. Even as the Congress rejected non-cooperation as a strategy for the time being, it endorsed Gandhi's version of swadeshi by emphasizing home-spun, home-woven cloth. Taken together, the creation of the Khaddar Board and the later adoption of the spinning franchise marked the high points of support for the swadeshi movement among Congress leaders.

But the spinning franchise promptly drew controversy. The compromise reached among Congress leaders appears to have been quite tenuous at best. Those critical of a spinning franchise, and in favor of returning to a simple membership fee, argued persuasively that the monthly yarn requirement had not automatically produced a dedicated Congress membership. Opponents further pointed out that the attempt to promote universal labor on behalf

of the nation, while a noble ideal, was less successful than had been hoped. They directed attention to the fact that wealthy members of the Congress had submitted yarn for their membership that had been spun for them. Jawaharlal Nehru was, in fact, among those who were investigated by the Khaddar Board for this practice. Critics argued that the spinning franchise ironically exacerbated the economic disparities within colonial India, and that it, therefore, posed a threat to the expansion of membership.

Within nine months of its adoption, the spinning franchise was successfully repealed, and the Khaddar Board was disbanded. Congress membership was now accessible to those who either paid 4 annas per year or contributed two thousand yards of yarn of their own spinning.[50] While one could still qualify for membership by spinning yarn, the amount of yarn required to satisfy membership dues was so dramatically decreased, to roughly 8 percent of the original requirement, that it amounted only to a token show of support for swadeshi.[51] Thus, within a year of adopting the spinning franchise, the Congress replaced it with a diluted commitment to swadeshi politics and khadi. The Congress's new position on swadeshi was reflected too in its withdrawal of support for the Khaddar Board. In its place, the Congress affirmed their whole-hearted support for a new, independent organization to manage the swadeshi movement. These changes marked a clear defeat of Gandhi's form of swadeshi, which emphasized hand-spinning and the use of khadi, yet it is nevertheless important to recognize that the Congress's initial support for and later rejection of hand-spinning—while retaining an emphasis on indigenous production—also helped to popularize khadi. Once it was freed from the controversies of the Congress, khadi was, in fact, brought to the general public with greater success.

The All-India Spinners' Association

Eight years after Gangaben Majmundar arrived at Satyagraha Ashram with her spinning wheel in hand, a new swadeshi movement was well under way. Gandhi founded the All-India Spinners' Association in 1925 to oversee the development of the swadeshi movement from the ashram. Although independent of Congress oversight, the new institution was sanctioned by a resolution passed at the annual Congress meeting held at Kanpur. According to its charter, the Spinners' Association was an institution of private citizens working toward the economic independence of India through the revival of hand-spun, hand-woven cloth, but the Congress agreed to transfer the assets of the defunct Khaddar Board to the new association. Far from undermin-

ing swadeshi efforts, the separation of swadeshi politics from the Congress spurred a period of growth in the swadeshi movement. The annual report of the Spinners' Association in 1927 indicates that sales of khadi grew from Rs. 2,399,143 in 1926 to Rs. 3,348,794 in 1927, an increase of nearly 40 percent. At the end of the first year of its efforts, the Spinners' Association boasted that it employed 110 carders, 42,959 spinners, and 3,407 weavers, who worked in over 150 production centers across the country. Figures for the year 1926–1927 indicate that the movement was still growing; by the end of 1928, the association consisted of 703 carders, 97,700 spinners, and 4,944 weavers. Six years later, in 1934, the number of people employed by the association had more than doubled to 227,931 spinners and 11,192 weavers.[52] Although the significant rise in numbers may not at first glance seem important in a country of nearly two hundred million people, the increased availability of khadi in the marketplace made possible a new phase of swadeshi politics. Over the course of the next decade, the swadeshi movement provided one of the most powerful symbols of public dissent in modern India, and the Spinners' Association played a key role in transforming khadi into a signal visual symbol for Indian nationalism.

The mid-1920s and the 1930s witnessed a revival of the use of khadi on a scale formerly seen only in the non-cooperation movement. Yet during this period there was a qualitative shift in who produced khadi and how khadi was used. With greater frequency, and especially on ceremonial occasions, ordinary people began displaying khadi goods to express their opinions on a variety of issues. This shift to greater public and political use of khadi may be partially explained by three important changes initiated by the Spinners' Association. First, the association reconsidered and amended its efforts to promote khadi. By producing a wider range of goods in response to consumer demands, the association set out to win new consumers. Second, the association reversed the Khaddar Board's funding policies, placing resources in its own institutions, rather than subsidizing private business interests and independent entrepreneurs. This centralization allowed the association greater control over the distribution centers it had taken over from the board. By 1931, the association's annual report listed 635 production and sales centers across British India.[53] Third, the association significantly widened its funding sources. By undertaking rural tours and exhibitions, the subjects of the next chapter, the association not only sought additional funding for local efforts, but also used such occasions to spread its message to people who might not be aware of khadi and hand-spinning.

One of the main challenges facing the new organization was how to make khadi more attractive for Indian consumers. While the swadeshi movement

continued to emphasize the political importance of khadi, production was no longer restricted to plain white cotton goods. The Spinners' Association's 1925 annual report reflected the new approach:

> Every effort was being made to supply to the consumer, wherever he happened to be, as much khadi as he had the mind to consume, of whatever quality he might choose to ask for, at the lowest possible price. More than that there was noticed a constant endeavor to tempt the appetite of the urban user of khadi by offering him an ever widening variety of designs and by continuous improvement in the appearance and fineness of the texture.[54]

Under Maganlal Gandhi's leadership, the variety of khadi goods available in the marketplace greatly expanded. In attempting to provide a wider range of products, the Spinners' Association encouraged the production of khadi with regional patterns, prints, and colors that were popular among consumers. Tailoring khadi production to meet consumer desire, however, marked a major break from Gandhi's earlier insistence that swadeshi meant giving up modern consumerism in all forms. Although Gandhi had successfully transformed the meaning of the term "swadeshi" by emphasizing hand-spinning and khadi, his commitment to changing the way people consumed goods was tempered both by the kinds of products produced after 1925 and also by the association's increasing reliance on modern marketing and sales techniques.

The Spinners' Association, which had adopted the organizational structure of the Khaddar Board, also concentrated its efforts upon improving the quality of khadi available in the marketplace. The technical department, for example, increased its efforts to train khadi workers by sending out demonstration parties to villages. Through proper training, the association hoped to raise the quality of the thread spun by ordinary people, thereby providing higher-count cloth that would appeal to urban, as well as rural, consumers. Acknowledging the quality of non-khadi cloth available, the association also focused upon improving and developing tools for home production. The spinning wheel itself was the major target of the association's efforts. Leaders of the association believed that they could improve both the quality and the quantity of thread produced by streamlining charkas available to the average producer. Toward these ends, the association sponsored competitions for inventors, encouraging the public to design a more efficient, less expensive spinning wheel.[55]

Once the movement had attracted new consumers through an improved product, it needed to be able to provide consumers with a regular supply

and selection of khadi. In an attempt to maintain a steady distribution of khadi goods, each major region of the subcontinent had at least one khadi production center.[56] Ideally, each center would eventually be able to meet regionwide consumer demand, but in the meantime the Spinners' Association recognized that a consistent supply of goods was crucial to maintaining consumer interest in their product. After the mid-1920s, khadi depots carried goods that were produced both within their regions and beyond, thus both providing a steady supply of khadi goods and appreciating regional consumer preferences. Like the compromises over the color, pattern, and kinds of khadi goods produced, the Spinners' Association embraced a compromise on distribution. Gandhi had seen hand-spinning and khadi as means of community regeneration at the local level, but the association came to realize that, to attract enough supporters to be meaningful as a political movement, it needed to ensure that sufficient goods were produced and available across the country. Moreover, the extra-local sources of khadi offered the association another kind of opportunity to use khadi to help people see themselves as part of a political community bound by cloth. A transformation in the focus of swadeshi politics from the local community to the national community was under way.

The founding of the Spinners' Association also brought about significant changes in the funding of swadeshi politics. In 1925, when the association assumed the assets of the Khaddar Board, it was clear that the swadeshi movement faced a serious financial crisis. The precious resources that had been invested by the Congress over the course of two years to popularize khadi had been ineffectively used or lost altogether.[57] Recognizing that much of the Khaddar Board's failure had been the result of defaults on loans it had made to private businesses, the Spinners' Association decided to reduce this particular kind of funding.[58] Moreover, the association concentrated its resources on establishing its own khadi stores and production centers, overseen directly by the institution's workers. The association could no longer afford the expense of keeping track of the hundreds of semi-affiliated stores across the subcontinent.[59] In 1926, after the major problems had been identified and addressed, the association resumed its substantial investment in khadi production, spending some Rs. 2,440,857.[60] According to annual reports, this level of investment in swadeshi politics continued through at least 1934.

Whence came the tens of millions of rupees invested in the swadeshi movement? The movement was originally financed by several of India's wealthy industrialists. It is well known, for example, that Gandhi's ashram was funded by the prominent Ahmedabadi industrialist, Ambalal Sarabhai.[61] Without this funding, the Satyagraha Ashram, where Gandhi revived hand-

spinning and khadi, would have collapsed well before the non-cooperation movement. Gandhi also secured the financial backing of several of India's leading industrial families over the course of the 1920s. Both Jamnalal Bajaj and G. D. Birla generously supported the swadeshi movement. Bajaj gave much of his personal fortune away, becoming a devoted follower of Gandhi and regularly providing funds for the movement, including contributions of Rs. 108,000 between 1926 and 1927. J. R. D. Tata, a steel magnate, contributed 100,000 *taklis,* or spindles, to the Spinners' Association in 1926.[62] Industrialists Godrej and Rustami contributed Rs. 300,000 and Rs. 52,000, respectively. And a cotton broker, Anandilal Poddar, donated Rs. 200,000.[63] The steady stream of contributions made by industrialists eased the financial burdens of the movement within the ashram and under the direction of the Congress.

In addition to support from the Congress, which continued at reduced rates after 1925, swadeshi politics drew resources from the Tilak Swaraj and C. R. Das Funds. Gandhi established the Tilak Swaraj Fund following the death of Lokamanya Tilak, the Maharashtrian nationalist leader, in 1920.[64] This fund was particularly important for the swadeshi movement in the first half of the 1920s, collecting an estimated Rs. 13,000,000 between 1921 and 1923.[65] Gandhi established the C. R. Das Fund, which became more important to the movement in the second half of the decade, following the sudden death of the Bengali leader in 1925.[66] Gandhi's decision to seek contributions for his swadeshi movement with a fund named after C. R. Das was no less interesting than his choice to use Tilak's name. Like Tilak, Das had become an outspoken critic of Gandhi and the swadeshi program. In the two years prior to his death, Das had not only led the movement to repeal the 1924 spinning franchise, he had openly questioned the significance of both swadeshi politics and satyagraha. Gandhi, nonetheless, used Das's name to rebuild support for his swadeshi movement in Bengal.

What distinguished the fundraising efforts of the Spinners' Association from those of the Khaddar Board was the participation of rural populations. Tours across the countryside both allowed swadeshi proponents to share their program with rural communities and ensured an additional source for funding the movement. When swadeshi leaders toured the country, giving speeches, providing demonstrations, and showing magic lantern slides, they were periodically presented with "purses" collected from the local community by local organizers. Writing about Gandhi's travels in Gujarat in 1925, Mahadev Desai, Gandhi's secretary, explained, "Little villages collected on the spot from three to six hundred [rupees] each, and some collected eight hundred. It is a sign of the times that the Suba [District Magistrate] of Navasari contributed Rs. 25."[67] From the fragmentary evidence available, it is not clear

whether local people were encouraged to contribute because their landlords had pledged support for Gandhi's movement, or whether they acted solely on their own enthusiasm for Gandhi and his swadeshi politics. However, in the case of the native district magistrate of Navasari, it is just as likely that a local official was encouraged to contribute by local sentiment. The cooperation of the people in the district was essential to the magistrate's success; contributing to the purse was a way for the magistrate to earn political capital.[68] At the very least, Desai's account suggests that ordinary people contributed to the movement through monetary donations. With few exceptions, the money received from these "purses" was distributed to the local swadeshi institutions.

As Gandhi perceived spinning as an ideal form of political participation for women, rural tours were often aimed at village women—who often donated jewelry to the purses collected in their communities.[69] Among the records of the Spinners' Association are receipts that provide insight into how women contributed financially to the swadeshi movement; a short inventory of the jewelry collected from rural women and mailed to the Spinners' Association after two tours of Bengal in the summer of 1925 is a good example. Writing to Maganlal Gandhi, a khadi worker indicated that he was forwarding to the association a package that included four bangles, eighteen *churi* (anklets), one nose ornament, five rings, four ear ornaments, two silver plates, three silver caskets, three sovereigns, and one gold *mohar* (necklace).[70] Although the exact value of the jewelry is difficult to estimate, we can assume that it was worth approximately Rs. 800 because this was the sum for which the worker insured the package.

Reading over the list of items donated by Bengali women, one may wonder if they were so impressed by the visitors that they spontaneously took off items they were wearing that day. As it was taboo for a woman to give away jewelry from her inlaws, which was on loan to her as a daughter-in-law in the patriline, it seems more likely that women arrived at the meeting prepared to give khadi workers specific pieces of their personal property, such as jewelry given to them by their own parents at the time of their wedding. For women to give up some of their limited financial security to support the swadeshi movement was far more than a symbolic act. Unlike the larger cash contributions by industrialists and middle-class consumers, these contributions can be viewed as a direct response to Gandhi's pleas.

Far from simply using rural communities to fund the movement at the local level, swadeshi proponents dedicated their resources to aiding rural communities in times of natural calamity. Famine and flood relief programs run by the Spinners' Association, and made possible largely by urban middle-

class supporters of the Tilak Swaraj and C. R. Das funds, provided villagers with free spinning wheels, cotton, and khadi clothing during times of need. In at least half a dozen instances, the association sent relief workers to disaster areas. Richard Gregg, a Harvard economist, detailed the use of the spinning wheel for these purposes in his *Economics of Khaddar*. Not only did swadeshi proponents hope to aid those in need, they viewed these catastrophes as opportunities to return village communities to their "natural," self-sufficient state.[71]

Swadeshi in Practice

By the late 1920s, Gandhi appears to have stopped insisting that the swadeshi movement should prioritize only hand-produced, locally made goods. The strict definition of "swadeshi" that had characterized his movement in the first half of the decade gave way to a broader program that included native, industrially produced goods, as well as homespun cloth. The critiques and financial support Gandhi's programs received from industrialists may explain his reconciliation with the textile mill industry in the second half of the 1920s.

At least as important as Gandhi's relationship with industrialists in shaping the later meaning of swadeshi was the way in which the public accepted and made use of khadi. The widening definition of swadeshi in the late 1920s reflected the efforts of the Spinners' Association to reshape the movement so it would be embraced by the public upon whom its success depended. By 1930, swadeshi proponents set aside the distinction between handmade and industrial systems of production, emphasizing instead the distinction between indigenous and foreign production—that is, between production in India and Great Britain.

The broadening of the term swadeshi can be seen in advertisements from businesses that allied themselves with Gandhi and Congress politics. Two advertisements included here were among dozens that filled the pages of a catalog published by the Bombay Swadeshi League, a business organization founded to promote the sale of Indian goods. The first, "Patronise Indian Industry," clearly redefined the term *swadeshi* in keeping with the critiques of industrialists of the period (figure 1.6). Calico Textile Mills was owned by Ambalal Sarabhai, who had underwritten Gandhi's ashram when he decided to admit untouchables to the community. Aside from claiming that the company's goods were of superior quality and strength, the advertisement

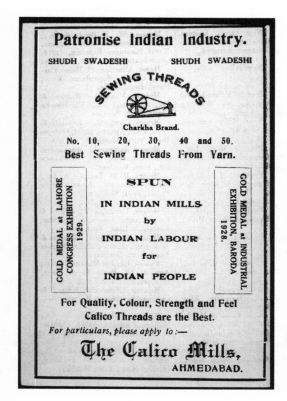

Figure 1.6. "Patronise Indian Industry," Calico Textile Mills advertisement, Bombay Swadeshi League catalog, 1930

asserted that the cloth was aesthetically superior to others on the market. The advertisement also noted two medals awarded to Calico cloth at the Congress Exhibitions in 1928 and 1929. Most significantly, however, was the definition at the center of the advertisement that pointed out that the thread (not cloth) was spun in Indian mills, by Indian labor and for Indian people. This was a new and important way of defining swadeshi.

In the advertisement "Swadeshi and Swaraj," Khatau Makanji Mills, of Bombay, listed its various kinds of products while promising that all goods bearing its stamp were guaranteed to be swadeshi cloth (figure 1.7) Besides associating the Khatau Makanji brand with the swadeshi movement, this advertisement drew upon the popularity of the terms *swadeshi* and *swaraj* to explicitly promise consumers that they could participate in realizing swaraj simply by purchasing Khatau's (swadeshi) goods. Once again, the cloth was acceptable because it was "manufactured with Swadeshi Yarn by Swadeshi

Two words uppermost on people's lips are

Swadeshi And Swaraj

You can observe the Swadeshi pledge implicitly when you buy cloths manufactured with Swadeshi Yarn by Swadeshi Capital, under Swadeshi Management.

Dhoty Sadi Patal Dupatta Mulmul Voiles	See that these Cloths bear Khatau Makanji Mills tickets which are your guarantee for pure Swadeshi Cloth.	Shirting Twill Longcloth Satin Duck Drill Towels Etc., Etc.

KHATAU MAKANJI MILLS

1. **Luxmi Building, Ballard Estate,**
2. **Gowraj Gully, Mulji Jetha Market,**
3. **Haines Road, Byculla.**

Figure 1.7. "Swadeshi and Swaraj," Khatau Makanji Mills advertisement, Bombay Swadeshi League catalog, 1930

Capital, under Swadeshi Management." In both advertisements, Gandhi's original formulations of swadeshi, particularly with regard to its relationship to khadi, were compromised. By 1930, "swadeshi" was a term configured broadly enough to cover a range of economic and political processes.

The All-India Spinners' Association also developed a range of new institutional tactics to pursue its goals in a more coordinated fashion. One innovative tactic was the organization of spinning competitions. Writing to Gandhi in 1927, a young man who participated in a twenty-four-hour spinning marathon during National Week recounted his experience:

I began to lose courage in the eighth hour. The hands refused to work, my head reeled. Much against my will I left the wheel and lay down on my back; but I could get no peace. Suddenly the thought of the Jallianwallah Bagh [massacre], the anniversary of which we are celebrating, came to me and with it the picture of those that lay bleeding in the Bagh for over twelve hours unattended. Then my fatigue left me and with a bound I was at the wheel again.[72]

The young man who wrote this letter to Gandhi emphasized both his physical exhaustion and the relationship of his labor to the national cause for independence. That spinning competitions such as this one produced evenly spun, high-count thread is doubtful. Yet spinning and other swadeshi competitions were useful in promoting the swadeshi movement. Potentially, they offered transformative experiences for their participants. At the very least, they provided propaganda that could be used by khadi workers as they professed their ideas to audiences in villages, towns, and cities across British India.

The All-India Spinners' Association reported many impressive results, often built upon the earlier work of the Congress's Khaddar Board. The general secretaries of the Congress acknowledged that the association improved sales and production figures, and that in 1926 the association oversaw 364 institutions carrying out swadeshi work across British India.[73] Only six years after the association's founding, it had substantially expanded its scope. Recounting the work being done from province to province, the annual report for 1933 claimed that there were 638 khadi production and sales depots.[74] The Indian subcontinent was peppered with khadi institutions, weaving new consumers and producers into a national community. Swadeshi politics flourished also because it could be carried out simultaneously at the local and the national levels. Thanks to the Government of India Act of 1919, with its system of "devolution" of responsibilities from the central to provincial governments, proponents of the swadeshi movement were able to create new kinds of local political action with official sanction.

While Gandhi's swadeshi movement failed to bring about home rule in 1921 and offered no permanent solution to India's poverty, it played a crucial role in the larger process of imagining community. Like the swadeshi movement in Bengal, the later movement produced many influential political materials. While the symbols of the first swadeshi movement, including national poetry, fiction, and songs, had been limited by their regional language and textual nature, the symbols of the second swadeshi movement were accessible to people who did not share language or literacy. This crucial difference may help us to explain why the products of the second swadeshi movement, namely khadi clothing and the flag of the Indian National Congress, became the most important symbols of the Indian nation.

2

TECHNOLOGIES OF NATIONHOOD

Visually Mapping the Nation

Proponents of the swadeshi movement organized khadi exhibitions to do more than demonstrate cloth production and sell khadi goods. On the occasion of one such exhibition in 1926, Gandhi explained their purpose, writing that they were

> designed to be really a study for those who want to understand what this *khadi* movement stands for, and what it has been able to do. It is not a mere ocular demonstration to be dismissed out of our minds immediately. . . . It is not a cinema. It is actually a nursery where a student, a lover of humanity, a lover of his own country may come and see things for himself.[1]

Gandhi asserted that the "nursery" of the khadi exhibition would showcase the values of the nation and demonstrate the processes through which swaraj could be attained. The communication of his ideas at exhibitions depended upon neither the ability to read nor a common language. Gandhi regarded visual experience as a neutral and transparent kind of communication open to everyone, and he privileged visual discourse as a means to spread the idea of Indian national community.

In his examination of mapping in colonial India, Matthew Edney argues convincingly that Britain needed to produce a scientific map of the subcontinent as a single, coherent political entity before it could dominate India as a colonial space; a cartographic understanding of India was a prerequisite of Britain's imagination of colonial authority.[2] As Sumathi Ramaswamy demonstrates, however, British maps of India did not represent India only to the

British themselves. By the beginning of the twentieth century, South Asians had been exposed to colonial maps of India through the administrative practices of the British government in India and in their schools. Although very little work has been completed on the role cartography played in nationalist India, Ramaswamy has persuasively suggested that Indian elites were influenced by their introduction to globes, wall maps, and maps in books, which were all commonly used in classrooms by the late nineteenth century.[3]

Given that the colonial map played a significant role in the establishment and maintenance of colonial power in India, it should come as no surprise that Indian nationalists sought to refigure the British map for their own purposes. In South India, according to Ramaswamy, Tamil intellectuals transformed the colonial map of India by filling its empty spaces with pre-colonial geographies in an effort to recover territory—both physical and cultural—that had been lost. Like the Tamil resistance, swadeshi proponents throughout the country refigured the colonial map to establish their own political boundaries and to represent their version, or geography, of national community. Relying on the visual power of khadi, they sponsored tours and exhibitions that rendered these geographies visible. And by tracking the spread of khadi, they attempted not only to establish their difference from British India, but also to distinguish themselves from pre-colonial, premodern, and competing forms of community. Thus they employed a visual vocabulary of nationhood both to lay claim to a national land and to build a national community.

Khadi and the Visual Vocabulary of the Nation

What comprised a visual vocabulary of national community? Sandria Freitag has suggested that popular posters, film, and statuary were key objects in the grammar of nationhood in colonial South Asia.[4] Clothing and other consumer goods of the swadeshi movement were perhaps even more important, as they linked a distinct material culture of nationalism to what were seen as the nation's basic values. But the swadeshi movement was not the first to use cloth to suggest group solidarity. South Asia's many religious communities had long expressed their norms of comportment visually through clothing and caste marks. Hindu women's marital status, too, was commonly signaled by the jewelry and vermillion that they wore, in addition to their caste marks. By the late 1800s, Freitag writes, various groups employed symbols in public arenas as a means of signaling their political or community associations. A central feature of the Muslim Tanzim movements, for example, was the use

of fabric—including green badges, distinctive uniforms, and flags—in public arenas in cities like Banaras, where adherents gathered to engage public opinion over local matters.[5]

Like the tanzim and sangathan movements, Gandhi's swadeshi movement employed a range of visual objects, including khadi hats, new styles of dress, and a new flag, in their public activities. By 1919, for example, Gandhi was popularizing the cap that came to be known as the "Gandhi topi," as well as the *khadi kurta pajama,* a tunic and a pant. Although the *topi* was a new invention, Gandhi drew upon the shape of men's traditional headgear—which he dismissed as impractical and limited by its community associations—to design it. Thus, although the topi constituted a break from tradition, Gandhi could portray it as "traditional" precisely because of the khadi from which it was made.

The reverse was true of the khadi kurta. Consistent in design with traditional men's dress and common in much of British and Princely India,[6] it was popularized by Congress members, particularly in Northern India. As the kurta pajama gained notoriety as a Congress uniform of sorts, however, it was made "fashionable," or at least more acceptable to a higher class of people, who might otherwise have chosen not to wear it outside the house. What made the kurta pajama distinctive from traditional wear, aside from the class of people wearing it in public, was the hand-spun, hand-woven cloth from which it was made. Still, the familiar cut of the cloth made it easy to adopt in the face of the other choices available; it was clearly not Western. In short, the topi and kurta pajama were neither Western nor strictly traditional; both were "modern" by virtue of the way they invoked "tradition" through the coarse khadi from which they were cut, even as they created a new style. And both should be viewed as examples of broader trends, common among many urban groups that attempted to establish legitimacy by inventing uniforms that would render their causes visible in public.

One other symbolic artifact of the swadeshi movement deserves particular attention: the khadi charka flag. At the flag's center, a charka was superimposed over three colored bands of khadi: white, green, and red, the last of which was eventually replaced by saffron. Although the Indian National Congress did not previously have a flag, as we shall see, the flag used by Gandhi and later by the Congress referenced at least two other Indian flags. Unlike other flags and other forms of dress, however, it was the consistency of home-spun, home-woven cloth that made khadi goods, clothing, and flags such powerful visual emblems of public expression.

Besides hats, suits, and flags, the swadeshi movement made many other khadi goods available to India's urban communities in the 1920s, including

bed linens, towels, draperies, shirts, saris, and shawls. Yet even as middle-class consumers began purchasing these products, swadeshi enthusiasts recognized that the support of urban India was not enough to bring about the economic and social changes that they sought. The All-India Spinners' Association, therefore, set out to bring its ideas to India's rural communities by using a new material and visual vocabulary to connect those who had traditionally been separated by language, religion, and region. Significantly, swadeshi proponents used strategies that contained aspects of both entertainment and consumption. The excitement of a magic lantern slide show about national issues, for example, rested not only in its use of new technology, but also in its use of an entertaining forum. Perhaps more than the content of such shows, it was the form through which they were presented that captured the attention of rural viewers. Exhibitions and khadi catalogs also appealed to people as consumers. Gandhi criticized Western consumption, but at the same time tried to define a "good" nationalist consumption to take its place. Rather than relying entirely upon the prescriptive literature associated with late nineteenth-century religious reform movements, the Spinners' Association created a body of visual images to communicate their messages to India's diverse population—and then distributed their images through both swadeshi and Congress networks.

The use of lantern slide technology is worth dwelling upon briefly. According to the records of the Bombay Presidency's Education Department, the lantern slide was quite effective for drawing a crowd, almost regardless of the subject being depicted, in large part because of its entertainment value.[7] For this reason, the government maintained a collection of not less than twenty thousand slides that were used in district schools across the region it administered. One high school principal, writing to the Visual Instruction Division of the Education Department, encapsulated the power and potential of the technology:

> I have to state that of all the organs of knowledge, the visual sense is the most important. An appeal to the eye is always more efficacious than any other sense. The sensations conveyed through the eye are clear, distinct and vivid. . . . I have found that students relish much the magic lantern lectures. . . . As a result of the visual instruction their memory becomes tenacious for impressions are fixed and are thereafter durable.[8]

At the beginning of the 1920s, lantern slide shows could lure viewers in rural settings in particular, according to one official, because the technology was less familiar and movies were still unknown. School principals reported that,

in addition to drawing students, the shows drew whole villages, creating an event that no villager wished to miss.

Like government officials, swadeshi proponents embraced lantern slides for what one principal termed "a sort of recreation" from which students learned without realizing that they were doing so.[9] Thus, khadi workers arranged tours including lantern slide shows and exhibitions because they believed that people would take away consistent messages about the nation. The extent to which swadeshi proponents were successful in this endeavor is a subject to which we will return.

Swadeshi tours and exhibitions both brought into being and mapped a new cultural and political geography by connecting communities within and outside the nation. The visual language of the movement created a map of the nation distinct from the territorial divisions of both pre-colonial and colonial India. Aside from making various regions of the subcontinent familiar through photographs and lantern slides, khadi exhibitions transformed their visitors into tourists of the nation, encouraging them to experience their nation through a wide range of consumer goods produced in different regions. Unlike the national symbols associated with nations of the West, which emphasized a shared natal land and fairly homogenous culture, the goods of the swadeshi movement defined—and legitimized—the Indian nation by consciously bridging otherwise disparate regions and subcultures. From spinning and weaving demonstration-booths to tables with merchandise for sale, the exhibitions displayed the contours of the nation through its productive capacities and provided an opportunity for participants to take a small piece of their nation home with them. Khadi made the "geo-body" of the nation imaginable precisely by making explicit its difference from both traditional and colonial manufactures.[10] The goods being produced and displayed at the khadi exhibitions were not simply products of India's traditional industries, nor were they products of the British colonial economy. Rather, they were products of a new political community that surpassed the limitations of both traditional and colonial India.

The swadeshi movement represented a critical break from significant parts of India's past. While the movement embraced cloth production as a defining feature of the nation, a strict adherence to the conventions of traditional textile production was not the movement's aim. For instance, swadeshi proponents insisted that *every* Indian devote at least a half hour a day to spinning. However, spinning and weaving were not forms of labor traditionally performed by all members of society. Textile production, like other forms of labor in pre-colonial South Asia, was the work of particular groups distinguished by their religion, caste, or sex. Muslims, for example,

disproportionately comprised the weavers in areas of north India, while specific Hindu castes in central and south India assumed similar roles in their communities. Traditionally, women were the spinners of thread in communities across the subcontinent. Asking everyone in society, regardless of social status, to participate in every aspect of cloth production for the benefit of the "nation" was an idea that superseded traditional productive relationships. Prasenjit Duara has observed that all community building requires a new vocabulary that "selects, adapts, reorganizes and even recreates the older representations."[11] Swadeshi proponents effectively transformed a common object of everyday life, home-spun, home-woven cloth, into the consummate symbol of the "Indian" community. In addition, they widened the meaning of swadeshi so that manufactured goods, if natively produced, could be allied with home-spun and home-woven cloth. This sleight of hand meant that familiar, common objects could at once be clothed in the rhetoric of traditional community and could supercede traditional community boundaries. Khadi itself was a successful symbol in large part because its longstanding cultural connotations were not entirely lost in this process of adaptation.[12] Swadeshi proponents seem to have been less interested in breaking from tradition than they were in cleverly reworking the past.

Swadeshi in Print

As described earlier, following the Congress's disbandment of the All-India Khaddar Board in 1924, the independent All-India Spinners' Association assumed responsibility for every aspect of swadeshi politics, from the distribution of funds that the Congress approved for local swadeshi initiatives to the training of khadi workers, who were charged with the work of teaching their skills in rural and urban settings. One of the most important functions of the association was the popularization of swadeshi ideas through publicity. Besides developing slide shows, exhibitions, and spinning and weaving competitions—which became focal points of conversation in local communities and newspapers—the association oversaw the use of print media as a public relations tool. Khadi enthusiasts wrote political pamphlets and news stories, but, perhaps most significantly, they sought to communicate their vision of national geography and community through printed materials that could be "read" regardless of one's literacy or specific linguistic group.[13] The three images examined below provide a sense of how swadeshi advocates visually and symbolically remapped India in political pamphlets and on posters between 1920 and 1930.

Figure 2.1 presents a popular poster that originally appeared on the front cover of a pamphlet published in Bombay around 1922. It is significant because of the way it represents the process through which swaraj would be achieved. At the bottom left-hand corner of the image is a map that has been labeled in the Hindi script "*Bharat*," a common term for India. At its center is Mohandas Gandhi, who is dressed in a khadi shirt and hat. On the far right-hand side of the image is a woman, likely *Bharatmata,* or Mother India, who holds the khadi charka flag over the image of Gandhi with one hand and spins with the other hand. As she spins, the map of Bharat comes into clearer focus. In this visual narrative, only women's labor, orchestrated through Gandhian principles, will produce India as a bounded, sovereign nation-state. Although it is unwise to assume that visual representations necessarily confirm what is expressed in writing, this image, nonetheless, reinforces Gandhi's speeches and writing from the period that emphasized that swaraj, or home rule, would only be won through women's participation in national regeneration.[14] The geography of India made visible here was expressed specifically through the promise of women's labor for the regeneration of the nation; Gandhi's swadeshi rhetoric was literally embodied in the figure of the rural woman.

A second image (see figure 2.2), drawn from the cover of the *Khadi Bulletin* and printed for the All-India Spinners' Association in both Hindi and English,[15] also features a map, although here a cartographic sense of national territory is only one of the important features. In the image discussed above, a map of the nation materializes as Mother India spins. In the second, the nation is not produced in such a concrete way, but emerges from the labor of India's rural population. The illustration is composed of an outline of colonial India and several distinct pictures, which together delineate the nation's boundaries and provide a way to define the nation that was not, strictly speaking, limited to geographic mapping. Clearly within the boundaries of colonial India, for example, is a peasant hut and a woman squatting, her back to the viewer and her head covered. Although we cannot quite see what she is doing, her posture and movement suggest that she is spinning. The image presents the Indian peasant not as a lazy, under-utilized national resource, as the colonial regime might have argued, but as a willing and productive member of a national community. The peasant woman's labor not only falls within this map of the nation, it is the most important feature of the map. This image suggests that national India was defined more by the nation's productive activities than by cartographic boundaries drawn by British imperialists.[16]

The *Bulletin* cover also delineates the nation by depicting that which lay

Figure 2.1. Gandhi and woman spinning India. *Khaddar Work in India,* 1922.

beyond. On the left-hand side of the image, outside the boundaries of India, is a cluster of chimney stacks, representing the foreign textile industry that Indian nationalists held responsible for the destruction of the Indian textile industry and, by extension, the impoverishment of India's population.[17] An outstretched arm, clearly marked as foreign by its Western-style shirt and coat, reaches toward a bag of money marked "60 Crores," or 600 million rupees. Here, swadeshi proponents drew explicitly upon the rhetoric of nationalist leaders, including R. C. Dutt and Mohandas Gandhi, to map India as an economic space separate from Great Britain. (Not only had Dutt forcefully exposed the contradictions of British profit, taxation, and trade policies in India, but Gandhi calculated that each year some 60 *crores* of rupees were being lost to the British economy.[18]) India's productivity and her profit are located within the boundaries of the Indian nation; they are basic features of India's identity. The poverty of India, so central to nationalist critiques of colonial governance, is represented as a problem that originated beyond the territory of the nation. By contrast, the solution lies within.

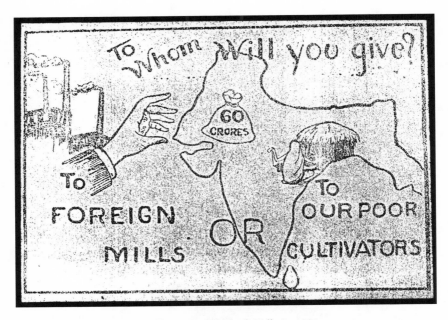

Figure 2.2. "To Whom Will You Give?" *Khadi Bulletin,* 1931.

The pamphlet cover was not simply an endorsement of peasant productivity and a critique of British colonial policies. Given that the image was titled in English "To Whom Will You Give . . . To Foreign Mills Or To Our Poor Cultivators?" it was also an appeal to the sense of responsibility and philanthropy of a middle-class, urban, English-reading public. The urban middle class faced a daily choice: whether to support foreign industrial production that was economically devastating for the great majority of Indians. This publication implored readers of English to sympathize with their struggling compatriots in village India. In setting out to bridge the gap between India's "Westernized" and rural populations, Gandhi and other swadeshi proponents encouraged middle-class audiences to sympathize with India's rural communities, and to consume accordingly. The image suggested that there was only one answer for India and Indians. Rather than giving one's money to British industry, one should contribute to the livelihood of village Indians and thus become, as Rosalind Williams would put it, a "moral consumer."[19] Using visual images in tandem with printed text, Gandhi and swadeshi proponents employed a Western strategy of mobilization aimed primarily at the middle classes. The economy of the nation, whether defined in terms of production

or consumption, became a means to build a national community that ultimately transcended class differences.

A third image, a Bengali political poster, probably produced around 1930, tells us something else about the geographic definition of India (see figure 2.3). Entitled "*Bharatuddhar*," or "Gandhi, the Protector of India," it conveys yet a third kind of national geography associated with swadeshi politics. Rather than using a map of India, this image relies upon mythology to define the territory of the nation. Christopher Bayly has lucidly explored the symbolism of this particular image and suggests it is useful to consider the image alongside a swadeshi song popular in the same period.[20] Entitled "Mahatama Gandhi jo Charka" ("Mahatma Gandhi's Spinning Wheel"), the song begins: "Hear the behest of Gandhi, Save the honour of Bharat, Drive out accursed foreigners, Save the honour of Bharat."[21] In the poster, Gandhi is portrayed as Shiva, the protector/creator of Mother India, or Bharatmata, whose honor is clearly at stake. Armed with the various implements of his power—a charka, a takli, and a piece of khadi—Gandhi-Shiva responds to Bharatmata's prayer, represented by the khadi flag she holds that reads, "*Bharatmata ki jai*" ("Long live Mother India").[22] The young Mother India clutches a Shiva lingam in hopes of breaking free from a bull, identified as foreign by the words *yam raj* ("devil's rule") on his back quarters. As well as conveying ideas through Hindu idiom, the image references visual symbols, particularly styles of dress, of colonial officials. The foreigner, seated on the bull, wears a hat and clothing that identify him with the British regime. The illegitimacy of British colonial rule, the plight of Mother India, and the association between Shiva's power and the implements of the swadeshi movement could be read by a variety of viewers, literate and illiterate alike, regardless of their proficiency in any one vernacular language.

Unlike much of the middle-class nationalist rhetoric that attempted to reconcile the religious communities of India, some images served to reinforce exclusive visions of community. Gandhi's reliance upon a Hindu idiom, whether visually or verbally expressed, has been explored by scholars as one of the strengths and weaknesses of his political movements.[23] On the one hand, Gandhi's popular appeal was probably the result of his ability to communicate through language that was accessible to both rural and urban India. On the other hand, Gandhi's reliance upon religious language may also account for the steady alienation of Muslim communities from his politics. Because "*Bharatuddhar*" expressed its message through Hindu religious symbolism, it seems most likely that it was aimed at India's predominantly Hindu majority. Or was it? Note that in one of his right arms, the Gandhi-Shiva clutches a piece of cloth rolled up and labeled "khadi"—both in Hindi,

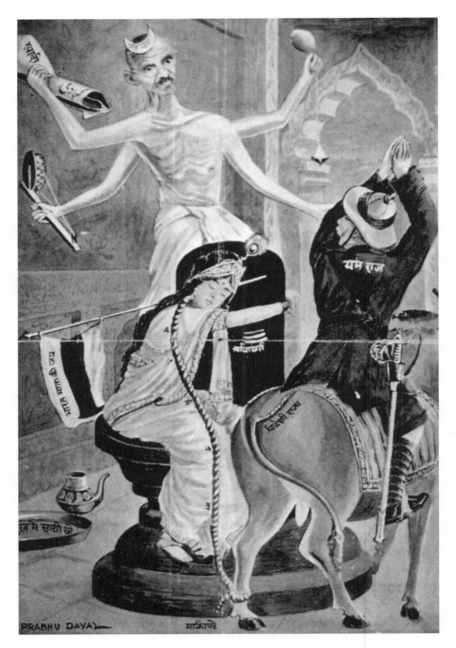

Figure 2.3. *Bharatuddhar* (Gandhi as protector of India). Used with permission from the British Library (f. 58).

a language associated with Hindu north India, and in Urdu, the language of Muslim north India. Given that all of the other written language in the poster is Hindi, how do we explain this one word of Urdu?

For most people who viewed the poster in 1930, the written language would have been secondary to the images. Indeed, most Bengali residents at the time could read neither Hindi nor Urdu. This does not mean, however, that the religious symbols would not have resonated. Rural Indians in the north lived in a world where Hindus and Muslims frequently participated in the same public ceremonies, even when these ceremonies were clearly connected to one religious tradition rather than the other. Indeed, shared public ceremonies and controversies over language in north India would have made the poster intelligible to both Hindus and Muslims, particularly in that region—at least to the degree that viewers would most likely have felt addressed by the religious community associated with each script.[24]

Swadeshi posters and pamphlets reflect the complex relationships between Hindu and Muslim populations in north India in the 1920s, connecting audiences precisely through overlapping scripts. Even those who were not literate in the language of one community or another could in a sense "read" the script and the "*Bharatuddhar*" poster. It is significant that this image, by representing both communities, was not attempting to homogenize the nation, as was the case in the European contexts about which Benedict Anderson has written. Quite to the contrary, swadeshi "texts," whether as image or song, tended to emphasize the heterogeneity of an "Indian" nation, even if unevenly. As did many swadeshi songs beginning in the 1920s, "Mahatma Gandhi's Spinning Wheel," mentioned earlier, addresses Hindu-Muslim unity. The third stanza of the song reads: "Arise, awake, Hindus and Muslims. This is not the time for enjoyment. All Bharat is in sorrow. Save the honour of Bharat."[25] In an interesting way, then, swadeshi songs and images may have conflated Gandhi as savior of Bharatmata with Hindu-Muslim unity as the savior of India. Here there appears to be evidence of consciously containing the heterogeneity of the nation by depicting it in one image.

The All-India Spinners' Association also made extensive use of both the English and vernacular presses in popularizing their view of the geography of India. A single file from the association's 1922 records contained nearly six dozen newspaper articles from that year. Nearly all of these pieces were published in regional English-language papers, including the *Independent, Rangoon Mail, Servant of India, Janabhumi,* and *Hindu,*[26] suggesting the particular significance of the English reading public to Gandhi and his associates.[27] Although few examples of vernacular pamphlets survive from this

period, the All-India Spinners' Association records demonstrate that at least a dozen swadeshi pamphlets were published in Gujarati by the organization in the 1920s.[28] Regional swadeshi organizations also devoted significant attention to popularizing their movement in the vernacular press, as well as through the publication of pamphlets.[29] In 1925, for example, the association's Bengali organizations reportedly contributed to the publication of at least four hundred and fifty newspaper articles in support of the movement.[30]

Political pamphlets and articles promoted an awareness of India's geography as news coverage followed khadi workers from village to village, town to town. Printed materials familiarized the reading public with the places where khadi was being produced, distributed, and sold, thereby associating the material goods of the swadeshi movement with specific places within the nation. Not only did English newspapers and pamphlets publicize swadeshi politics, but they also provided an important new space for a nationwide conversation in the 1920s and 1930s by linking middle-class readers in Bombay and Allahabad, cities in which two different vernacular languages were spoken and read. Thus, Indian nationalists in distinct language groups could express themselves and their opinions to people they might not otherwise have addressed. If in Europe vernaculars replaced the sacred languages and thus enabled the rise of national languages, it was ironically the rise of English in relationship to vernacular languages and the use of khadi as a symbol that provided swadeshi's new language of power for the Indian nation.[31]

News articles commonly discussed the identification of swadeshi goods with the nation's welfare.[32] Most commonly known as "country cloth," khadi was redefined during the 1920s to make a crucial connection between India's past and future. Specifically, it became a symbol that strategically connected India's past, as one of the world's greatest producers of textiles, to a future, as a self-sufficient community. C. Rajagopalachariar, one of Gandhi's closest associates and a leading advocate of swadeshi, wrote a series of articles beginning in 1922 that defined khadi as hand-woven cloth, exclusively composed of hand-spun thread.[33] Explaining that khadi was produced solely by hand, not in industrial factories, Rajagopalachari emphasized the significance of the nationality of the producer. He cautioned consumers about the authenticity of "khadi" available in the marketplace. (Many Indian weavers relied exclusively upon foreign, industrially produced thread, which they wove into cloth that was often marketed as khadi.) Such cloth, even though woven by Indian weavers, did not meet the swadeshi criterion; it had been tarnished in the process of production. Unless a cloth was both hand-produced and *entirely* produced by the labor of Indians, the cloth could not be defined as khadi and would not qualify as a swadeshi good.

The portrayal of India's nationalist geography was not only the product of swadeshi workers and their rhetoric, but was also a common feature of popular advertising of the period. Businesses that sought to make use of the swadeshi movement for their own purposes presented sometimes distinct and sometimes overlapping conceptions of national geography. Two Edsu Fabrics advertisements published by the Bombay Swadeshi League provide important examples of this process; both delimited the territory of India through words and through careful attention to extra-national space. In figure 2.4, for example, India is defined through British colonial terminology in the words "From Bombay to Burma," but, in both advertisements, India is just as much defined by its place in a global geography. India is the place over which Mother India presides, her arms outstretched, her crown reaching to the northern territory of Kashmir, her feet stopping just short of the island Ceylon. Maps of India were used by many organizations during this period. Some of the businesses involved in the Bombay Swadeshi League may have actively supported Gandhi's swadeshi program, but they more likely made use of the rhetoric of swadeshi politics to increase their profits.

Swadeshi posters and print materials provide a glimpse of the multiple meanings of "India" popularized by swadeshi's proponents and through khadi. Visual media presented a range of national geographies. Some were territorial, although they often defined India's territory as much by what lay beyond the nation as by what lay within. Others emphasized India as an economic, or productive, space.[34] Still others suggested national community through extensive use of religious idiom. Despite the narrow focus of swadeshi politics itself, the nation would not let itself be easily defined in accordance with one vision.

Taking It on the Road: Khadi Tours and Lantern Slides

In October 1926, an article in *Young India* described one of the most innovative forms of swadeshi propaganda: the lantern slide show.

The visitors to the [Bihar] exhibition numbered about ten thousand including many ladies. . . . The Khadi Pratisthan of Calcutta . . . sent its exhibits and Sjt. Durga Bhattacharji gave lantern lectures on slides illustrating the causes that led to the economic and educational downfall of India as well as the ways and means for its revival and uplift.[35]

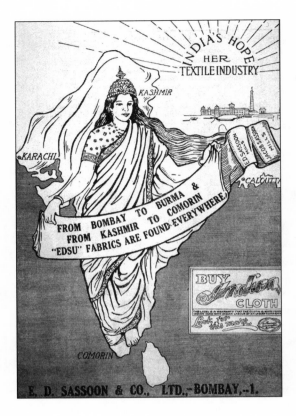

Figure 2.4. "Bombay to Burma," Edsu Fabrics advertisement, Bombay Swadeshi League catalog, 1930

The All-India Spinners' Association utilized two exceptionally powerful visual strategies to popularize swadeshi principles during the 1920s. Over time, the role and format of tours featuring magic lantern slide shows and khadi exhibitions, as well as both demonstrations and goods for sale, were refined to visually express the ideas of the swadeshi movement to a broad audience. The lantern slide shows were certainly not new to India's urban communities, but official Bombay education records suggest lantern slides were still being introduced in rural schools, often to such great enthusiasm that both students and their families turned out to see lectures on topics as mundane as geography and hygiene.[36] By effectively utilizing forms of entertainment that proved popular particularly in rural colonial India, the swadeshi movement finally found a way to extend its reach. The tours helped create a new Indian national identity (based on swadeshi and swaraj) that people wanted to adopt; the exhibitions supplied them the tangible means of adoption.

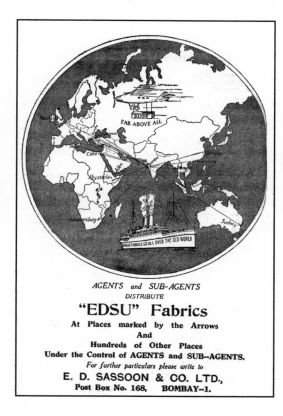

AGENTS and SUB-AGENTS
DISTRIBUTE

"EDSU" Fabrics

At Places marked by the Arrows
And
Hundreds of Other Places
Under the Control of AGENTS and SUB-AGENTS.
For further particulars please write to

E. D. SASSOON & CO. LTD.,
Post Box No. 168, BOMBAY-1.

Figure 2.5. "Edsu Fabrics Around the World" advertisement, Bombay Swadeshi League catalog, 1930

In the first complete year of operations, the Spinners' Association publicized Gandhi's khadi tours in south and central India. Not only did Gandhi appear before Congress associates who were predisposed to his swadeshi politics, he reached out to people in small villages who were neither Congress members nor swadeshi-minded. The Spinners' Association recounted in its report:

> Mahatma Gandhi toured through many provinces and went through a strenuous program of collection of funds and propaganda which has had the most beneficial results in stimulating interest in *Khadi* and has given considerable impetus to the movement in the provinces he visited.[37]

According to the same report, the association successfully sponsored "five tour parties that visited 96 different places and sold over Rs. 40,000 worth of *khadi*."[38] The extent of these tours was particularly impressive given that the

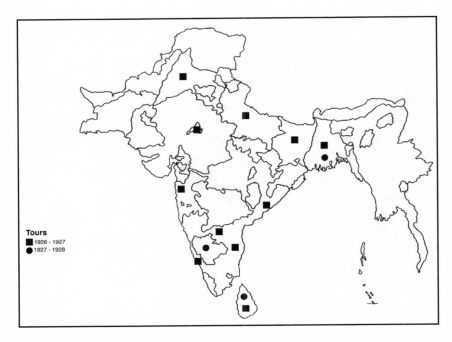

Figure 2.6. Khadi tour map, 1926–1928

association faced the task of assuming the operations of the Khaddar Board and reversing the financial crisis they had inherited. For at least a decade, the association continued to sponsor tours, consistently achieving similarly significant results (see figure 2.6).

The Spinners' Association's commitment to popularizing and distributing swadeshi goods across the country is remarkable. In its 1926–1927 report, for example, the association reported that it had carried out khadi tours in Bihar, Bengal, Utkal, Andhra, Punjab, United Provinces, Ajmer, Maharashtra, Karnatak (including Mysore and South Kanara), Tamilnad, Kerala, and Ceylon.[39] In 1927–1928 the association sponsored tours in Ceylon, Utkal (which was toured twice), and Bengal, raising approximately Rs. 193,402. In the same year, the association carried out an extensive tour in the princely state of Mysore, where it distributed one thousand new charkas and sixty-two looms that produced an estimated ninety-two hundred yards of khadi.[40]

Aside from raising funds at a steady rate and distributing a considerable number of spinning wheels and looms, tours provided an opportunity for

khadi proponents to display both their skills and their ideas. Generally, tours involved a small delegation of khadi workers, from three to ten, who visited areas deemed appropriate for khadi work. In some cases, a member of a local community might have become interested in promoting swadeshi and so had asked the Spinners' Association to provide spinning and weaving demonstrations. In other cases, the association selected a particular village community in the aftermath of a natural calamity and sent khadi enthusiasts with all the supplies necessary to revive, or, in some cases, introduce cloth production to the people in the region. In still other cases, Gandhi and his allies selected areas outside Congress influence in order to build party support among new populations.

Workers regularly carried with them a variety of materials, including khadi, spinning wheels, cotton prepared for spinning, lantern slides, and posters, each of which was used for a distinct purpose. Because khadi was not widely available in rural areas, swadeshi proponents brought samples to potential consumers. Workers also traveled with a variety of spinning wheels, cotton, and step-by-step displays of cloth production to demonstrate how cloth could be made locally.

Central to communicating swadeshi ideals were lantern slides that illustrated the process of cloth production, and, more importantly, slides that communicated various narratives of national community. Enthusiasts of the movement hoped to find new participants by capturing their imagination with a visual technology that was new to communities in rural South Asia.

The "Nation" in Lantern Slide Shows

The potential excitement of an Indian audience at a lantern slide show should not be underestimated. Although photography was used in India as early as the 1840s, especially following the Indian Mutiny of 1857–1858, Christopher Pinney indicates that photographic images were for the most part connected with the colonial administration and elites.[41] With the notable exception of those who came in contact with missionaries, most people in colonial India, particularly among the rural population, had never seen photographs or lantern slides before the era of mass nationalist politics.

Like missionaries, khadi workers used photographs and lantern slides to spread their message. A precursor to film projectors, the magic lantern slide projector used a candle and multiple lenses to illuminate glass slides and project their images onto suitable screens. These simple technologies were

well suited to the long and arduous journeys that khadi workers faced as they toured communities across the subcontinent. The equipment required for the slide shows was easily portable, making it particularly useful for rural travel and exhibition. The leading khadi institution in Bengal, the Khadi Pratisthan, produced several series of slides that were available for purchase by local khadi organizations around the subcontinent. Relatively inexpensive for tour organizers, slides were priced at 12 *annas,* photo prints of the images could be purchased for 2 annas and 6 *paise* each, and the "magic lantern" cost Rs. 39, an amount that corresponded roughly to a mill worker's monthly salary.[42]

This means of visual propaganda was both economical and novel enough to reach viewers who might otherwise have been uninterested in swadeshi or nationalist politics. Villagers probably saw slide lectures foremost as a form of entertainment, and it is significant that although the lantern slide was a modern technology it was grafted onto well-established forms of entertainment in villages, which commonly enjoyed traveling storytellers and troupes of dancers and actors.[43] Khadi proponents used their presentations to define "national" issues and simultaneously to define the nation. The slide shows made statements about how the world worked, what was important, and what behavior was admirable. They also offered the possibility of attracting a wide variety of people who otherwise did not congregate.[44] Ordinarily, one's status group determined with whom one lived, worked, married, and socialized. Lantern slide shows, like visits from storytellers and performers, were local spectacles that offered the brief, if partial, suspension of social customs that otherwise separated castes and religious communities from one another. These occasions made possible the convening of temporary community, one that was "national" to the degree that the slide shows succeeded in connecting audiences not only to each other but to the rest of India. The adaptation of entertainment technology to this kind of political purpose may have been seamless in the eyes of its audiences.

Although the Spinners' Association did not preserve the slides used during this period, its archives include the correspondence of association workers who detailed the contents of the lantern slide presentations.[45] These descriptions do not offer much insight into the messages that viewers may have taken away from the slides; however, they do suggest some of the intentions of the khadi workers who produced the slides. An overview of some slide collections provides insight into the visual imagery through which ordinary people were encouraged to imagine a national community. Central to this vision of the nation was a willingness to imagine a community beyond the traditional local communities of one's personal experience. According to

correspondence from the head of the Khadi Pratisthan, five slide series, comprising some two hundred and seventy separate images, were available to swadeshi proponents in 1926: (1) the Jallian Wallah Bagh, (2) the South African Satyagraha, (3) the North-Bengal Flood, (4) the Deshbandhu Das, and (5) the Health and Hygiene. At first glance, the collection may seem incongruent with the immediate concerns of swadeshi, but taken as a whole it provides rich evidence for the nature of swadeshi narratives of nationhood. The slides prepared by the Khadi Pratisthan, and used by swadeshi workers on khadi tours, offered wide-ranging views of India as a nation. Together, they presented a map of the nation that was composed of the places, ideas, people, and objects that made up India.

The Jallian Wallah Bagh and South African Satyagraha series were aimed at constructing a new national past, one characterized by the egregious abuse of colonial power and the success of the nation in resisting such abuse. The Jallian Wallah Bagh slides showed the walled-in meeting ground where General Reginald Dyer fired upon a gathering of nearly ten thousand people in 1919. The series also included images of the infamous "crawling lane" where British authorities subsequently forced the native residents of Amritsar to crawl on their bellies. Bringing these locations alive was very important to establishing a narrative of nationhood. By visually depicting the particular locations of heinous crimes, khadi proponents connected the illegitimacy of British colonial power to particular, real places within the Indian geography. Moreover, the use of visual materials such as slides helped people around the subcontinent identify with the people of the Punjab, who had suffered on behalf of the larger community. An unspoken message was clear: the massacre in Amritsar could happen anywhere within the boundaries of India's map. All Indians were bound by their vulnerability to an illegitimate, foreign regime. Viewers were encouraged to see themselves in the images of the massacre.

The Khadi Pratisthan's South African Satyagraha series also helped establish a sense of national territory by placing India and Indians within an international context. Mohandas Gandhi had traveled to South Africa in 1893 in order to work as an advocate on behalf of the Indian merchant community. In subsequent years, he had been radicalized by the repressive South African regime, whose laws treated its Indian subjects unfairly, exploiting their labor, denying them basic civil rights and refusing to recognize their marriages. Drawn largely from Gandhi's newspaper, *Indian Opinion* (1903–1961), this series of lantern slides contained images of Gandhi's political activities in South Africa, picturing various forms of civil disobedience that he and his associates undertook against the colonial government.

The large protests of Indians in South Africa provided an object lesson to people in India about how they might confront illegitimate government. Non-violent, civil disobedience was portrayed as an "Indian" way of legitimately challenging the rule of law. The series also assumed the existence of an Indian identity and promoted the concept of a pan-India community. Pictured protestors represented a variety of India's religious, ethnic, and regional communities. The people of the Punjab might seem less distant to the Tamil villager after he saw a Punjabi protesting against the British in South Africa. The Gujarati in Kathiawar who saw these slides might even recognize his brethren in Durban as they struggled against discriminatory colonial laws. All of these people were presented to viewers as "Indians," although it is unlikely that viewers would have identified with one another so closely had slides focused only on struggles within India. The series made the geography of the nation visible both by defining a particular style of protest as Indian and by defining people from the subcontinent, regardless of their original local community, as "Indian."[46] Significantly, the narrative of national community portrayed through the South Africa slides was realized also by a willingness to locate one's community within an "Indian" community abroad.

Other slide collections created by the Pratisthan promoted a national geography by emphasizing the philanthropic characteristics of the ideal subject-citizen. The North-Bengal Flood series introduced the potential role of swadeshi (particularly spinning) in alleviating poverty nationwide by presenting images taken during the devastating floods of 1925, which had destroyed the homes of millions and precipitated widespread famine. As Satish Das Gupta explained, "The devastation by flood led Bengal to take to [the] spinning wheel as insurance against famine. Relief work by Charkha is the ideal and permanent relief to the poor. This series will greatly help the khadi workers in their propaganda. Every picture will tell a story."[47] In keeping with this ideal, swadeshi proponents advocated that middle-class people in particular should spin daily. The North-Bengal Flood series highlighted the work being done by urban middle-class Indians to benefit devastated rural communities, thereby providing those who had not yet taken up spinning with clear evidence that doing so would directly and positively serve their fellow countrymen.

Swadeshi proponents clearly understood the potential power of their visual images and used slides not only to convey information about the plight of the rural population, but also to recommend to colonial India's urban population a specific course of action. The North-Bengal Flood series asked viewers to identify with the problems that faced their "neighbors," to use Ajay

Skaria's formulation,[48] and to offer assistance. Viewers were asked to donate money to fund the purchase of cotton, spinning wheels, and looms for the people hardest hit by the disaster, and they were encouraged to produce cloth that could be sold to benefit flood victims or could be given to the victims themselves. Beginning in 1924, Gandhi's weekly newspaper, *Young India,* regularly ran advertisements reminding its readership to contribute to the Famine and Flood Relief Funds, publishing the names of contributors. Philanthropy beyond one's traditional community was clearly a central theme promoted by the swadeshi movement.

The North-Bengal series also suggested that the effects of national disasters could be curbed through the swadeshi program. The spinning wheel and the swadeshi movement were presented as concrete solutions that anyone could adopt in a time of national crisis.

Fittingly, the last slide in this series was of a spinning wheel, and stated that "Swaraj is possible through Charkha." Choosing to take up swadeshi politics was presented as both a personal, local choice, and a national one. The slides charted a new narrative of the nation, suggesting that India would overcome its colonial past through the shared experience of labor performed on behalf of the nation. Those who chose to use homespun, to spin cotton, or to contribute money after viewing the lantern slides were acting in unison with millions of other people they would never know personally. What bound people, the slides suggested, was their vulnerability to natural disaster—and their generosity, which they were asked to extend to one another.

While the colonial regime used images of India's various peoples to legitimize its right to govern, swadeshi proponents used images to build understanding across geographic and traditional social boundaries. Like no printed word, these slides sought to bridge the distance between India's many subcultures by visually depicting a shared national community and shared national purpose. Swadeshi politics, building upon earlier forms of local entertainment and personalized performance, entertained their audiences with object lessons in the basic values of a new India.

P(a)laces of Consumption: Khadi Exhibitions

Traveling exhibitions were not new to colonial India.[49] Beginning in the second half of the nineteenth century, the British had arranged industrial and empire exhibitions that displayed the latest foreign machines and products. Imperial exhibitions, however, were intended not so much to introduce these technologies to colonial subjects as to impress upon subjects the superiority

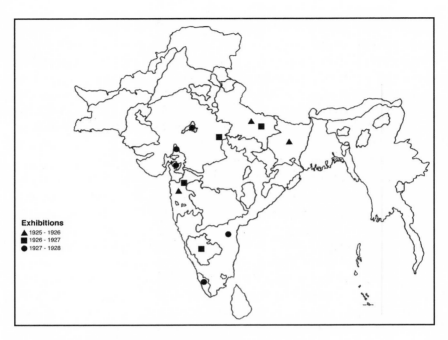

Figure 2.7. Khadi exhibitions map, 1925–1928

of the metropolitan culture and, therefore, the legitimacy of foreign rule.[50] Swadeshi advocates employed a similar strategy in popularizing their ideas by organizing their own exhibitions, beginning with the 1923 meeting of the Indian National Congress that featured the first annual exhibition of khadi and swadeshi goods.[51] In addition, swadeshi proponents targeted India's regional towns and villages. A map of the princely states and provinces where khadi exhibitions were staged during the second half of the 1920s indicates the geographical scope of this strategy (see figure 2.7).

Even more than magic lantern slide shows, exhibitions offered their participants a unique *experience* of the nation by promoting a kind of national tourism that included three features: demonstrations, displays, and sales. Visitors to an exhibition were provided opportunities to see, firsthand, how raw cotton was spun and woven into cloth. By gathering spinners, weavers, and dyers together, exhibitors re-staged the authentic Indian village economy they argued would render India sovereign. Most khadi exhibitions also offered their visitors the opportunity to learn how to spin. Swadeshi workers

also provided placard displays that promoted the movement by charting the steady decline of Indian textile production alongside the skyrocketing increase of British imports to India. A visitor to a khadi exhibition was unlikely to escape without learning something about the way in which the British economy had robbed India of her economic and political self-sufficiency.

The vast majority of an exhibition space, however, was dedicated to booths that displayed khadi goods for sale. A report on the Cawnpore Khadi Exhibition in January 1926 reveals the variety of goods made available to the consumer, including plain white, printed, and dyed cloth. Richard Gregg, the Harvard economist and close associate of Gandhi, observed, "There were dhotis, saries, shirtings, coatings, towels, blankets, shawls, assans, durries, bags and knitted wear fancy work."[52] To attract the new consumers necessary for creating new producers, the Spinners' Association displayed as many different kinds of household objects made from khadi as was possible, presenting a wide variety of khadi alternatives to the foreign manufactures that had become so common in the marketplace. As was the case with the mapping that appeared in political pamphlets and posters, khadi enthusiasts paralleled colonial discourses that were communicated through imperial exhibitions, offering alternative visual experiences to their audiences.

Writing for *Young India*, Gregg observed in 1926 that "[a]n exhibition is not a mere show. It is a form of education. As such it should be both informative and persuasive; a strong stimulus to understanding, realisation, thought, and action."[53] Despite the economist's conviction that exhibitions should be more than entertaining, there is little doubt that exhibitions were organized to be as appealing as possible. Khadi workers made sure not to overwhelm their visitors with technical information, but rather enticed new people into the movement by visually capturing their imaginations. They challenged audiences to identify with the plight of producers whom they did not know personally and to imagine themselves as part of a new community defined by the kinds of products they consumed.

The appeal of khadi exhibitions is amply demonstrated in their attendance numbers, which frequently measured in the thousands. In 1926, khadi exhibitions in Jamshedpur and Ahmednager each drew an estimated 10,000 people over a period of one week; an exhibition in Madras a couple of years later reportedly drew 40,221 people, who purchased Rs. 66,117 worth of khadi goods.[54] Describing the audience at a 1926 exhibition in Bihar, one worker explained, "These exhibitions are being visited by Congressmen, Non-Congressmen, Government officials, zamindars, lawyers, big and small merchants, and in some cases even Europeans. The exhibition at Mairnea was visited by crowds of simple villagers rather than middle-class men."[55] In

other words, exhibitions were not simply occasions for India's bourgeoisie. The unique opportunity to reach a broad and diverse segment of society was not lost on swadeshi proponents, who seized the occasion to popularize their vision of the nation.

An important characteristic of the khadi exhibition was its rhetorical consistency. While local khadi workers or congressmen often initiated exhibitions, the architects of swadeshi at Satyagraha Ashram had significant influence over what people experienced at khadi exhibitions.[56] Displays, whether signs, maps, or charts, were generally provided by the main office of the Spinners' Association in Ahmedabad,[57] meaning that the organizers of khadi exhibitions across the country, regardless of their specific location or their particular affiliation, conveyed a consistent message. They set out to inform the people in the Madras Presidency, the Bombay Presidency, and the Central Provinces about the same developments in the movement. Visitors to an exhibition were supposed to see the same kinds of demonstrations, view the same diagrams and charts, and be introduced to khadi samples from various parts of the country. This kind of consistency in organization and presentation was intended to be the source of a new, common experience of the nation that tied people across traditional divisions of religion, region, caste, and class. Although swadeshi proponents made use of the strategies of the colonial state, they did so for new reasons. If the colonial state demonstrated its power in large part through the establishment of difference between the people of the subcontinent, swadeshi workers set out to create shared experiences upon which a new conception of community could be built.

Exhibitions introduced a national geography in yet another way: one can imagine the nation envisioned by the Spinners' Association simply by following the movement of khadi exhibitions throughout the subcontinent. Consider for example, the map of khadi exhibitions conducted between 1925 and 1928 (see figure 2.7). The geographic reach of these exhibition routes offers a sense of which places were considered part of the Indian nation. Extensive news coverage of over a dozen khadi exhibitions organized in Bihar during the summer of 1926 provides another, striking, example how the national geography was drawn.[58] Many of the Bihar exhibitions were held in prominent cities, including Patna and Gaya. However, a significant number of exhibitions also took place in smaller regional towns, which were almost certainly unknown to those outside Bihar. Once publicized through the popular and nationalist press, places like Arrah, Chupra, Bettiah and Hazaribagh were added not only to a visual map of Bihar, but, more significantly, to the national community. The territory of the nation was articulated, at least in part, by the places in which khadi was exhibited.

The exhibitions themselves also physically carved new national spaces out of colonial India, if only temporarily. In one sense, exhibitions simply gathered hundreds or thousands of people whose presence effectively redefined local public spaces as national. But khadi exhibitors also established tangible national space by building wooden fences around the exhibitions grounds and then covering these fences with khadi cloth. Organizers often decorated the fences inside and out with khadi charka flags and garlanded them with khadi streamers. Within a couple of days of steady work, a physical and symbolic boundary had been established around the exhibition space. Peering into the exhibition grounds would reveal a variety of people, who otherwise would never have socialized together, congregated in a common space. Within the borders of this nation defined by khadi walls, religious, caste, gender, and class divisions were, at least temporarily, suspended. While it is doubtful that visitors were entirely freed of traditional social conventions, these occasions provided an unusual, if brief, opportunity to see oneself as part of a new community.

The exhibition's regional displays also promoted a map of the nation. As early as 1923, Maganlal Gandhi explained the logic of the displays in an article for *Young India,* describing the exhibition as a sort of competition in which "different provinces vied with each other in bringing out the potentiality of Khadi for artistic finish."[59] Samples of khadi from the Karnatak were reportedly the most delicate, while those produced in Sind were thick but strikingly patterned. Thus Khadi exhibitions enabled audiences to "visit" various places in the nation by presenting the unique goods of each region. In the course of a couple hours at an exhibition, a person could travel from one end of the subcontinent to the other and back again.

An exhibition held in Madras in January 1928 and covered in the pages of the *Khadi Patrika* provides an excellent example of the virtual travel possible in an exhibition: "The very first stall that caught a visitor's eye on his entering the Exhibition portals was the one displayed by Sjt. V. R. Kamath. . . . Thus arranged, this first stall served as a good object-lesson to show the visitors the various places [in one's home] where Khadi was capable of being used."[60] Like many accounts of exhibitions, this one began by recounting the visual experience of an exhibition. Following the description of the booth that contained samples of khadi from across the nation were descriptions of booths devoted exclusively to the goods of particular regions such as Bihar, Bombay, Madras, Mysore, and the Punjab. Thus the exhibition both distinguished khadi goods from one another and put them in relationship to goods from other regions of the nation. Regional displays set side by side also established a relationship between the "places" in which khadi was produced.

Exhibition displays may be read not only as expressions of the nation's boundaries, but also as representations of a new national economy and culture that bridged the political gap between traditional and modern society on the subcontinent. One account of an exhibition explained, "An important feature of the Exhibition was the attempt to make people realize the importance of spinning and the place of khadi in *national* economy."[61] To achieve this goal, compromises had to be made. As has been seen, although Gandhi had originally outlined a swadeshi program that prioritized khadi above all other kinds of hand production, by the mid-1920s the parameters of swadeshi had been expanded to accommodate a range of traditionally produced goods as well as particular goods that were industrially manufactured. Inside the exhibitions one could find the products of traditional artisans, such as Benarsi silks and Lucknowi chikan embroidery, displayed beside the products of the swadeshi movement, such as khadi kurtas and topis. Lying side by side, "traditional" and "national" goods were linked within a new geography, one distinguished from the colonial by the exclusive presence of Indian goods and distinguished also from the pre-colonial India by the powerfully symbolic khadi, which sometimes made use of traditional patterns and motifs. Exhibit organizers may have hoped that when a Punjabi visitor saw saris from Banaras, she would connect the goods, whether traditional or khadi, with the place of production. Where else was Banaras if not in India? Standing back and taking in the entire exhibition, a viewer was both reminded of regional textiles, with which she or he would have certainly been familiar, and introduced to a kind of material geography of the nation being made explicit by new manufactures.

At one and the same time, exhibitions emphasized the local specificity of one's community and provided the context in which one was connected to a broader community. Swadeshi workers rhetorically, physically, and materially mapped the geography of the nation by offering khadi as a symbol of the Indian nation. Like the department store for the working classes in Europe, the khadi exhibition provided an important space in which ordinary people could dream about being part of a larger, more egalitarian community, a community free of foreign rule, or perhaps just a community other than their own.[62] While running her hands over the smooth, white Punjabi khadi, a Sindhi might imagine being in the Punjab or participating in demonstrations in Lahore or Amritsar. While examining the products of the Madras Presidency, a visitor to an exhibition might ask, who are the Tamil producers if not Indians? The experience of seeing the objects firsthand and, by extension, connecting to the people who produced the khadi, made it possible to imagine a national geography and community.

Visually Mapping the "Nation"

A map created a nation, though not single handedly.

—Thongchai Winichakul,
Siam Mapped (1994)

The All-India Spinners' Association transformed khadi from an object of everyday life into a central symbol of nationalist ideas and political community. Each one of the strategies discussed here—the proliferation of printed visual materials, the organization of regional tours featuring lantern slides, and the arrangement of goods in khadi exhibitions—helped to express the boundaries of the Indian nation and fashion a national identity. The association successfully encouraged a new conception of community through new modes of consumption, which were reflected in rising khadi sales during the 1920s. The association claimed, for example, that profits from sales of khadi rose from Rs. 2,366,143 in 1926 to Rs. 3,348,794 in 1927. While these figures should be viewed with some skepticism, the overall trend they suggest is supported by the increasing frequency with which people used khadi in public demonstrations across colonial India.

It is important to reflect upon the sometimes distinct and sometimes overlapping geographies of the nation that were promoted through the swadeshi movement's mapping strategies. Taking, for example, the case of political posters, it is striking how differently the nation was depicted. On the title page of the khadi pamphlet discussed earlier, the nation literally came into focus because of Gandhi's leadership and women's labor. This was very much a vision of Gandhi's nation—a nation created through the hand-spun cloth that he popularized. In the case of the cover of the *Khadi Bulletin,* the nation was mapped in terms of the productive capacities of village women, which contrast sharply with foreign industry. The boundaries of the nation were drawn by two forces: modern factories, located outside the nation, and women's hand-spinning, inside the nation, both defining the national economy and, therefore, the nation itself. And, in the case of Gandhi-Shiva as protector of India and destroyer of the devil's rule, the geography of the nation arose directly from mythology. In this idiom, the "territory" of the nation was posed as cultural and religious, and Gandhi was once more conceived as a catalyst for bringing about India, even if he worked in tandem with Bharatmata or Indian women to do so.

Imagining nationhood became possible only when ordinary people chose to consume the idea of the nation, whether by recognizing the boundaries of the nation in the illustrations of political pamphlets, identifying with people beyond their direct experience in lantern slides, or by purchasing khadi at exhibitions. In each of these cases, the swadeshi movement provided people with the option of developing their own relationship to community by seeing themselves at home in a new India.

3

THE NATION CLOTHED
Making an "Indian" Body

[Khadi] . . . stands for simplicity not shoddiness. It sits well on the shoulders of the poor and it can be made . . . to adorn the bodies of the richest and the most artistic men and women. . . . [Khadi] delivers the poor from the bonds of the rich and creates a moral and spiritual bond between the classes and the masses. . . . [Khadi] brings a ray of hope to the widow's broken up home. But it does not prevent her from earning more if she can. . . . [Khadi] offers honourable employment to those in need of some. It utilises the idle hours of the nation.

—Gandhi, March 1927[1]

Writing for *Young India* in the years following the transfer of khadi's future from the Congress's Khaddar Board to the All-India Spinner's Association, Gandhi pointed to the fact that being Indian was no natural matter. Becoming a nation entailed joining disparate groups, linking rich and poor, classes and masses, men and women. Toward that end, proponents of the swadeshi movement created new forms of nationalist dress that visually defined an Indian body as something distinct from both pre-colonial and colonial conceptions. Central to this process was Gandhi's promotion of various kinds of khadi clothing. The clothing that Indians wore, he said, should be neither foreign in style, nor industrially produced. Khadi, a tangible object that could bind people together through the common experience of labor performed on behalf of the nation, was conceived as the ideal material. Though most people in colonial India never adopted khadi habitually, by 1930 there was

little ambiguity about the visual message conveyed by a khadi-clad body. For the international community, the British government of India, and a growing number of South Asians themselves, khadi clothing transformed a colonized body into an Indian body.[2]

The subject of cloth in South Asia has long attracted the attention of historians and anthropologists. Some have argued that "clothes are not just bodily coverings and adornments, nor can they be understood only as metaphors of power and authority, nor as symbols. . . . Clothes literally are authority."[3] Others have suggested that as a "language of commodity resistance" cloth was transformed by nationalists who challenged colonial domination by employing khadi.[4] Still others, who characterized khadi as "the fabric of Indian independence," have highlighted the idea that khadi was both a symbol of India's potential economic self-sufficiency and a medium for communicating to the British the dignity of poverty and the equality of Indian civilization.[5] Most recently, Emma Tarlo has focused attention on the specific contexts in which Indian people have chosen to change their clothing.[6] Tarlo's ambitious study illuminates the extent to which the choice of what to wear did not convey a stable, singular meaning, and that clothing choices should, therefore, be interpreted both as signs of identification and signs of disassociation.[7]

If scholarship on clothing has emphasized the use of apparel in expressing and challenging social identities, it has also emphasized the degree to which identity itself is both mediated and mutable. First, while the way in which one dresses one's body has been commonly understood as a means of announcing one's identification with a larger community, the adornment of the body is not something that is completely in the hands of individuals. Most societies, including South Asian societies, possess behavioral norms of comportment connected to status that limit people's choices. In other words, although clothing should be understood as performative, the relationship between clothing and identity is not completely in the hands of the performer.[8] Second, norms of comportment are far from static, changing over time and communicating various messages, sometimes at the same instant, depending upon specific context. In nationalist India, as Tarlo has argued, khadi clothing both visually bound elite nationalists together and exposed the disparities between the Congress's middle-class leadership and its followers.

Tarlo has successfully captured many meanings associated with khadi during the nationalist period. She describes khadi dress as a form of mourning suit that conveyed Gandhi's sadness for the condition of Indians in South Africa, as a means of cross-dressing that disguised power through mistaken identity, and as a means of exposing the naked brutality of Indian impoverishment under British rule.[9] Her narrow focus on the various meanings that

Gandhi associated with khadi, however, potentially overestimates his agency to the exclusion of others and leaves unresolved the extent to which he had control over what people wore, how, and why.

More general studies on the body as discursive territory also enlighten any discussion of khadi. The modern state, as Michel Foucault observed, is particularly concerned with the disciplining of the body as a means of creating its citizen-subject. The modern period was certainly not, as Foucault tells us, "the first time that the body had become the object of such imperious and pressing investments; in every society, the body was in the grip of very strict powers, which impose on it constraints, prohibitions or obligations." What distinguished the particularly modern view of the body that Indian nationalists, including Gandhi, practiced was the scale and the modalities of control.[10] For both the colonial official and the nationalist reformer in India, the clothed body was understood to express the essence of the subject-citizen; the body's potential to subvert identities defined by those in power was limited only by the state's ability to discipline its subjects effectively. Though their goals were not entirely similar, reformers of the British government of India and Gandhi's swadeshi movement certainly participated in parallel attempts to reform dress as a means of creating subjects who were worthy of colonial efforts in one case and self-government in the other. Khadi was intended to create an "Indian" body distinct from both traditional and colonial bodies. Unlike the dress associated with colonial power in South Asia, khadi clothing announced identification with a community that stretched beyond conceptions of India as had been defined by foreign governments, caste, class, region, and religion. By discarding other forms of dress in favor of khadi, nationalist leaders sought to visually associate themselves with the new "geo-body" whom they claimed to represent.

Yet khadi proved to be an exceptionally flexible symbol, and the effects of the popular consumption of khadi on the negotiation of community remain in question. By looking beyond the *Collected Works of Mahatma Gandhi* to the memoirs, letters and autobiographies of some of Gandhi's associates and their families, we can at once confirm that khadi did indeed bridge particular groups of people, even as it failed to offer such resolution to others. But we can also begin to identify tensions among nationalist elites over khadi and to see how Gandhi's ideas about "India" were contested by many who were both loyal to him personally and unwilling to embrace his swadeshi project in its entirety.

The circumstances in which khadi was adopted and those in which it was not provide important clues about the specific limitations people placed on swadeshi politics, Gandhian ideology and the nation as their community.

By addressing khadi's use—and the unstable nature of its symbolism—this chapter finally points to crises over status that arose with the idea of the nation as the new family.

Modernity and Materialism

Gandhi challenged the legitimacy of Western civilization by exposing the limitations of industrialization and one of its most pernicious outgrowths, modern consumerism.[11] In his estimation, a key reason for the degradation of English civilization was the way in which industrialization had transformed ordinary people into consumers whose desire for goods had enslaved them. Workers in England were forced from working "in the open air only as much as they liked" to working in factories and mines where their "condition is worse than beasts."[12] Gandhi clearly held a romanticized view of India's rural communities, but it is true that industrial workers generally were employed at great distance from the moralizing influences of their families and local communities. Also, although men had been enslaved by force in previous eras, Gandhi found the condition of industrial society far more troubling, believing that the insatiable desire for money and manufactured goods drove men to enslave themselves, to compromise their morality, and ultimately to forfeit their humanity. Gandhi further believed that the moral degradation of the individual would ultimately compromise the society as a whole.[13]

Among the moral challenges facing India as it adopted Western industrialization was materialism, or an overemphasis on bodily welfare. For Gandhi, this problem was encapsulated in the intimate relationship between duty and sexual desire.[14] In his autobiography, he recalls that as his father's health began to fail, it was his responsibility to look after him at night. On one occasion, Gandhi was distracted from this duty by sexual desire. As a result, he was with his wife when his father passed away.[15] At this point in his autobiography, he concludes that control of sexual desire is central to the ability to perform one's duty to one's family, and by extension, to one's national community.

In a very interesting way, the control of desire figured prominently in Gandhi's speeches and writings to women. Gandhi advocated that women adopt the spinning of thread and the wearing of khadi as a means of controlling both sexual and consumer desire, asserting that much of women's consumer desire was driven by their attempts to be attractive to their husbands. Addressing women in his article "The Position of Women," he explains, "If you want to play your part in the world's affairs, you must refuse to decorate

yourselves for pleasing man and revolt against any pretension on the part of man that woman is born to be his plaything."[16] He also warned that adornment promoted not only their own sexual desire but also their husbands'. The implication was that if women could contain sexual/material desire through the adoption of swadeshi politics and khadi clothing, they would be able to fulfill their duty to the nation and enable their husbands to do the same.

In urging women to refrain from wearing not only provocative clothing but adornments of any kind, Gandhi was laying out a method by which women could direct their energies (and those of their husbands) to building national community—but at the expense of social norms associated with "traditional" community. Consider, for example, that a woman's attire generally, and her ornaments in particular, reflected the preferences of the family into which she married. At the time of marriage, a woman commonly received clothing from her natal family and from the family into which she was marrying. Her jewelry, too, might have come from her parents, but it was more likely made for her by her husband's family. Clothing and ornaments were among a wife's few personal possessions and, in the case of ornaments received from her husband's family, were regarded as items she could use, but which remained a part of family wealth. When Gandhi asked women to give up their regular clothing and jewelry, he was asking them to relinquish material links to kin. Thus the adoption of khadi and rejection of adornment was not only a critique of Western modernity, it was simultaneously a revision of "traditional" community in so far as it foregrounded women's relationship to the nation at the expense of relationships to family, caste, or class groups. In an interesting way, "traditional" linkages established through clothing and ornaments had to be severed in order to establish the nation, which was a family in another sense. Sexual/material desire only served to distract people from their duty to the nation. Participating in an economy of desire—whether by making oneself the object of desire or by desiring a particular object—compromised one's dedication to the nation as one's primary community.

The economy of desire was not the only one Gandhi wanted to curtail. He promoted alternatives to traditional styles of dress to combat capitalist consumerism as well. In contrast to the foreign cloth and foreign-styled clothing that he derided as signs of Western materialism and modernity, Gandhi viewed khadi clothing as a great equalizer, potentially binding together a nation that had been torn apart by the impoverishment that accompanied colonialism and industrialization. His solution to the problem of economic dependency, which owed much to the late-nineteenth-century drain theorists and the colonial state, was to reform Indians by changing the ways in which they chose to dress:

The householder has to revise his or her ideas of fashion and, at least for the time being, suspend the use of fine garments which are not always worn to cover the body. He should train himself to see art and beauty in the spotlessly white khaddar and to appreciate its soft unevenness. . . .[17]

In prescribing khadi dress, Gandhi sought to reclaim the bodies of South Asians for the nation in two crucial ways. First, by convincing each person to spin, Gandhi hoped to encourage Indians to be productive in a way that would benefit their national community. Western industrialization promoted productivity of the individual; Gandhi wanted to replace this with labor that was performed for the benefit the nation. Second, by changing people's style of dress, Gandhi sought to reform their consumer habits. For Gandhi, modern consumerism was a threat brought not only by industrial workers, but also by middle-class and wealthy Indians, who fetishized Indian luxury goods at the expense of national well-being. Khadi was an ideal material for a new style of Indian dress because it provided a means of rejecting both Western and traditional norms of production and consumption.

Khadi Clothing and Community

The khadi clothing Gandhi advocated was visually distinct from other forms of dress in two particular ways: texture and color. It was uneven, rough, and heavier than mill-produced or luxury goods. The fact that it was hand-spun and hand-woven was meant to emphasize visually that it was not industrially produced and to represent Gandhi's conviction that people should strive towards self-sufficiency rather than rely upon foreign technologies and people. Khadi, moreover, visually expressed the idea that India should return to non-industrial forms of production to provide a largely rural population with better employment possibilities. Khadi's ideal color, white, was no less significant than its unrefined texture. By promoting the plainest style of dress, Gandhi sought to create a symbol that visually announced the consumer's renunciation of bodily welfare. Devoid of patterns or embellishment, it also directed attention away from "traditional" community and toward a nation defined by hand production. When taken together, the texture and color of khadi symbolized Gandhi's belief that clothing should express common, rather than individual, interests. The distinctly "Indian" body envisioned by Gandhi and his followers was characterized by its labor for the nation, its control of consumption, and its acceptance of equality across classes and communities.

For the British, who similarly understood the adoption of modest Western styles of dress to be a significant part of their civilizing project, the sudden appearance of khadi clothing was shocking. Khadi wares were, as Gandhi put it, "like a red rag to a British bull"; the cloth drew the colonial regime into conflicts it did not necessarily wish to engage.[18] The appearance of khadi was perceived as so threatening that the Gandhi topi, which had gained initial popularity in the 1921–1922 non-cooperation movement, was banned in the remainder of the decade from courtrooms, government offices, and even government colleges.[19] In light of government reaction, selecting khadi became a bold act with clear signification. It was tantamount to rejecting the supremacy of the West and its imperial vision. No less significant, however, was the implication of this dress for "traditional" identities.

If the foreign government created obstacles for popularizing khadi, equal challenges came from those who sought to safeguard the integrity of the family and existing communities. Even in the case of nationalist-oriented families, including the Nehrus, and Congress leaders close to Gandhi, like Sarojini Naidu, the adoption of khadi was initially not easy. In negotiating the challenges that khadi posed, particularly to "traditional" identities, however, local, regional, and individual tastes transformed the plain, coarse khadi that Gandhi and his associates envisioned. Once transformed with the adoption of motifs, color, and patterns, khadi became an increasingly acceptable option for those whose interests lay beyond those of Gandhi, the swadeshi movement, and the Indian National Congress.

Prior to Gandhi's swadeshi movement, a person's attire had signaled his or her precise "communities." This point is evident in a photograph of delegates at the Amritsar meeting of the Indian National Congress in 1919 (see figure 3.1). A contemporary viewer would have perceived distinctions of caste, class, region, gender, and religion—each conveyed through clothing. By contrast, khadi presented a visual rejection of the colonialist view of India as a country of hundreds, perhaps thousands, of distinct communities. Particularly striking is the uniformity of dress visible in a second photograph of Congress workers (figure 3.2). Sarojini Naidu, the Congress president, and two others are the only ones not dressed exclusively in the plain white khadi that Gandhi advocated, clothing that presented another vision of India to the international community, to the British Government of India, and to the people of colonial South Asia. In contrast to the first photograph taken only a few years earlier, India appeared here as a single, disciplined, cohesive community. Khadi clothing implicitly rejected the notion of India as a place too heterogeneous in its population to constitute one nation.

The swadeshi movement sought to create a common visible identity for

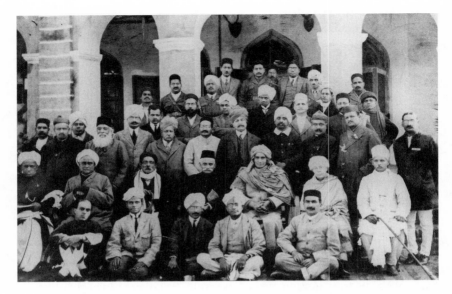

Figure 3.1. Delegates to the National Congress, Amritser, 1919. Photograph pro-
vided by the Nehru Memorial Museum and Library.

Indians by idealizing the kind of laborer who produced khadi in the first
place. Writing about the ideal producer of khadi, Devdas Gandhi wrote,

> the self-spinner has no class high or low. He spins because he takes a pleasure
> in spinning and because he sees its importance, if not to himself . . . to the vast
> masses of the country. He spins in sympathy for the poor. . . . If he has a sister
> or a wife he will make her spin too. And ultimately the womanhood of India if
> they choose would be able to clothe the whole population as they did before.[20]

In writing about the producer of khadi, Devdas Gandhi assumed his subject
was both male and probably middle-class. The nation's ideal citizen not only
contributed his own labor for the nation, he also recruited women—mothers,
wives, sisters, or daughters who lived under his influence—to work in service
to the national community.[21] The "Indian," then, was defined not so much
by labor performed for his benefit or the benefit of his immediate family, but
rather by the labor that he offered the new national family.

Spinning thread and wearing khadi produced fictive kinship between
people who had never and would never meet, and it did so by introducing
new kinds of productive relationships among those who lived in proximity to

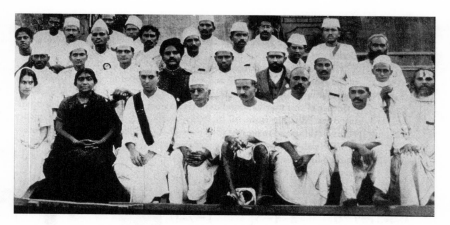

Figure 3.2. Congress workers in South India with Sarojini Naidu, circa 1924.
Photograph courtesy of the Anand Bhavan.

one another. A fictive kinship characterized by laboring for the nation created
new roles for men in nationalist society. Since, Gandhi reasoned, women had
long ago strayed from their traditional roles as spinners, men needed to rein-
vigorate this particular form of labor by performing it themselves. Although
they were not the nation's biological reproducers, they could be producers of
the nation in another important sense. And, by transforming men into spin-
ners, Gandhi hoped to transform other relationships: not only would men
reintroduce women to spinning, they would enable both men and women to
withdraw from industrial production as well. It is not difficult to see why the
swadeshi movement's notion of nationalist labor raised concern even among
nationalist families. Traditional relationships of every sort were threatened.

Despite Gandhi's claim that the adoption of spinning would transform
India's productive capabilities on the broadest level, it was far more success-
ful in providing goods for public consumption and demonstration. Gandhi
topis, vests, and kurtas (shirts)—the most prevalent articles produced during
this period—were among those used visually to make claims of community.
Advertisements from the *Khadi Patrika* of 1926 highlight some of the goods
that were available in Bombay at the Khadi Bhandar or through mail order
(see figures 3.3 and 3.4). Among the goods on offer were everyday forms of
dress including dhotis and shawls. Undergarments, especially men's under-
shirts and underwear, were produced for another purpose altogether. It was
not enough that people refrain from wearing British goods in public spaces
and occasions. Ideally, proponents wanted everyone to refrain from using for-

Width 45"

Single Dhotee measure

4yds.	3½yds.	2yds.
Rs. 2–4–6;	2–4–3;	1–7–0

Thick Wove Quality

yds. ✕ 45" @ Rs. 2–2–6 each

Figure 3.3. Khadi dhotee advertisement, *Khadi Patrika,* 1931

eign materials in their private lives as well. Khadi undergarments—whether for men, women, or children—were, as Foucault would suggest, a modality of discipline; they were aimed at transforming the individual, in this case from the inside out. While khadi was an important element in the visual vocabulary of the nation, it was also a central technology of the nation's development; its force was aimed not only at the world, but also at the reform of the emerging subject-citizen.

Comparing photographs of Motilal Nehru and Mohandas Gandhi, as Emma Tarlo has also done, is particularly helpful in understanding how clothing transformed a body both for the individual wearing khadi and for observers.[22] In the first photograph of Motilal Nehru, Congress leader and father of Jawaharlal Nehru (see figure 3.5), he wears Western dress—more specifically the formal attire of a person of significance in the British Empire. It is clothing for important occasions, like an imperial *durbar* (audience) be-

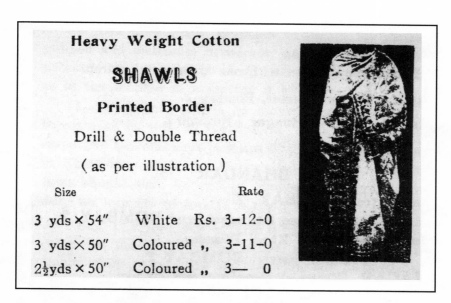

Figure 3.4. Khadi shawl advertisement, *Khadi Patrika,* 1931

fore the viceroy or a visiting prince. The photograph conveys Nehru's stature and status within the British Empire because of both the ceremonial dress he wears and the authority he conveys through his posture. The first photograph of Mohandas and Kasturba Gandhi, by contrast, is both less formal and domestic (see figure 3.6). Gandhi, who is also clothed in Western dress—a suit, collared shirt, and shoes—is clearly an educated person. His clothing is that of a working professional; that is, one can imagine the suit pictured here being worn on a regular basis rather than at a formal event. If Gandhi's professional status is made visible with his Western suit, it is made explicit by his wife's attire. Mrs. Gandhi wears a sari, but one that has been Westernized with the adoption of a high-neck, long-sleeve blouse. Although her husband's clothing tells us that he works in the world of the colonial regime, Mrs. Gandhi's clothing suggests that she maintains a respectable household in South Africa, even thousands of miles away from India. Mrs. Gandhi's presence beside her husband also establishes Gandhi as a respectable family man with a modern outlook.

Two later photographs capture the transformation of these colonial subjects with the adoption of khadi (figures 3.7 and 3.8). The telltale markers of colonial taste and domination—Western coats, hats, and shoes—have

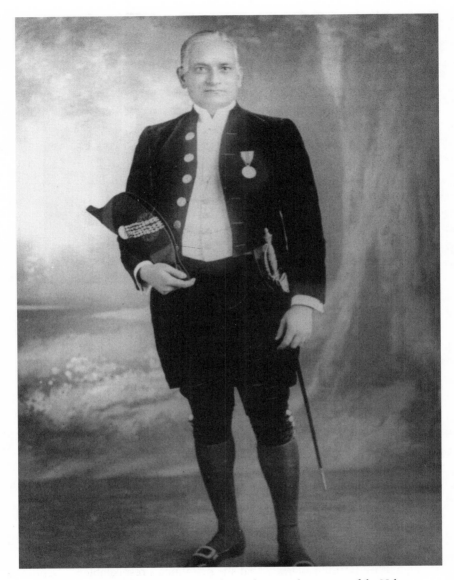

Figure 3.5. Motilal Nehru in Western dress. Photograph courtesy of the Nehru Memorial Museum and Library.

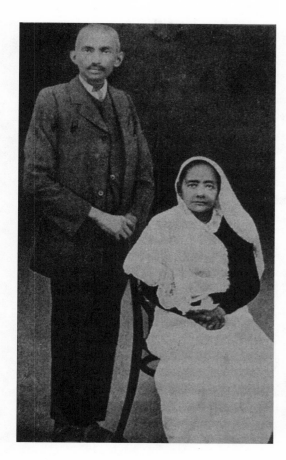

Figure 3.6. Mohandas and Kasturba Gandhi. Photograph used with the permission of the National Gandhi Museum, New Delhi.

been replaced both in style and in material. And so, too, have many of the caste, regional, and religious markers that had been part and parcel of the clothing seen in the earlier photograph of Congress workers. In the case of Nehru, the transformation is particularly striking, as visible in the modesty with which he stands as it is in the material that clothes his body. Khadi not only transformed Nehru's body by promoting national identification at the expense of imperial and "traditional" community, it also subjected him to the authority of the nation. In the second photograph of Gandhi, he appears as a prosperous Kathiawari peasant. An issue of respectability is also in play in this photograph. Note the formal pose and the background of the photograph in particular. Only a notable could afford such a refined studio photograph in this period. Although Gandhi is pictured in a turban specific to a particular

region, the image does not emphasize regional identity as much as it suggests how such identities were redefined as national, or Indian, to be precise. A man dressed in khadi, even an elite native man who had once adopted colonial norms of dress, became an Indian both in colonial and nationalist eyes. In this visual vocabulary of nationhood, the Indian man and the nationalist ideal of Indian identity were collapsed together much as they had been in Devdas Gandhi's description of the patriotic, selfless self-spinner. In both consumption and production, khadi was meant to transform a heterogeneous, Westernized, and elite-dominated subcontinent into a unified Indian and national community.

But when worn by women, khadi's transformative effects were problematic.

Of Poor Women and Prostitutes

The function of women is not to allow themselves to be prostituted by men in exchange for their support, but to be queens of the household . . . running a home efficiently, caring for and educating children properly. . . . steadily seeking to conceive and transmit new, proper, and higher ideals before they come under the influence of others of the opposite sex, all these things represent work of the highest, most important and most difficult kind that can be performed in this world.

—Gandhi, October 1928[23]

The new Indian woman, like her male counterpart, announced her identification with a national community through her clothing. The swadeshi movement, however, provided fewer choices of dress for women. A woman seeking to wear khadi would most likely have to adopt a sari, entailing a major change of dress for those who, like Punjabis, Rajasthanis, or Gujaratis, were accustomed to wearing other kinds of clothing. Across northern India, particularly between the United Provinces and Punjab, many women wore a long tunic and loose pant, known as the *salwar kameez,* while others wore the *churidar,* a tightly fitting pant that was also worn with a kameez (tunic). In India's western regions, Rajasthan and Gujarat, many women before marriage and in rural communities were accustomed to wearing a *chanyo choli,* which consisted of a long skirt, bodice, and long scarf, which covered their

Figure 3.7. Motilal Nehru in khadi. Photograph courtesy of the Nehru Memorial Museum and Library.

heads and midsection. Even for those for whom the sari was a standard form of attire, the khadi sari, particularly in the early part of this period, marked a sharp departure from regional styles that differed in length and featured particular colors, designs, and patterns.

Many women who were willing to embrace the spirit of unadorned simplicity of Gandhi's program expressed their difficulties in adopting khadi clothing to Gandhi and the All-India Spinners' Association at meetings and through letters. One such woman wrote after she heard Gandhi speak about khadi, and was clearly persuaded by his argument, but could not overcome a substantial obstacle to adopting the cloth. Her difficulty was that, as a "poor" person, she could not afford to buy a sari of nine yards, the length which Maharashtrian women like herself needed for a respectable sari. Tarlo analyses this particular exchange with Gandhi by recounting his suggestion that the woman needed to give up her provincial identification in order to gain national status:

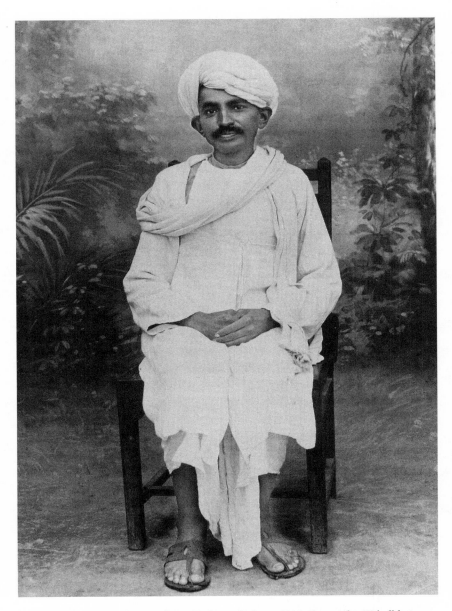

Figure 3.8. Mohandas Gandhi in Kathiawadi dress, 1915. Copyright: Vithalbhai Jhaveri/Gandhiserve.

> Provincialism is a bar not only to the realization of national swaraj, but also the achievement of provincial autonomy. . . . Variety is worth cherishing up to a certain limit, but if the limit is exceeded, amenities and customs masquerading under the name of variety are subversive of nationalism. The Deccani sari is a thing of beauty, but the beauty must be let go if it can be secured only by sacrificing the nation.[24]

To accept Gandhi's response to the woman in this way overlooks the extent to which Gandhi's ideal form of attire was aimed at transforming elite and middle-class nationalists like himself in the image of ordinary people, but not so much the reverse.[25] Gandhi continued his reasoning by arguing that while it "would be very courteous and patriotic on the part of a Gujarati . . . to put on the Bengali style of dress when they entertain Bengali guests . . ." this kind of action "is open only to the patriotic rich."[26] On the one hand, Gandhi's response seems to have taken into account the woman's predicament, namely that the wealthy could make choices not available to everyone. It appears that although the woman's family may have been willing to allow her to wear a plain white sari, as Gandhi advocated, they would not allow her to wear a sari of six yards, which Gandhi's movement was popularizing and would have been more affordable. This was not necessarily a sign of their desire to cling to regional identity as much as it may have been an indication of their desire to maintain status. On the other hand, Gandhi remained silent on the issue of the cost of khadi, which was, after all, the problem addressed in the letter. For women and families who were at the margins of society by virtue of their class position, the adoption of khadi was complicated. Unlike elites whose respectability could be established in other ways, families like this relied upon the dress of women to establish and maintain status. Gandhi's portrait from South Africa, which established Gandhi as a respectable professional of the empire in large part through the modest sari of his wife, is a perfect example.

Gandhi's rejection of traditional norms in women's dress makes greater sense when one considers the context of the nineteenth-century British reform of women's clothing. Until that time, Nirad Chaudhuri tells us, most Bengali women had not worn blouses under their saris. (In fact, "the wealthier a woman, the more transparent her sari" was likely to have been.[27]) Both British and Indian reformers prevailed upon respectable women to do so. Gandhi aimed to accomplish much the same thing, although he proposed to render women respectable by desexualizing them with homespun. Khadi was too thick to expose the outline of a good figure, too heavy to be seen through, and too plain to draw one's attention. In short, Gandhi used khadi as a way of

discouraging Indian men from looking upon women as objects of desire. The adoption of the khadi sari certainly signaled a departure from regional styles of dress and announced one's identification with a larger moral community; the dress of women in nationalist India, in this manner, resembled that of men. But for women and their families, khadi also accomplished something quite different. It made them invisible in a public world that might otherwise have posed a threat.

The khadi sari was not simply an equivalent form of dress for women; it communicated a complicated message, especially when worn by young, married women, many of whom gave up their ornaments, as well, to support swadeshi. The white coarse homespun that women were asked to adopt carried with it multiple, weighty connotations, for homespun had long been associated with the dress of poor women and the dress of India's most reviled person—the widow.[28] How was it that men were transformed into patriotic ideals of national discipline and pride by their khadi garments, while women were asked to adopt a form of dress associated with moral degeneration, weakness, and exploitation?

The fact that Indian nationalists envisioned roles for both men and women in national regeneration prompted Partha Chatterjee to conclude that the "women's question," what role, that is, women should play, had in fact been resolved long before the era of mass nationalist politics. However, the position of women vis-à-vis the swadeshi movement suggests something quite different. By the early 1920s, there emerged a problem for which the nation had not yet found a resolution, as evidenced by the resistance that emerged over the adoption of the khadi sari. The nineteenth-century formulation, "woman as sign of the nation," protected the moral and cultural authority of the nation by carving out a significant private space for women, one that would be safe from Western, colonial intervention. Women's rescue from the public material world was seen as a rescue of the nation itself. If the women's question ever had been resolved, its solution unraveled very quickly, as its requirements could not be reconciled with the realities of nationalist politics that relied upon women's public political participation as a sign of legitimacy. To participate in the nation, women needed to appear in public in news ways.

Perhaps unwittingly, Gandhi's rhetoric on swadeshi presumed, like that of his colonial and nationalist predecessors, that women were objects "of their strategies, to be acted upon, controlled and appropriated within their respective structures."[29] As a result, an important tension can be seen between the idea and practice of women dressed in khadi. For swadeshi proponents, khadi

clothing offered women access to the public. Unlike their male counterparts, whose khadi clothing expressly rejected the desires of Western consumption and materialism and therefore enabled men to become visible as Indians, women's khadi clothing in many ways disguised the problem of desire—and in doing so made women safely invisible. Khadi-clothed women could move safely and legitimately in public, participating in the political life of the nation as the moral force of the nation, precisely because khadi made them invisible as (sexual) individuals.

This reading of the khadi-clad woman, however, was restricted to those who were inculcated in Gandhian thinking, or were persuaded by his politics. Certainly for a broader segment of society, particularly in the 1920s, the women dressed in khadi were not so easily accepted. Indeed, plain white khadi probably rendered a woman too visible in the minds of many. Because of the association of cloth with widowhood, khadi signaled to the general public the moral degradation of women who had fallen, either by virtue of their profession or their circumstance. Nationalist rhetoric aside, khadi clothing marked women; they became *more* visible because of the inherent danger widowhood posed for the moral authority of the nation. This kind of concern is reflected in negotiations over respectability discussed earlier and in those that took place in many households across the country, particularly in the 1930s and 1940s. It is quite likely that among the concerns about a daughter, sister, young daughter-in-law, or wife who might take up khadi was an implicit question about her visibility in khadi and, therefore, both her vulnerability as well as the nation's.

In order to address the chasm between Gandhian ideals and popular concern with the khadi-clad woman, swadeshi's proponents were thus engaged in employing a rhetoric that both theoretically and practically reframed the visual impact of the female body in homespun. It was their aim to transform khadi from the clothing of the weak to that of the noble. As the nineteenth-century debates over *sati* (ritual self-immolation) and infanticide made explicit, women were seen both by colonial and early nationalist reformers as essentially moral, but vulnerable, members of society.[30] By the 1920s, it was impossible to shelter women from the public as Chatterjee's nationalists, including Gandhi, preferred. Indeed, women's moral authority was desperately needed in order to transform the public world of men. Khadi made that possible, if not easy. On a visual level, khadi clothing offered women a uniform that signaled both their safety and their success in the "most important and most difficult" tasks that they faced.

Whether through the spinning of cotton thread, the purchasing of swa-

deshi goods or the wearing of khadi clothing, swadeshi politics, then, offered a practical solution to the nation's predicament. Women were introduced to new tactics that were aimed, at least ideologically, at protecting their safety in the world outside so that they might perform their duties in public.[31] Spinning would provide women with a secure income; financial destitution would, thus, no longer jeopardize the moral integrity of women. As a supplementary occupation for agricultural laborers who made up the vast, impoverished population of India, spinning would provide a small income in times of natural calamity and during off-seasons.[32] Unlike the employment opportunities available in the subcontinent's growing industrial sector, spinning offered agricultural laboring women at least two distinct advantages: it afforded them consistent, if not well-paid, employment, and, perhaps more importantly, it was a form of labor that could be carried out safely within the purview of one's family, or one's national family.

Proponents of swadeshi also often made the case for women's spinning as a solution to the plight of Indian widows because they were among the most problematic persons in the nationalist imaginary; they were evidence of national failure.[33] Widows were of particular concern precisely because they were outcastes, living at the margins of the national community. This was, at least, the ideological assumption shared by proponents of swadeshi. Without the support of their husbands or family, widows were forced into begging for their livelihood. Once transformed from a beloved into a beggar, what would prevent them from prostituting themselves? Gandhi observed:

> Widowhood imposed by religion or custom is an unbearable yoke and defiles the home by secret vice. . . . So long as we have thousands of widows in our midst we are sitting on a mine which may explode at any moment. If we would be pure . . . we must rid ourselves of this poison of enforced widowhood.[34]

Gandhi was not alone in this view. By 1928, officials of princely states like Mysore and Hyderabad echoed Gandhi's conclusions. The finance minister of Hyderabad, for example, delivered a speech at a Co-operative Conference in which he explained that

> respectable widows who have no other means of livelihood used to support themselves and their children by spinning and sewing. By popularising this occupation, you would not only augment the slender resources of the people but by providing them with useful work for filling their spare time save them from falling prey to many a temptation.[35]

For nationalists, the nation's very authority and legitimacy were threatened by the problem of impending prostitution.[36] All women were potential widows and, therefore, potential prostitutes in the nationalist imaginary. This was a danger that every woman confronted regardless of her class or caste, religion or region; it was a problem that increasingly defined women's relationship to the nation. Proponents of swadeshi envisioned women's spinning as a way to transform the most vulnerable, most dangerous part of society into accepted, productive members of the national community. As Gandhi explained,

> While . . . the earning for the spinner is to be despised by the best peasants of these villages, it is the sole support of many widows. There are some hundreds of them among our spinners who but for spinning will be reduced to begging. To these people, our Khadi work has been no less than a social revolution, for from being unwelcome and despised dependents they have become independent and valued members of their villages.[37]

A woman dressed in khadi could be seen as the keeper of the less fortunate parts of a larger national community. "Every yard of Khaddar you purchase means a few coppers in the hands of those women," wrote Mahadev Desai while on a khadi tour in Bihar.[38] A woman wearing khadi was representative, at least in the nationalist imaginary, of a bond between India's rural poor and middle classes. Spinning khadi also provided a means for middle-class women who were deemed unproductive in an economic sense to become self-sufficient and to contribute to the well-being of their less fortunate countrywomen. In 1927, for example, the longstanding advocate of the swadeshi movement Urmila Devi urged a group of middle-class women to take up khadi and daily spinning in order to "help the poor of their country."[39] Following her speech, nine women took a vow to spin at least half an hour a day. The sight of a woman in khadi was a visual message that communicated not only the reform of middle-class consumer habits and the preservation of respectability, but also the end to the economic destitution of India's agricultural, laboring women.

Moreover, the khadi-clad woman carried at least one other significant message. The khadi sari came to represent women's escape from a world dominated by the materialism of the colonial world. In the event of widowhood, from which even a middle-class lifestyle offered no security, the value of spinning would be realized; women who could spin could support themselves, rendering them free from exploitation and the probability of

defilement. The moral authority of the sight of a woman in khadi might have been augmented further by the desexualized symbolism of her widow's dress. Women who traversed the boundaries of the spiritual and material worlds by dressing in khadi thus posed neither a threat nor a temptation to the moral authority of the nation and the male subject-citizen. In this regard, the clothing of women in nationalist India entailed more than a subsuming of class, caste, regional, or religious identities. Khadi clothing marked women as beacons of virtue, culture, and authenticity—as the desexualized partners of the Indian subject-citizen. In an article entitled "The Function of Women," Gandhi elaborated that

> not only married women, *any* girl, with the proper guidance, can transmute her sex appeal, much or little, into a powerful inspirational force for good or evil, with the results limited only by the height of her ideals, the character of her personality, the degree of her beauty, and her ability to make contact with the proper type of men.[40]

The degree to which khadi allowed women to radically change their participation in the nation in part by transforming their manner of dress is nowhere more apparent than in a photograph of Krishna Huteesingh and Kamala Nehru taken in 1930 (figure 3.9).[41] Faced with sweeping government arrests of the Congress leadership across the country, a sister and the wife of Jawaharlal Nehru took it upon themselves to carry out public protests planned by the Congress. In preparing to march through the streets of Allahabad and hoist the khadi charka flag, Nehru and Huteesingh appropriately dressed for the occasion. Either one of these women might have chosen to wear a khadi sari; both certainly did so on numerous other occasions. However, on this occasion, the young married women made another choice altogether: they opted to wear khadi—but men's clothing rather than women's.

We cannot be sure why this choice was made, but it is worthwhile to consider a few possibilities. Both Nehru's and Hutheesingh's husbands were in prison at the time, as were most of the male members of the Congress leadership in Allahabad. Perhaps they sought to avoid calling attention to themselves as *women* in the public protests they were leading. Perhaps wearing a khadi sari without the protection or presence of male members of their (national) family would have made them targets of particularly troubling police violence or harassment. In other words, perhaps even the khadi sari exposed them in ways that men's attire did not. When dressed in khadi clothing like this, Nehru and Huteesingh not only managed to clearly communicate their affiliation with the Congress, and Gandhi's politics to the public whose

Figure 3.9. Kamala Nehru
and Krishna Huteesingh
in Allahabad. Photograph
courtesy of the Nehru
Memorial Museum and
Library.

sympathies they sought, they may have also found a means of accomplishing this without rendering themselves vulnerable as women. But, like the dress of the widow, it seems that was possible primarily by erasing their visible presence in public, even as the nation increasingly depended upon their action.

In the nationalist imaginary, the potential immorality of women, not unlike the problem of unruly peasants and other outcasts, threatened to undermine the legitimacy of the swadeshi project. As spinners, women could ultimately resume their appropriate roles in the nation not only as spiritual leaders, but also as producers who could penetrate the material world, reclaiming the space dominated by the colonial regime. As women adopted the uniform of the widow—a sign of India's vulnerability in the material world—the image of the simple, white cotton, homespun sari was transformed from the dress of the poor woman, the widow, and the prostitute into the dress of the "new Indian woman."

The Khadi Body in Question

Despite the nationalist hope that khadi clothing would transform South Asians into a distinct, cohesive community, this particular style of dress did not produce a nation of whole cloth. Instead, khadi clothing was a medium through which issues of community were contested and negotiated. As khadi clothing and swadeshi goods became available in the marketplace, new questions about the relationship between local and national identities were raised. It was not so much that the idea of being Indian was unthinkable, but that it was unclear what adopting Indian identity through attire might mean in terms of other local identities, be they regional, religious, gender, caste, or class.[42] Could one, for example, be Indian and Muslim? Could one maintain one's regional or caste identification and adopt this "Indian" style of dress? What did this new national dress convey about the relationship between men and women? In short, what did becoming "Indian" mean to ordinary people who considered spinning, weaving, buying, and wearing khadi?

From the very beginning, popularizing khadi was neither as easy as proponents had envisaged, nor as clear-cut as their statements might suggest. Despite a rhetoric that initially disparaged materialism, some nationalist leaders, like Jawaharlal Nehru, opted to distinguish themselves by wearing luxurious versions of khadi cloth. High thread-count, luxury fabrics, elaborate designs, colors, and prints were elements of the swadeshi clothing worn by others, including Sarojini Naidu. These options, however, were wholly dependent upon an individual's ability to buy expensive clothing that was far beyond the means of the rural and working poor with whom Gandhi associated homespun. By the mid-1920s, these compromises were not only common among India's political elites, they were in time institutionalized by organizations that promoted the revival of khadi. As khadi became the ideal clothing that defined "Indian" bodies, many traditional and luxury items were enveloped within the category of "swadeshi goods," and the role of khadi in addressing the vast disparity between rich and poor became yet more complex.

Significant personal identities—namely, those of caste, class, region, religion, and gender—were precariously balanced through the use of khadi clothing within the visual vocabulary of nationhood. To the extent that khadi became a sign of Indian national identity and marked bodies as distinctly Indian, examples drawn from accounts of people who adopted khadi shed light on the ways that the meaning of khadi was shaped not only by the proponents of swadeshi, but by those who embraced khadi on their own terms.

By revealing the ways in which people lived with their swadeshi principles, these fragmentary examples suggest that the making of the "Indian" body was a process that often followed local innovation, rather than—or in addition to—institutionalized, nationalizing ideology.

Particularly in the early 1920s, homespun was hard to find in most marketplaces. Those who spun or produced cloth at home did so primarily for their own use, rather than for profit. More significantly, the khadi available in the marketplace was more expensive than mill-made cloth and often of comparatively poor quality. This meant that it was particularly hard for working people to afford it, even if they could find it in their local bazaar. Many detractors criticized khadi as an unlikely choice for those with limited incomes.[43]

The cost, availability, and poor durability of khadi clothing were not its only problems. For urban and middle-class people, khadi clothing was a choice that compromised important markers of social status and community boundaries. Perhaps the single most common experience among those who adopted khadi during this era was conflict within the family over their choice of dress.[44] Parents, in particular, were reluctant to allow their children to take up this rough, plain clothing. Who could tell in such clothing that a young woman was from a Maharashtrian family? If dressed like an agricultural laborer, how would a young man be identified as a judge or a member of the exclusive gymkhana? How could parents be expected to arrange a suitable marriage if their daughter wore the dress of a poor widow? While many still opted to take up swadeshi clothing, they did not necessarily embrace the style as Gandhi and his khadi workers envisioned. Even among swadeshi's greatest proponents, the original conception of khadi clothing left much to be desired. Two case studies illuminate the ways in which class identification managed to assert itself as a visible part of the nationalist body dressed in khaddar.[45]

Among Gandhi's closest associates were Sarojini Naidu and Jawaharlal Nehru, both of whom challenged the swadeshi dress code from within the Indian National Congress. Naidu was already a well-known poet and member of the Congress before Gandhi entered the nationalist political scene in 1915.[46] She was a prominent supporter of women's educational reform and regularly participated in campaigns to popularize spinning as an integral part of national regeneration. It is noteworthy that she did not habitually adopt the simplest attire even when she regularly spoke to women's groups or met with khadi workers to promote the movement.

In pictures of Naidu at Congress functions throughout this period, she

rarely appears in a white khadi sari. When she did wear khadi, she preferred to dress in boldly colored saris, usually silk rather than cotton. In reviewing Naidu's personal correspondence, it is clear that she routinely chose her attire from a wide variety of expensive traditional textiles, and Naidu's biographers all mention her penchant for beautiful things and her great sense of personal style. It is no wonder that homespun did not capture her imagination. Upon occasion, she expressed her distaste for khadi's limited aesthetic value, arguing for an expanded idea of swadeshi:

> How many have considered the romance and adventure of Swadeshi? Many people think that Swadeshi means making yourself look perfectly ugly by wearing the most unpleasing texture and colour of cloth, the more unpleasant it is, the higher the Swadeshi! But I have quite a different definition of Swadeshi. For me Swadeshi begins, maybe with Gandhiji's charka, but by no means ends there. For me it means the reviving of every art and craft of this land that is dying today. It means the giving of livelihood again to every craftsman—the dyer, the embroider, the goldsmith, the man who makes tassels for your weddings, the man who makes all the little things that you need for your home. All these dying industries—which Mahatmaji has called "the small unorganised industries," are awaiting the magic benediction of your hands to bring again livelihood and living chance to thousands upon thousands of those who today, for lack of a little initiative or a little help, are among the unemployed and the desperate of your country. For me, it means the renaissance of all our literature, the revival of our music, a new vision of architecture that is in keeping with our modern ideas of life. It means for me a kind of experiment that explores and exploits every resource within the country. It means to me the spirit of Indian nationhood. . . .[47]

Naidu's view of swadeshi was clearly broader than Gandhi had ever intended. In addition to limiting consumption, Gandhi specifically called upon elites to resist the purchase of luxury goods. Yet Naidu's approach was quite different. She was not as concerned about the moral degeneration that Gandhi associated with luxury goods. Popularizing the handicrafts and traditional textiles of the subcontinent, especially those of great beauty, satisfied Naidu's nationalist orientation.

Although she was devoted to Gandhi personally, Naidu articulated her own idea of nation through a different choice in clothing. She too saw the creation of the nation as a cultural project, but, in contrast with Gandhi's project, Naidu's vision clung to India's traditional textile production in all its extravagances. Sengupta, one of Naidu's biographers, vividly recalls Naidu's love of fineries, commenting that

while preaching the cult of the spinning wheel as a sound economic proposition, [she] did not debar or prohibit the use of anything else which was basically Indian. She donned rich Conjeevaram, Kollegal, Kornad, Murshidabad and Kashmiri silks, and except at times of grave political crises, wore the silks of India more than Khaddar. Even when she wore Khaddar she beautified it by choosing rich colours and dressing neatly and with taste. There was never anything slovenly or hurried about her. *She was aware that it was essential to dress well.*[48]

Naidu envisioned a nation that was distinct because of its beauty and rich textiles; like many people of her era, she did not accept the austerity that Gandhi and his middle-class reformers promulgated. Although she advocated that women take up spinning for the national cause and suggested that they adopt swadeshi goods, there is less evidence that she regularly spun or wore the movement's distinctive dress herself.

Among elite nationalists like Naidu, it was possible to maintain a commitment to the principle of swadeshi by wearing clothing made by traditional artisans. They were able to limit the occasions on which they wore plain cotton khadi in part because they could afford a larger wardrobe; dress was a luxury good, rather than a bare necessity. Conceding to wear the plain uniform of Gandhi's ideal subject-citizen was not as difficult if one knew that one ordinarily had other choices available; regional specialties and brightly colored hand-spun silk were among the options that elites, like Naidu, chose. Their status in society allowed them this remarkable flexibility; whether they were clothed in colored khaddar or in conspicuously expensive luxury goods, their status was, in fact, displayed on their bodies. Thus, adopting khadi did not necessarily mean giving up status, as Gandhi had originally envisioned.

While many wealthy nationalists took to the hand-spun, hand-woven cloth that Gandhi idealized, they did not necessarily adopt the clothing of ordinary nationalists, let alone agriculturists. Jawaharlal Nehru, for example, became the source of serious concern among members of the All-India Spinners' Association by the mid-1920s. Although Nehru was an early convert to khadi clothing, his choice of apparel was distinguished by its exceptional quality and style. Like many of his class, he did not appreciate the low-quality, rough cotton khadi widely available in the early years of the movement, so even though he gave up the Western-style attire to which he had become accustomed, he did not replicate the attire of the laboring classes of the subcontinent. How did nationalist leaders like Nehru acquire the rare, higher-quality khadi clothing? According to one biographer, Nehru reportedly approached the agents of khadi depots and ordered khadi of particularly fine quality.

Emma Tarlo tells us that he asked his father to send him higher-quality dhotis and kurtas while he was imprisoned.[49] Searching out and purchasing high-thread-count, cotton khadi was certainly not within the spirit of Gandhi's original message. In fact, by mid-decade, these practices drew the attention of khadi's opponents, who seized upon such cases as evidence of the hypocrisy of the swadeshi movement. Gandhi had no choice but to take a stand on the issue. When a devoted follower presented him with a gift of particularly fine cloth for a dhoti during one of his khadi tours in 1927, rather than responding to allegations being leveled by his critics at Nehru's expense, Gandhi accepted the high-count cloth that had had been presented only to auction it off for funds to benefit khadi programs in the region.

Though the difference between regular khadi and the exceptional variety Nehru routinely wore would have been a visible marker of his status to those who met him, it may not have been as recognizable to the agents of the foreign regime against which he was struggling. Nehru reached an important compromise in his use of khadi that became a trademark of the Indian political elite for generations to come. While expressing a shared past through homespun, Nehru also marked himself as exceptional. In doing so, he made sure that his sympathy for the plight of his fellow-countrymen was visible, but that he could not be mistaken for a common person. Nehru's high-count khadi clothing marked him both as a consummate subject-citizen to the nation and as a representative of his nation to the British.

In the context of the wider international community in which the Indian nation was imagined, a cohesive Indian people became visible as more people dressed in khadi.[50] Middle-class and elite nationalists were interested in redefining themselves within the nation in so far as they had to "appear" like the laboring masses of the subcontinent if they were going to claim the status of a nation. Yet, at the same time, it is clear that khadi did not entirely erase evidence of class and status. Rather, the ways in which class was marked changed. No longer marked through European styles and Lancashire-produced cloth, class identification was maintained through khadi clothing that only elites could afford to wear.[51] The Dacca muslins and the Banarsi and Madrasi silks worn by nationalists like Sarojini Naidu provide evidence that some of swadeshi's greatest supporters were reluctant to abandon "traditional" India, even as they sought self-rule. Departing from the strict definition of khadi, they defined expensive, artisanal or Indian-made clothing as swadeshi and maintained their preference for styles of clothing that lay beyond the means of most people in colonial India.

The qualified adoption of khadi dress discussed above was not restricted to the nationalist elite, but was also evident among people from other walks of

life. Gandhi, the Congress Khaddar Board, and the All-India Spinners' Association received correspondence from people who conveyed both the desire to adopt khadi as an emblem of national identification and the problems that they faced in doing so. As has been discussed, many of these problems stemmed from reluctance for women to adopt the plain white sari nationalists prescribed as the appropriate dress of a "new Indian woman." Gender relations in the emerging national community were far from resolved. Three examples illustrate the contestation and negotiation surrounding local initiatives to popularize khaddar.

As early as 1921, Gandhi received a letter from a south Indian lawyer who described his failed attempts to popularize khadi among his community of Tamil Brahmans. He wrote:

> Khadi is not widely used in Tamil province . . . mainly because the women-folk do not wear it. . . . Plain white cannot be worn by married women here. They can only wear dyed sadis. In former times cotton was the only wear of ladies. Now except by the poorest, cotton sadis are discarded, and silk sadis form the daily wear. . . . This presse[s] on the poor Brahman householder, specially as he has to clothe the members of his family only in these. . . . [O]n marriage occasions the minimum cost of a sadi fit for presentation is above 100 Rs . . . This ruinous habit . . . has spread among other classes.[52]

How was the dedicated khadi worker to proceed in the face of such obstacles? The Tamil lawyer's account of his own community was telling. The silk saris worn by women in his community were much more expensive than the khadi saris the swadeshi movement sought to popularize. (The cost of a khadi sari was perhaps one-fifth that of the silk saris presented at such weddings.) The lawyer acknowledged that women in his community were too fashion-conscious to adopt khadi, while simultaneously making clear that his major obstacle in popularizing khadi clothing was the social standards of the community. These norms of comportment, used to make status explicit within the community, made it unlikely that Tamil Brahman women would choose to wear homespun. In part, this khadi worker exposed the practices of the community in order to bring to light the challenges facing swadeshi proponents in overcoming traditional gender roles.

Whether married women could be allowed to dress in white for the benefit of the nation and whether silk was a necessity or a luxury that should be abandoned were questions that could not be answered through the proclamations of a single person, even if that person was Gandhi. Such issues had to be pursued locally, through the sustained efforts of the community itself. In

some cases, communities found answers for themselves. In other cases, the negotiation of gender relations was actively pursued by Gandhi and his workers. Learning from problems in one region, they formulated responses that were exported to other regions as similar contestations presented themselves. It was the relationship between local community ideas and rhetoric that was extra-local in its orientation that provided the space for imagining the nation. Khadi workers sought compromises that could reconcile Gandhi's ideal and community practice. Only by finding such common ground could swadeshi proponents hope to transform Indian society.

Having learned of a specific Tamil community in which an impact could be made, Gandhi appears to have put Chakravarti Rajagopalachariar, his most loyal follower in the Madras Presidency, on the case. Within the year Rajagopalachariar began an aggressive public campaign to break down the social customs that stood in the way of khadi, writing articles and giving speeches that appeared not only in the pages of *Young India,* but in regional papers such as the *Hindu.* Pleading with Tamil women to forego silks and turn to khadi, Rajagopalachariar asked them to celebrate openly their affection for Gandhi and the late radical Maharashtrian nationalist Bal Gangadhar Tilak by dressing in khadi clothing. He wrote,

> On the first of August last at the call of the Mahatma the whole of Bombay came out dressed in Khaddar, to pay homage to the great departed soul [Tilak]. Mahatmaji is now in prison. . . . His voice calls out to you now, before August 1st comes, wear Khaddar, the cloth that binds all brothers and sisters of India into one, which purifies and ennobles their soul and will lift them to freedom from the present life of poverty and bondage. If you wear khadi you declare yourself on Gandhi's side. If when he is in prison and suffering you still wear cloth made of foreign yarn, it means you are against him.[53]

Khadi was the cloth of the free nation. As a tool for overcoming domination, it had served admirably, but it also required all people to visually proclaim their allegiances. Rajagopalachariar made it absolutely clear that this was the issue at hand when the women of Tamil chose their dress. Accepting the norms of comportment—which at one time had simply distinguished the Brahman, the upper class, and the married woman—now communicated something else. The clothing of a woman signaled more than the identity of her caste, region or class; it also communicated her relationship to the nationalists and to the foreign government.

Rajagopalachariar did not ask Tamil women or men to take up the drab

white khadi that Gandhi wore. Recognizing that white cotton saris were un-
likely choices for women in the Madras Presidency, Rajagopalachariar asked
them to compromise. He asked them, at the very least, to give up silk for
cotton, and he pointed out that colored khadi was available. In this, his words
stand out in the extant historical records, but we cannot assume that he was
the single force who may have turned the tide in Madras. Ordinary people
undoubtedly played some role in amending the kinds of swadeshi clothing
available. Perhaps their initial refusal to take up the drab white cotton khadi,
and their adoption later of more colorful, designed, smoothly textured cotton
and silks, are evidence of their will. They likely formed, even if in some small
part, the kind of answers at which Rajagopalachariar arrived. After all, the
Madras Presidency became one of the highest khadi-producing and khadi-
consuming regions of the country.

Like the Tamil Brahman women who were not keen to adopt plain khadi,
village women contested the way Gandhi and his movement prescribed
khadi, and negotiated a more limited adoption of the clothing. At a meeting
with Gandhi in 1925, Gujarati women expressed their ambivalence, saying,

> We will [wear it], but it is rather difficult to put up with coarse Khaddar, replied
> one of the women. It interferes with the digestion. And you know we eat very
> coarse food, not easy to digest. Besides we might wear Khaddar but not our
> young girls. They have yet to marry and they must have the stuffs.[54]

While initially suggesting, like so many other women had before, that khadi
saris were simply "impossible" to wear, these women also explained that the
thick, coarse cloth might impair their health. Was this a direct challenge to
Gandhi's rhetoric that cotton khadi was more suited to the Indian climate
than silks or machine-manufactured cottons? Even as they conceded to Gan-
dhi, who sat before them, that they would take up khadi, they refused to
advocate that all women in their community wear it. If these women were
not directly rejecting the clothing of the reformed widow and the new Indian
woman, they were certainly protecting their "young girls" from what they
perceived as a danger associated with such dress. Though they might support
men's decision to wear khadi by purchasing and spinning cotton, they did
not believe men and women were equally suited to employ khadi as a visual
signal of their political aspirations. Or perhaps they were uncomfortable with
the way the new nation was impinging upon their community?

The Nehru family also found itself at odds with Gandhi and the encroach-
ment of nationalist politics into family affairs. The issue arose after Jawaharlal

Nehru's elder sister, Vijayalakshmi, fell in love with a young man who was employed as an editor at her father's Allahabad newspaper, *The Independent*. Motilal Nehru was an open-minded man of his time, but he would not allow his daughter to marry his loyal friend, who was Muslim. Vijayalakshmi was, according to her autobiography, sent away to Satyagraha Ashram in Ahmedabad. After nearly a year of a hard, uncomfortable life in Gandhi's community, she agreed to marry the man chosen for her by her parents. Unfortunately, this marriage to a Maharashtrian, similarly viewed as an outsider because of his regional background, was no more accepted by the Nehru's Kashmiri Brahman community than the marriage to a Muslim would have been. The community decided to boycott the marriage functions in protest against the intercommunity union.

Gandhi, who had acted as a matchmaker in this particular case, insisted that the bride wear khadi for the ceremony and refrain from jewelry of any kind. Vijayalakshmi recounts her mother's reaction to Gandhi's pronouncements on her wedding attire:

> Mother could not have been more angry. She . . . could not understand his Politics, and certainly did not think he had the right to advise the family on personal matters. . . . She felt intuitively that this man was the enemy of her home. . . . Khadi at that point was not only coarse, it was . . . very ugly.[55]

Like the women in the Gujarati village who were willing to adopt khadi themselves but unwilling to make their unmarried girls do the same, Mrs. Nehru's reaction was at least partially founded upon specific ideas about who could properly transgress the boundaries of community. Her daughter should not think of marrying outside her Hindu community, and yet it was perfectly acceptable for Motilal Nehru to arrange for exactly that less than a year later. Similarly, her son and husband might adopt the khadi clothing for political reasons; they were, after all, public men. But the suggestion that her daughter wear khadi on the occasion of her wedding jeopardized both her and the status of the Nehru family. Like so many parents in the nationalist period, Mrs. Nehru may have viewed khadi clothing as a threat to everything that she understood about herself and her community identity. Khadi was acceptable as a uniform one donned while in public, but it was not the stuff of the well-appointed home and the family. Moreover, Gandhi's demand that the bride wear khadi was received as a trespass of national concerns into those of the family and traditional community.

Motilal Nehru gave in to Gandhi's request about his daughter's wedding

attire, but on the occasion he also presented his daughter with 101 silk saris and several pieces of family jewelry for her married life.[56] What his wife had to do with this specific decision is impossible to say, but given Vijayalakshmi's account of her mother's reaction, it is likely that she and Nehru agreed upon the limits of khadi clothing with regard to their private family life. While remaining a supporter of khadi in his public life, even as he departed from all of Gandhi's political strategies, Motilal Nehru did not assume that his daughter's married life would be the same as his public life. Indeed, the trousseau that accompanied Vijayalakshmi suggests exactly the opposite.

Conflicts and contradictions between the ideology of swadeshi and its practice were not insignificant. In negotiating a compromise that would reconcile, however temporarily, local, familial sensibilities and the nationalist program, consumers of khadi were often the driving forces behind important innovations later institutionalized by the All-India Spinners' Association. As we have seen, the community markers, which were supposed to be entirely erased by khadi, did not disappear as much as transform. Class status, though no longer marked by Western styles, became discernible in the kind of material a person wore. Artisanal goods and high-count cotton remained two of the most dramatic markers of class in the clothing worn by elite supporters of khadi.

New Bodies, Indian Bodies

Lancashire cloth is a symbol of our helpless exploitation whereas khadi is the symbol of self-help, self-reliance and freedom, not merely of individuals or groups, sects or clans, but of the whole nation.

—Gandhi, February 1927[57]

First and foremost, Gandhi's project to transform the bodies of 180 million South Asians was intended to create an irreversible bond between the urban elites and the rural masses.[58] Such a connection required more than a return to traditional norms of comportment; it entailed the creation of new kinds of dress. This is not to suggest that the styles of khadi clothing that became available in the subcontinent's marketplaces were entirely new. Neither was the kind of cloth available new, nor were the methods of textile production. What was distinct about khadi dress was the *meaning* attributed to it begin-

ning in 1921. Khadi clothing was no longer the clothing of India's rural and working poor; it had been effectively transformed into the clothing of Indians. Khadi, as Gandhi made clear in 1927, was a symbol of India's long path from colonial domination and dependency to liberation.

Although Gandhi continued to treat khadi as a superior choice, he clearly accepted the transformation of swadeshi into a broader concept because it drew people together. Khadi clothing definitely marked bodies as "Indian," and it did so with increasing success because a broader swadeshi outlook encouraged a national consumer orientation. As the definition of khadi clothing shifted from extremely plain and rough material to articles that varied in color, weight, pattern, and design, Gandhi's original ideals were tempered. Once khadi became defined as any cloth—cotton, wool, or silk—that was made of hand-spun thread, it was successfully associated with the Indian upper and middle classes, who presented themselves as the consummate subject-citizens. Elites, whether urban or rural, used khadi to distinguish themselves as ideal subjects who were qualified to represent the emerging nation. In adopting khadi of high-count cotton thread, silks, or brightly decorated cotton, they reconciled their need to associate themselves with the laboring poor of the country without compromising their dominant position in society.

The re-dressing of nationalist bodies—particularly elite men's and women's—was a proposition whose promise was only partially fulfilled. Khadi clothing made it possible for elite men and women to ally themselves with the masses; imagining themselves as Indian was a crucial step in transforming their identities. This clothing made it possible for others—Britons and villagers—to see them as Indian as well. Men who replaced their Western dress with khadi clothing visually expressed their autonomy from the colonial regime and announced their affiliation with a national community in which class, caste, regional, and religious identities had been subsumed. However, as we have seen, this transformation was not evenly undertaken by all. As the clothing habits of Jawaharlal Nehru suggest, khadi clothing continued to distinguish some nationalist men from others. Differences in quality of thread count betrayed the universal promise of the swadeshi movement.

The limitations of khadi clothing for women are no less revealing in evaluating khadi's efficacy. For women, who had never adopted the clothing of the West to the same degree as men, dressing in khadi was nevertheless quite significant. If the nation's legitimacy was founded upon women's moral authority, khadi clothing announced women's escape from the threat of impending prostitution. By wearing khadi clothing, the "new Indian woman" made her economic self-sufficiency visible and, by extension, signaled the

material independence of the nation that she embodied. Unfortunately, the possibilities of khadi and the Indian body came at a cost sometimes too dear both in terms of resources and in terms of respectability for all to embrace. Even as the khadi-clad body emerged as "Indian," the many limitations of the nation were also made visible in who was able to don the uniform of the nation and who was not.

4

RITUALS OF TIME
The Flag and the Nationalist Calendar

A mile long procession wended its way through crowded city streets to swell the gatherings at Azad Maidan [a large open space].

The procession which began at the Congress House proceeded through Vithalbhai Patel Road, Bhuleshwar, Kalbadevi . . . and poured into the Maidan.

The procession was headed by a pilot car carrying a huge National Flag. This was followed by eight bullock carts, on one of which was mounted a giant charkha. Groups of volunteers were sitting on the other carts, plying the charkha.

A Muslim procession headed by a large contingent of Red Shirt volunteers and others joined the procession near the Congress house. Several bands and bhajan mandals [groups of devotional singers] brought up the rear of the procession.

Crowds of the enthusiastic spectators lined the city streets, and crowded in the windows, balconies and terraces throughout the route. Many of these joined at the rear of the procession and marched to the Azad Maidan.[1]

An article from the *Bombay Chronicle* on January 27, 1940, thus recounts the celebration of "Independence Day" and provides a glimpse into one of the most striking features of nationalist India: its ritual holidays.[2] Between 1920 and 1945, swadeshi proponents created an annual calendar comprising more than four dozen new holidays that challenged colonial authority by refiguring time for their own purposes. Central to the popularization of the new calendar was the khadi charka flag, which Congress workers marched through busy city streets and hoisted at gatherings in large open spaces. Colonial officials felt compelled to act and eventually developed intricate

protocols that were designed to curtail the public celebrations, but that inadvertently reinforced the very nationalist calendar they sought to proscribe.[3] People watched these celebrations from their homes and workplaces and commonly joined processions that took them from their neighborhoods to a city's central meeting grounds, such as Bombay's Azad Maidan or Chowpatty Beach. Such public demonstrations, ritualized through predictable sequences of events, challenged colonial authority by providing common temporal and symbolic experiences across British India.

Conceptions of Time

The reform and control of time were important both to imperial policy and Gandhian thought. The late nineteenth century witnessed a variety of imperial efforts to render India more productive through the regulation of time. Not only did the government devote significant resources to measuring India's economic progress, as was the case with the annual report *The Moral and Material Progress of India,* it also tried to reform the ways in which its subjects made use of the hours in their days. For example, the massive building projects that characterized the last twenty-five years of the nineteenth century produced town halls, which typically sported clocks by which the public could coordinate its daily business and the regime could dictate time-work discipline to its subjects. The colonial government also placed emphasis on the Georgian calendar (which was eventually revised to reflect some native holidays) in an effort to alleviate the absenteeism that plagued India's industrial centers. After 1891, gazetteers published a list of some fifteen holidays from which workers were allowed to select five or six.[4] The list included not only Christmas Day, Good Friday, and the Queen's birthday, but also sanctioned religious and regional celebrations like Diwali, Mohurrum, and, in Bombay, Coconut Day. Colonial officials in India, as in other parts of the British Empire, believed that the project of civilizing foreign subjects depended upon instilling a more formal temporal structure.[5] Only greater productivity would enable colonial subjects to benefit from the rising living standard and access the modern consumer culture that were the hallmarks of progress and civilization.

Gandhi too believed that Indian society needed to be more productive if it was to realize its independence. While his conception of progress and productivity varied greatly from that of the British government, he also undertook to reform people's use of time. The rigorous daily schedule of the ashram community at Satyagraha offers one example. Ashram members

were expected to maximize their contributions to the community at large. Their day started well before sunrise and was broken into periods devoted to specific tasks: prayer, communal chores, spinning, eating, and the like. It is no wonder that Gandhi referred to the members of his community as "inmates"; he certainly expected them to live a strictly regimented life.

Following the adoption of spinning as a central project of the ashram, Gandhi urged all Indians to devote one half hour each day to spinning yarn.[6] It was his contention that if everyone, regardless of status, labored on behalf of the nation, India would attain the local self-sufficiency upon which it could then build meaningful political autonomy. Although he could not hope to impose the rigorous schedule of the ashram on society at large, the half hour of spinning was a more reasonable cultural expectation. By 1924, Gandhi had successfully convinced the Indian National Congress to adopt the spinning franchise, by which party members could exercise their voting privileges only if they appeared in khadi clothing at meetings and if they produced two thousand yards of hand-spun thread per month, an amount arrived at through calculations based on spinning for half an hour per day. Each day and each month, Congress members thus derived their right to participate in the political body through the labor they performed for the national community. The spinning franchise was short-lived as a Congress policy for the variety of reasons discussed earlier, but it nonetheless reflected Gandhi's conviction that time should be used neither for individual profit nor for material gratification, but rather for building community bonds by sharing scant resources and responsibility for one another. To promote his ideals, not only of a common Indian purpose but of a properly nationalist use of time itself, Gandhi and other proponents of swadeshi also deployed a powerful device: the khadi charka flag. As often as possible, in their public protests and activities, in the celebration of nation-building events, and wherever khadi was exhibited, they hoisted their symbol of the new India over the crowds.

Nationalist historiography has commonly misconstrued the origins of the khadi charka flag in a few significant respects. Gandhi was not the exclusive designer of the flag as is popularly believed. In 1907, an "Indian National Flag" had been unfurled by Madame Bhikaiji R. Cama at the International Socialist Congress in Stuttgart, Germany. Perhaps derived from a flag hoisted earlier by revolutionaries associated with the first swadeshi movement in Bengal, Madame Cama's flag comprised three horizontal stripes of red, yellow, and green. On the top (red) stripe were eight white lotuses. In the middle (yellow) stripe, "Bande Mataram" (All hail Mother India) was written in Hindi. The green strip on the bottom had a white sun on the left and a white crescent and star on the right.[7] The flag that Gandhi proposed drew

upon this flag and others that were being used in the first two decades of the twentieth century.

Gandhi had been aware of the need for a nationalist flag for over ten years prior to his presentation of a flag during the non-cooperation movement. The basic design for that flag had come from a South Indian student who had been lobbying Gandhi and the Congress and had produced several booklets on the subject. Gandhi's main contribution to the design of the flag that became popular in the 1920s and 1930s was his addition of the spinning wheel at its center and his insistence that it be made exclusively of homespun. Gandhi played a significant role, then, in creating the khadi charka flag, but he was not the sole creator of the symbol that captured India's attention during the nationalist period.

Finally, although Gandhi first introduced the khadi charka flag during the non-cooperation movement, he was unsuccessful in persuading the Congress to accept the emblem as its own for nearly ten years. So great was Congress's ambivalence that the Working Committee convened a "Flag Committee" in 1929 to come up with an alternative symbol. The committee proposed several other designs that they felt better reflected the values of the Congress as a whole, yet after testing these they found that none was as popular as the khadi charka flag—which, after all, swadeshi proponents and Congress workers had been using in protests and meetings for nearly a decade. As a result, the Congress finally adopted the symbol as its own. The khadi charka flag was first raised as the flag of the Indian National Congress upon the declaration of Independence Day, which was to be celebrated for the first time on January 26, 1930.[8] Its appearance marked a pivotal shift in Congress history. It was on this particular day that the Congress formally changed its political aim from the attainment of self-government within the British Empire, which had guided its leaders since the period of the First World War, to the attainment of complete independence from Britain. Following the Congress's adoption, the design and production of the charka flag became more stable, and so too did its symbolic potential.

The flags used by Gandhi and proponents of the swadeshi movement before 1930 had a variety of forms, but a few characteristics remained consistent (see figures 4.1 and 4.2). First, and perhaps foremost, the flag was always made of khadi in keeping with Gandhi's swadeshi program. As was the case with clothing, the khadi flag's appearance would have greatly contrasted with British flags of the era. The charka flag was thicker and heavier than its rival, and its coarse material would not likely have waved in the breeze as easily as a Union Jack. In the case of its color and form, the flag clearly referenced the earlier flags, including Madame Cama's and that of the moderate home rule

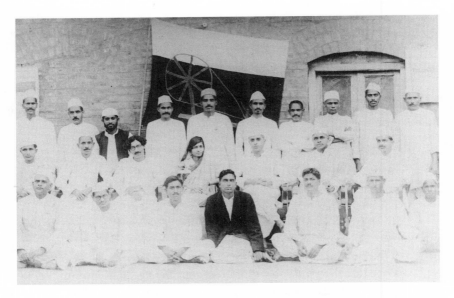

Figure 4.1. Khadi charka flag behind the Nehrus, Allahabad. Photograph courtesy of the Nehru Memorial Museum and Library.

movement during World War I.⁹ These two flags shared horizontal stripes, stars, and a crescent. The khadi charka flag, too, included horizontal stripes, initially two and then, eventually, three: first was a white band, next a band of green, then a red or orange (later replaced by saffron). Gandhi originally defined the colors as representative of India's religious communities—Hindu, Christian, and Muslim—all of whom were bound together as a nation. However, rather than adopting the lotus, crescent, or stars, all of which were associated with religious communities in India, or making use of the Union Jack, as had the Home Rule League flag, Gandhi opted for an emblem devoid of any connection to India's past. At the center of the khadi charka flag was a spinning wheel, the symbol of an India that Gandhi envisioned would eventually be reconstituted through local production and consumption.¹⁰ The bands of horizontal colors used in other flags would certainly have been visually referenced by Gandhi's flag, perhaps confirming continuity of purpose. But, for those still uninitiated in nationalist or Congress politics—the vast numbers of Indians in 1919—such continuities would likely have been lost. Instead, Gandhi's khadi charka flag probably reinforced something familiar about the communities that made up India, as the colors orange and green certainly

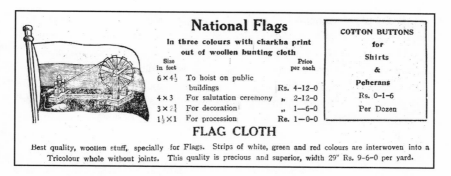

Figure 4.2. National flag advertisement, *Khadi Patrika*, 1931. Used with permission from Navajivan Press.

were associated with Hindus and Muslims, and introduced something novel about the achievement of swaraj through the use of the spinning wheel, a subject about which the uninitiated were soon to hear a great deal.

Nationalist Holidays and the Calendar

The nationalist calendar had its roots in the non-cooperation movement, when Gandhi sought to commemorate the first anniversary of the Jallian-wallah Bagh massacre. Although holidays were added to the calendar in the 1920s, it did not become widely important until the 1930s and 1940s, when local Congress organizations, particularly those closely associated with Gandhian strategies, began celebrating particular days as a way of honoring the lives of national heroes, thereby publicizing sacrifices made for the nation by people across British India. Lajpat Rai, Bhagat Singh, G. B. Tilak, and Mohandas Gandhi were among the many whose personal sacrifices were celebrated with new holidays.[11] In the case of Gandhi, a whole set of new celebrations came into being—marking his arrests, incarcerations, and even his birthday.[12]

In advance of the day chosen to celebrate Lajpat Rai, swadeshi proponents used political pamphlets to establish who he was and to explain precisely how he had sacrificed for the good of the nation. In that way, they were able to popularize Lajpatrai Day for those in parts of British India who might not know his name.[13] Consider the following excerpt published in 1932:

> The 17th of November is Lajpatrai Day. It was a police lathi [bamboo stick, often with a metal tip] that killed Lalaji. Saunders was the murderer. The lathi has maimed and killed many even our women and young boys have come under its cruel blow. This is therefore the Day when we should face the lathi. . . . Lalaji in taking the lathi bravely on his frail body lighted the torch of liberty. True to the memory of this great patriot and powerful fighter we must commemorate his death. . . . Citizens must muster strong to do honour to the heroic death of a great patriot.[14]

In this account, Lalaji's sacrifice was not made in isolation. His sacrifice and martyrdom were linked to the activities of others, specifically women and young boys, who had similarly faced the *lathi*. Not all paid the ultimate price, but their sacrifices were nonetheless connected to his. Thus, this pamphlet not only defined Lalaji as a national (rather than regional) hero, it also suggested how the nation's citizens should act on the anniversary of his death—how they too might sacrifice for the nation.

Aside from popularizing a common list of "founding fathers," martyrs, and their sacrifices, new holidays also schooled the public in the brutality of the imperial government and encouraged particular kinds of political protest. Note that the above pamphlet specifically names Lalaji's murderer and references imperial brutality toward women and young boys. To commemorate the Jallianwallah Bagh massacre, for example, proponents not only publicized the particulars of the event, they named a series of days known as National Week, during which people were called upon to perform a variety of activities—to strike, to give up foreign goods, and to take up hand-spinning, all in commemoration of the sacrifice in the Punjab. In order to encourage the use of Indian goods during the non-cooperation movement, swadeshi proponents had created Boycott Week. Each day of this celebration commenced with a flag hoisting and speeches. The public was then instructed to give up a different foreign good, such as Lancashire clothing, British soap, and even British biscuits. Serving as a series of tutorials, this week-long ritual was intended to encourage people to sacrifice for the nation. In all, the range and number of new holidays were designed to make it difficult for people to live more than a few weeks without thinking about the national community that Gandhi and his followers sought to create.

Popularizing the Calendar

The calendar was popularized through a variety of media, including newspaper articles, political pamphlets, and poster art, as well as speeches, songs,

and spectacles.[15] The combination was particularly important in spreading ideas to the main targets of swadeshi and nationalist propaganda, colonial India's middle-class and urban population. Perhaps the most frequently employed strategy was the use of the nationalist and regional press. A few days before Independence Day in 1937, for example, the *Bombay Chronicle* ran a feature story on preparations for the occasion. Typical of these articles were the specifics they provided:

> 6 a.m.: There will be Prahbat Pheries in all the wards singing national songs. The Prahbat Pheries from A, B, C, and D wards will start from their respective places and assemble at the Azad Maidan. . . . 7 a.m.: The procession of the Prabhat Pheries will start from the Azad Maidan. Kalbadevi Road, Bambhakahna Bhuleshwar, C. P. Tank, Vitlabhai Patel Road, and Congress House. The procession will reach the Congress House at 8 a.m. 8 a.m.: There will be a mass meeting on the Chowpatty Sands at which independence pledge will be read in all languages of the City and reaffirmed.[16]

Like other articles and speeches that promoted the holidays, this account not only made clear the activities that would take place, but also outlined a very specific timetable of events.[17] The attempt to schedule precisely the various activities of the participants was not only practical, it was reminiscent of the kind of temporal discipline that Gandhi had established in the ashram and wanted the broader population to internalize. The kinds of community bonds that Gandhi and his followers sought were fostered most effectively when a number of people met, marched, sang, and pledged together; it was simultaneous action that established that India's time had arrived. For those who were unable to attend the celebrations but were able to read or be read to, detailed reports run in the English and vernacular presses offered a chance to experience nationalist time by enabling imagination of the celebrations that had taken place across the city.

Although swadeshi proponents clearly made use of printed materials to popularize their agendas, they were not limited to strategies that depended on a common language or literacy. Reporting on the preparations for Independence Day, an article from the *Bombay Chronicle* explained,

> The selling of tri-colour button flags has become an annual feature of the celebration of Independence Day. This year the selling of the National Flags and the collection of money in boxes has got a special significance. . . . Hundreds of volunteers including ladies will be going in the streets and houses with collection boxes.[18]

This account makes clear that swadeshi proponents and Congress workers prepared their audiences not only through the publication of articles and pamphlets extolling the significance of public celebrations and laying out festival schedules, but also by seeking out people they might not otherwise reach at all. Given that many ordinary people might not have been inclined to purchase or have been able to afford the expense of khadi clothing, swadeshi proponents went house to house to sell less expensive alternatives, such as khadi charka flags in various sizes that could be easily hung from a balcony or carried along in a procession. The sale of flags to residents who lived along procession routes was particularly important because they aided in the visual expression of the celebration. Another way proponents successfully distributed their goods was the door-to-door sale of "button-flags." Composed of small scraps of khadi in the colors of the flag, the button flag, whose colors rather than specific design referenced the khadi charka flag, was not only inexpensive enough for anyone to afford, it offered consumers a less risky way of announcing their political sentiments. The button-flag could be easily concealed and quickly attached to or detached from a button on a shirt. It allowed a person sympathetic to nationalist politics to display khadi with flexibility. One did not have to be, for example, wealthy enough to afford khadi clothing or willing to take the risk of displaying a khadi flag on one's balcony or body, which would draw the attention of the foreign government. Such door-to-door and neighborhood-to-neighborhood sales of khadi clothing, household goods, and flags—whether full- or button-sized—enabled swadeshi proponents in Bombay to raise funds for their projects, distribute emblems of their movement and enter into conversation about khadi and the upcoming national holidays that refigured time for nationalist purposes.

The Performance of Ritual Occasions

As well as using printed materials and going door-to-door, swadeshi proponents devoted significant attention to realizing the nationalist calendar by creating the actual occasions that visually enabled the imagining of community. It was not enough to proclaim new holidays or to publicize them in newspapers and political pamphlets. Swadeshi proponents and, later, Congress workers enacted the calendar by bringing people together where they could experience and witness a community defined by the rituals being performed.

Perhaps the most important characteristic of these public celebrations was that they were empty of activities specific to the occasion they celebrated. So,

for example, although Lajpatrai Day was established to commemorate the martyrdom of a specific national hero, very little about the day itself actually referenced either his actions or the specific circumstances surrounding his death. For that kind of "lesson," proponents relied upon vernacular and English-language printed materials or public speeches. This suggests that swadeshi proponents were not interested in re-enacting Lajpatrai's martyrdom per se, as much as they were interested in using it to create a context in which others could sacrifice or witness sacrifice for the nation.

Whether addressing "Gandhi Day" in October 1932, "Anti-War Day" in April 1939, or "National Week" in April 1941, the records of the colonial regime confirm that nationalist celebrations followed a very similar script.[19] Take, for example, the celebration of All-India Congress Day in 1932. The occasion began with a strike that closed Bombay's major markets, including the Javeri Bazaar, Marwari Bazaar, and Dand Bunder, as well as cloth shops on Kalbadevi, Girgoan and Charni Roads.[20] According to police estimates, one of the evening processions drew at least three thousand people. (Other occasions in Bombay were celebrated in similar manner, but they drew larger crowds of five, ten, and twenty-five thousand, and sometimes more.[21]) At the conclusion of the marches scheduled that day, the hoisting of the flag on Chowpatty Beach provided a shared visual experience that honored not only the particular occasion being celebrated, but also the people who had been drawn together in its presence.

The celebrations were visually consistent in large part because of the display of the khadi charka flag—its salutation and procession, and, usually, its hoisting. The flag was often used first in neighborhoods to draw people out of their homes in the mornings or from their workplaces in the early evenings, creating circumstances in which speeches, songs, and pledges could be shared locally.[22] Having captured the attention of people in a given locale, swadeshi proponents and Congress workers routinely processed the flag through streets, usually on pre-publicized routes. Flag processions in Bombay drew people through the various neighborhoods, markets, and communities that made up the city to a central meeting ground. The flag led marchers through a geography that was both temporal (given the celebration of the day) and spatial (given the ground traversed) and provided the basis for imagining various kinds of community.

Nationalist holidays were visually consistent in one other significant manner. Although the occasions of the celebrations were new, the manner in which they were celebrated was not. In many ways they referenced pre-existing forms of public protest, including the *tanzim* and *sangathan* movements, which sought to define and defend religious community through public

activities dedicated to arousing public opinion. It was not just that the nationalist celebrations used processions, prayers, and song like the tanzim and sangathan movements, but also that the holidays were designed to reform their audience and in so doing constitute community.[23]

Most celebrations used three strategies besides the flag to enable the imagining of community: most involved the taking of a pledge, the most common of which was the Independence Day pledge, or the singing of nationalist songs.[24] Group activities such as these bound together those who shared in the moment; not only did one utter a pledge or sing a song, one's actions were also witnessed by others. In addition, swadeshi workers commonly organized demonstrations, mini-fairs, and khadi exhibitions that followed the rituals surrounding the flag. On larger occasions, like National Week, organizers concluded the celebration with public bonfires of foreign clothes and goods to which onlookers were encouraged to contribute.

The festivals also redefined traditional community as national. Vijayalakshmi Pandit's memoir, *The Scope of Happiness,* captures such a transformation of her home turned national space:

> January 26 was declared Independence Day, and on that morning every year after the historic Lahore Conference, we foregathered on the upstairs terrace of Anand Bhavan to read the pledge, hoist the Congress flag and sing the national anthem. In this ceremony every member of the family . . . which included our servants, was associated and generally the youngest member hoisted the flag. Even when the elders were in jail the flag was unfurled and the pledge taken by those who remained out, and there was a time when Tara and Rita [her daughters] had to have a flag hoisting by themselves. The whole country observed this day in town and village. . . . Men and women gathered together for the public ceremony.[25]

Pandit's characterization—of a holiday Indians began celebrating in 1930, in towns and villages, at home and in public—is borne out by the extensive colonial records on Independence Day, which received particular attention across British India.[26] According to Pandit, Independence Day brought together a national community through a variety of activities undertaken at home. It brought together husbands and wives, nieces and nephews, brothers and sisters, and even servants. Even in families separated by prison sentences, the youngest members of the community could carry out the day's rituals. But, more importantly, such ritual occasions seem to have been a deliberate effort to replace the earlier extended family of traditional India with a new national family. The consistent series of activities built around the display of the khadi

flag made national holidays different from religious or regional occasions that might have been celebrated by the very same people Pandit describes.

The ritual of the national celebrations also produced *memories* of community, which could be a powerful means of linking people across both time and space. Just as Pandit's account of the celebration of Independence Day transformed her family into part of a national community, a 1939 newspaper account of the celebration of Independence Day nearly a decade later linked its celebration with the first satyagraha movement. The article recalled,

> Slogans of "Congress Zindabad" resounding in every ward of Bombay from early morning till nightfall, reminding one of the glorious days of Satyagraha movement, motor trucks flying congress Tri-colour and patrolling the main streets distributing copies of the Independence Day pledge, processions of cyclists going round the city distributing miniature Congress flags, a mammoth procession led by Mr. Bhulabhai Desai terminating in a meeting at Chowpatty, where fifteen thousand citizens took the pledge. . . . 3 hundred municipal schools and the majority of private colleges remained closed.[27]

Just as the sanctity of Lalaji's martyrdom could be shared by those who took the lathi blow, the observance of Independence Day in 1939 linked celebrators to the those who had participated in "the glorious days of the satyagraha movement." One did not need direct experience of the previous event in order to join its community; ritual observance was a means of accessing that experience, even years later. Thus, community bonds could be created not only through direct, immediate experience, but also through rituals that allowed participants to become part of a community across time and space.

Contesting Authority

The celebration of nationalist holidays recast traditional forms of community by challenging the authority of the imperial regime. Government files acknowledge how the emergence of these celebrations regularly jeopardized the maintenance of law and order. The case of Motilal (Nehru) Day, celebrated on one of Bombay's maidans on February 7, 1932, for example, provides a typical example of how disruptive these occasions were for Bombay's head police office:

> An attempt was made to hold a public meeting on the Esplanade Maidan by the emergency council. At about 5 p.m. about 100 persons collected on the Waudby

Road side of the Maidan and one of them tied a Congress flag to a small tree. The police dispersed the crowd and arrested one man who refused to move. The Congress flag was also removed. About a thousand persons scattered themselves in and around the Maidan as spectators. Police parties were posted at strategic points on the Maidan to prevent people from making demonstrations. At about 6 p.m. the three members of the emergency council, accompanied by a flag-bearer and followed by a crowd of about 200 persons, entered the esplanade Maidan from Ravelin Street in the form of a procession. These 4 persons were put under arrest and the rest dispersed. After some time a crowd of about 25 persons with a flag came from Dhobi Talao side but was chased away by the police who arrested the flag-bearer. Another small procession headed by two women with a flag came Dhobi Talao side along the footpath on Cruickshank Road. They dispersed on the appearance of the police but the two women who refused to move were arrested. A crowd of about 25 persons again approached the Maidan from Waudby Road and they were similarly dispersed after arresting 5 of them. A small crowd of riff-raff collected on the Gymkhana side of the Maidan and kept on jeering at the police and shouting boycott slogans. After some time they induced a beggar boy to march to the place of the meeting with a Congress flag. When Inspector Bird of the Esplanade Police Station tried to snatch the flag from him, the beggar sat down and bit the officer on the thigh and hand and became very obstreperous. He was overpowered with the help of another officer and was taken to the lock-up. In all 14 persons were arrested as mentioned above. The police were withdrawn when it was getting dark. The crowd kept on showing for some time in the Maidan and dispersed.[28]

Clearly, Congress workers used scheduled marches to provoke conflicts with government officials that not only led to subsequent legal challenges to imperial authority but also made witnesses of onlookers. In this account we learn that Motilal Day was celebrated through a series of actions involving a wide variety of people, not all of whom were Congress workers. When the assembly planned for five in the evening was dispersed by the police, workers convened another gathering. When police disrupted that, still another Congress attempt to hoist the flag followed. The report also provides evidence that such events encouraged the involvement of bystanders, who reportedly joined in because of what they saw.[29] In the end, it was a beggar boy, cajoled into action, who completed the ritual celebration of Motilal Day by successfully marching a Congress flag to the meeting place. Even as the police overpowered him and withdrew, a crowd of onlookers remained on the maidan.

The detailed police description of Motilal Day reveals two significant narratives about the nationalist holidays. The first may be called a colonial

narrative of authority.[30] As part of the state's effort to demonstrate its efficacy and therefore its legitimacy to govern, most police accounts made specific mention of the series of laws that were violated by celebrators and provided a detailed accounting of the number of people arrested under which charges.[31] The Motilal Day report emphasizes the continued efforts of the police, who successfully disbanded at least five separate Congress-orchestrated attempts to raise the flag. Far from denying the challenges that civil and military administrators faced, the records speak primarily to the state's ability to maintain law and order. Each disrupted nationalist occasion demonstrated the continued authority of the colonial regime.

But the police record of Motilal Day also, arguably, recounts the success of Congress workers and bystanders in undermining imperial authority over time. Despite the organized and sustained efforts of the police, this particular account ends with the implication that the police withdrew their presence *before* the people had been dispersed.[32] The final success of the crowd that lingered suggests that the celebration did take place despite all of the carefully noted police efforts. We can only speculate on the influence of such repeated experiences on a bystander's view of colonial authority. Because the struggle with police had been so lengthy, lasting several hours, one can speculate that many people had witnessed it. Far from being a holiday whose meaning was limited to celebrating the life and sacrifices of Motilal Nehru, the incident may have been more clearly understood as the successful attempt to hoist a flag despite the efforts of the police. For the onlookers, some of whom stepped up to assume responsibility for the celebration, the colonial regime must certainly have left some of its authority on the maidan that evening.

The activities of swadeshi proponents and bystanders were not the only ones that mattered in realizing the Indian repossession of time. In the midst of the Second World War, the colonial government instituted stricter policies for maintaining law and order that had direct implications for nationalist holidays.[33] In a secret letter dated August 2, 1940, the central government laid out its instructions for provincial governments, outlining a series of standard measures that should be taken to protect order at the local level. Active challenges to law and order were to be met with a swift, firm, and consistent hand.[34] Interestingly, these instructions were used to respond not only to large movements, like the India National Congress's quit India movement of 1942, but also to the much smaller celebrations that made up the nationalist calendar. The government itself publicized the ritual holidays nationalists celebrated in an effort to ready its agents across British India to thwart public disturbances, thereby normalizing the nationalist calendar to such an extent that even the state and its officials began anticipating the celebrations and

observing the holidays, if in opposition. In setting up a system to deal with public demonstrations that threatened law and order, the Home Department prescribed specific actions to be taken, thus both ensuring that government officials themselves reacted to the nationalist calendar with increased consistency and producing an increasingly consistent experience for those who celebrated or watched the scheduled holidays. Thus the establishment of nationalist time was achieved not only through the enactment of the new calendar by swadeshi proponents, Congress sympathizers, and bystanders, but also through the unwilling acquiescence of the colonial regime and its agents.

This chapter has emphasized the intentions of swadeshi proponents and Congress workers in performing an alternative calendar, but the struggle to possess time and shape it for the nation, thereby assuming political authority, was not limited to Gandhians or Congress workers on the one hand and British government officials on the other. By the 1940s, colonial records indicate that a range of groups had begun proclaiming their own annual celebrations, sometimes even making use of their own flags made of homespun. These other groups, including working-class organizations in the Bombay Presidency and Communist groups in Bengal, did not subscribe to the same vision of community as Gandhi or the Congress. Perhaps the most striking example of the appropriation of the swadeshi strategy comes from a secret police letter addressing the celebration of Pakistan Day on March 23, 1941, which noted parades and processions much like the swadeshi occasions and drew thousands into the streets in Bombay city alone.[35] Certainly when the Muslim League proclaimed Pakistan Day, it was challenging not only the legitimacy of the imperial government but also the vision of community that Gandhi and the Congress had celebrated. The emergence of these alternatives to the swadeshi calendar further highlights both the importance of transforming time in making claims on authority and the significance of public rituals in the constitution of community.

What does the case of the swadeshi movement and the nationalist calendar tell us about the way Indian nationalist community was evoked through the control of time? Two decades ago, Sumit Sarkar wrote that the emergence of mass politics occurred when a sense of breakdown in the idea of "foreign rule as sacrosanct" was perceived. He attributed this breakdown primarily to "the spread of rumors, potent in their very vagueness about the impending collapse of British rule and the coming of 'swaraj' or 'Gandhi raj.'"[36] Swadeshi proponents contributed to this popular feeling of breakdown through a variety of practices involving the public display of khadi and the creation of a new national calendar. It may be that the sense of breakdown that continued

from the 1920s through the 1930s and 1940s derived not only from rumor but also from the ritual use of khadi to challenge imperial time. To the degree that swadeshi proponents were successful, they prevailed not so much by convincing their audiences of the efficacy of the spinning wheel as through their introduction of a material object that made possible the expression of a range of dissent and visions of community. Although the adoption of khadi emblems and ritual occasions by various groups should not, as Sarkar warned, be read as consensus over what would follow British rule, it can be read as part of the history of a shared visual language through which community could be re-imagined.

Douglas Haynes has argued that historians of modern India need to treat ritual as more than "a form of empty expression, devoid of any real content, a mechanical following of expected protocol."[37] This suggestion is particularly compelling in light of the study of the khadi charka flag and the nationalist calendar—two significant artifacts of Gandh's spinning program and his strategy of attaining swaraj. Because so many forms of political authority had been expressed through ritual in India, ritual remained a critical means of contesting imperial rule and imagining community of various kinds. Swadeshi politics were broadly conceived to transform identities, not only through the use of clothing, but also through the way that people experienced their daily life. An important means of bringing about such a transformation was the creation of a calendar that encouraged common, mass celebrations of particular events, and a visual emblem, which took the form of a flag, that could maintain the public's attention to the causes, concerns, and sacrifices of the nation. Scholars of nationalism have been correct to point out the significance of shared temporal experiences in imagining national community, but they may have focused too much on the role of printed materials, like the novel and the newspaper, in this process. There is no doubt that the written, printed word played a crucial role in the popularization of the new calendar in nationalist India. Of equal importance, however, were public rituals that transformed the way Indian people came to understand their place in time, providing experiences not only of the breakdown of colonial authority but also of the construction of other kinds of community.

5

INHABITING NATIONAL SPACE
Khadi in Public

By marking and filling public spaces with khadi, nationalists and ordinary Indians, less focused on India's identity, expressed both their political aspirations and laid claim to the territory of their community. With the popularization of the Gandhi topi and the khadi charka flag, it became possible literally to see and imagine the Indian nation in new ways. Visual and tangible, khadi objects made community imaginable not only by visually describing its boundaries, but also by providing a shared symbolic vocabulary that could be employed by a range of people. For example, newspapers and government files from the non-cooperation movement recorded the sudden appearance in 1921 of demonstrators wearing a khadi cap, which Gandhi had adopted shortly after his return to India (see figure 5.1).[1] Seemingly overnight, this new form of men's headdress appeared in India's city streets, educational institutions, courts, and offices.

The visual impact of the Gandhi topi had implications far beyond the individual's affiliations. It opened up the way that people could see public space. The confluence of changing conceptions of the Indian body and Indian time provided the context in which public space too could be used in service of swaraj. Physically moving through a city in or with khadi challenged the right of colonial control over public space, making it possible to conceive of public space as national. Khadi caps, that is, visually and physically linked India's public space to a body politic no longer colonial. Moreover, as local governments and associations increasingly displayed khadi on public buildings associated with government, they claimed the power of the foreign

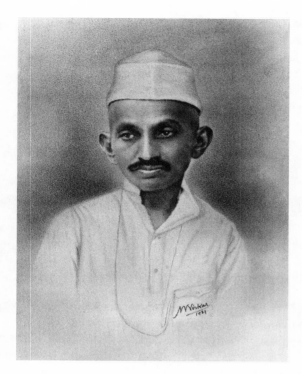

Figure 5.1. Gandhi wearing
the "Gandhi cap," 1921.
Copyright: Vithalbhai
Jhaveri/Gandhiserve.

government for the people of the nation. Imperial control over public space
eventually gave way.

As successors to Mughal authority, the British government of India had
borrowed and expanded upon rituals that defined the appropriate use of
space for their subject population. In turn, nationalists recognized that the
control of public space was essential to their political struggle. Two important
case studies in the years between the non-cooperation movement and the
salt satyagraha follow.[2] The first case study involves controversies over the
Gandhi topi and focuses not only on the multiple meanings associated with
the white cap by its designer, Mohandas Gandhi, but also on the variety of
circumstances in which people adopted the cap. The efficacy of the topi as a
symbol lay in the fact that it was not defined by a single political agenda, but
was employed more broadly, in varied ways, to register dissent. The second
case study examines the marking of public and official spaces with the khadi
charka flag. The use of the flag in public sheds light on the emergence of con-
flicts between the imperial regime and municipal bodies newly empowered

under the Government of India Act in 1919. It was at the local level of governance that native members of the government employed khadi to protest imperial policies and to assert a distinctive identity. Khadi's emergence as a prominent symbol in the visual vocabulary of nationhood depended not only upon the ideologies and activities of middle-class politicians, but also upon the use of these objects by ordinary people in public spaces.[3] It was the ubiquitous use of khadi that rendered a nationalist public visible.

The Public in South Asia

Since the mid-1980s, historians of South Asia have grappled with Jürgen Habermas's concept of the public sphere as a means to explain the emergence of the modern nation-state and the various communities that it came to represent. South Asianists have viewed the transformative nature of a Habermasian public sphere with skepticism, arguing that in a colonial context the public sphere provided a space for exerting power over a subject population, rather than for liberating it from an authoritarian regime. As Sandria Freitag observes, "an imperial state cannot function in the same way as a nation-state, nor can it create a role for its subjects that approximates that of a citizen."[4] South Asianists have alternatively used Habermas to understand the ways in which colonialism altered existing forms of community expression in South Asia and created new forms of authority. In 1991, the journal *South Asia* featured essays on the public sphere that highlighted "the public" as a topic for historiographical contemplation and identified directions for future study. In the introductory essay of this special issue, Freitag acknowledges that there were distinct ideas of the public in late colonial South Asia. It was the tension between arenas of power as constituted through public discourse and the state and arenas created through local activities that, she hoped, would become the focus of future inquiry.

A study of the display of khadi is crucial to understanding the contestation over the public in late colonial and nationalist India. By tracing the ways in which khadi goods were used in public spaces, one gains greater insight into what Pierre Bourdieu called *habitus*—the "immanent law, laid down in each agent, which is the precondition not only for the coordination of practices but also for the practices of co-ordination."[5] The colonial regime in India had particular ideas about public space and how it should be used, ideas that I term an "imperial habitus." These structured the ways in which colonial officials administered the public, the ways in which nationalists challenged imperial authority over it, and, no less significantly, the ways in which ordinary

people experienced and understood their place in it. Analyzing the display of khadi symbols exposes how the public was understood and contested—not only by officials of the colonial state and native elites, but also by people in their everyday lives. Just as Winachukal's concept of the geo-body allows us to observe the Indian nation's emergence from the colonial map, Bourdieu's conception of habitus—which exposes the tensions that arose when public spaces were used in violation of tacit imperial codes—enables us to see how a "national habitus" emerged as khadi was increasingly employed in public space, rendering the nation both visible and imaginable.

Imperial Habitus

By the time the British Empire set its sights on India, political authority in South Asia had been established and maintained for at least several centuries through the building and use of public space. The Mughals had used massive building projects across their empire in part to physically tame their new homeland.[6] Mughal building, whether constructed by the emperor or his nobility, communicated the key values of Mughal imperium across large stretches of the subcontinent, including areas over which the emperor never exercised direct control. The Mughals also used their built environments in particular ways to express relationships of power between sovereign and subjects, as Christopher Bayly and Bernard Cohn have argued.[7] Mughal durbars provided those assembled with visual, ritual experiences that made explicit both the boundaries of the imperial community and the nature of relationships within the imperial order. In other words, the Mughals made use of space, particularly through the imperial cities they built, and visual strategies, including processions and gifting, to communicate both their authority and the boundaries of the imperial community. The splendor and significance of Mughal building was lost neither upon the British agents of the East India Company, nor upon the Crown officials who succeeded them after the Indian Mutiny of 1857–1858.

The British imperial administration likewise made use of space and ritual to communicate its authority to a subject population. Following the mutiny, the government of India began holding its own durbars in order to define and enforce the relationship between the empress and the Indian princes.[8] In addition to these rituals for elite audiences, the government pursued its own building projects in the last quarter of the nineteenth century to communicate its authority more broadly. The transformation of space in colonial India was carried out through projects including the reorganization of important

regional cities, as Veena Oldenberg has shown in the case of Lucknow, the construction of a massive railway system, and the creation of a new imperial capital.[9] Consider, for example, the decisions to move the center of British administration from Calcutta and to construct a new imperial capital beside the old city of Delhi. The colonial government was the sixth political regime on the subcontinent to rule its empire from the vicinity of Delhi.[10] In choosing to build beside Delhi, even though their capital was *new,* the British were drawing upon centuries of political authority associated with Delhi as an imperial capital. Space was designed to promote effective administration of the new colonial territory and to impress upon colonial subjects in different ways the power and superiority of the colonial government. These coordinated efforts refigured space—public, civic, and private—as Thomas Metcalf has argued, expressing Britain's imperial vision.[11]

The imperial habitus of colonial India drew upon the spatial and visual strategies of its predecessors, associating its power with new government buildings, including courts, offices, and corporation centers, and developing an elaborate body of laws designed to ensure the correct use of public space. The investment in rebuilding regional cities, such as Lucknow, allowed the empire to appropriate the traditional prominence of the city and its people to shore up imperial authority. In addition, the construction of the imperial capital outside Delhi both reinforced the authority associated with this former political center of the subcontinent and established Britain as the rightful heir to earlier regimes. An imperial habitus was also communicated to the larger subject population through the building of structures designated for local governance, be they the bungalows of public servants, courts, and police chawks, or the wide thoroughfares, grand viceregal buildings, and India Gate that characterized the new capital. It was the extension of Britain's imperial vision through building at the local level that communicated the colonial regime's authority.

The visual dominance of this imperial habitus was disrupted in the second decade of the twentieth century when the administrative ideology, structure, and composition of governance changed significantly after the Montagu Declaration of 1917 and, more importantly, after passage of the Government of India Act in 1919. As particular administrative responsibilities devolved from the central to the provincial level of government and from executive legislative bodies to their provincial counterparts, dyarchy transformed municipal authority. (Although municipal organizations had for at least sixty years possessed considerable autonomy over local affairs, this autonomy had rarely been exercised in conflict with government policies, in large part because of the composition and orientation of municipal boards.) With greater numbers

of Indians eligible both to vote and to stand for public office, the composition and political viewpoints of municipal bodies changed, making it possible for the Congress and ordinary people to express their political orientation through legal public displays.

Nationalists criticized this system of dyarchy for being politically inadequate—for being a half measure intended to appease Indians rather than to strengthen their political voice—yet the act served in unanticipated and substantial ways to undermine the imperial habitus. Although nationalists generally accepted the structure of the imperial habitus, much as the British had made use of Mughal conceptions of space, visual experience, and power, they also used visual emblems and space to challenge imperial authority. Specifically, their use of the khadi charka flag and the emergence of khadi goods as popular political symbols allows us both to trace the nationalist occupation of colonial space and to suggest how a single symbol came to communicate disparate agendas in an emerging nationalist public.

Filling National Space

On July 14, 1930, Archibald Brockway, a Labour Party member of the British parliament, questioned the secretary of state for India about reports that the colonial government had banned the wearing of the Gandhi topi. The secretary, Mr. Benn, responded vaguely to Brockway's initial question. Clearly antagonized by Benn's seemingly evasive response, Brockway pushed farther. He pulled a Gandhi topi out of his coat pocket and, waving it above his head on the floor of the House of Commons, asked the secretary if "he really considered that the wearing of a simple cap of this kind is dangerous to the British Administration in India?"[12] Brockway's sudden display of the Gandhi topi in Parliament, the most important political space of imperial Britain, reveals how visually powerful this inanimate object had become not only in India, but in Britain itself. In fact, over the course of the 1920s local colonial officials had treated the Gandhi topi with increasing intolerance. In India as in London, the Gandhi topi had emerged as a powerful visual symbol of political dissent.

It should come as no surprise that swadeshi proponents had popularized khadi through the creation of a new cap. As Emma Tarlo has observed, men's headgear was one of the most important markers of community in South Asia.[13] The head was considered a sacred part of the body in many South Asian communities, and, in the course of establishing its formal relationship to its Indian empire, Britain had established elaborate rules for the kinds of

headdress its servants, military and civilian, should wear. For example, the government devoted a lot of attention both to procuring the dress for its civil and military servants and to creating rules that strictly regulated dress among its servants based upon rank. The Gandhi topi was distinctive from both those traditional headdresses typically worn in native communities and those prescribed by government dress codes; it was an "invented tradition."[14] The choice to wear this new hat eventually challenged both traditional norms of comportment and disrupted the imperial habitus.

Tarlo has retold a well-known story of the topi's design through the correspondence included in Gandhi's *Collected Works*.[15] She explains that following his return from South Africa, Gandhi was searching for a cap that was suited to India. He began by considering traditional hats, eventually concluding that

> the Punjabi phenta looks fine, but it takes up too much cloth. The pugree is a dirty thing. It goes on absorbing perspiration . . . and seldom gets washed. Our Gujarati conical Bangalore caps look hideous to me. The Maharashtran Hungarian caps are a little better, but they are made of felt. As for the U. P. and Bihari caps, they are so thin and useless that they can hardly be considered caps at all. . . . [and]the Kashmiri cap is made from wool.[16]

Without directly criticizing regional identities, Gandhi dismissed each one of the existing indigenous hats. Some he ruled out because they were not practical for economic reasons, and others he dismissed because they were hard to keep clean. Still others were deemed unsightly or useless in protecting one from the extreme Indian climate. Eventually, he arrived at a solution. His cap, similar in shape to a Kashmiri hat, would be of cotton to make it more suitable for the Indian climate. The white khadi material would encourage its wearer to keep it clean. It size and style could both be easily folded for travel and "harmonized" with the style of dress in the Indian subcontinent. Moreover, the white cap made of homespun would draw attention to the importance of reviving khadi through its prominent display on the most sacred part the body.[17] The khadi cap, as Tarlo points out, eventually provided "a visual uniformity which had never existed in Indian headwear."[18] Gandhi did not need to directly challenge traditional or colonial norms of comportment in order to disrupt them. The khadi cap visually signaled one's allegiances.

Gandhi's other writings and speeches shed light on the topi's use during the non-cooperation movement. Take, for example, his report of the first conflict over the appearance of the khadi cap. The incident involved a native employee of the Bombay-based *British Steam Navigation Company* who

chose to wear a Gandhi topi to his office in the summer of 1921. Outraged by this expression of "national identity and strength," the British managers enforced the company dress code; the employee was fired without warning. Upon learning of this incident and another similar case, Gandhi registered his criticism in an article entitled "The White Cap" in *Young India:*

> Such insults are more humiliating for nations than physical blows delivered willfully. . . . The two firms dismissed their poor clerks, because they had the manliness to wear their national dress. . . . [T]he proud firms could not break an exhibition of manliness on the part of their clerks.[19]

Gandhi's claims about the meaning of the cap and its broader implications are here quite different from those he entertained originally. Concern for its practical, aesthetic, and hygienic qualities gave way to the expression of national strength and manliness, which became paramount. By controlling the manner in which its employees dressed, the *British Steam Navigation Company* and its agents sought to reinforce the firm's power over employees. In essence, the employee's decision to wear the topi challenged imperial assumptions about power and authority over colonial subjects, even those subjects who worked in the private sector. Gandhi suggested that other Indian employees of the *British Steam Navigation Company* should resist the unfair treatment of their brethren by wearing "the white khadi caps by way of protest and [by] demand[ing] the reinstatement of their fellow clerks."[20] Gandhi had very quickly seized the opportunity to use the cap as a form of protest.

The Gandhi topi became an issue for the colonial government in large part because struggles over dress codes were not restricted to private business, but spilled into both the offices of the provincial administration and public thoroughfares. In July 1921, *Young India* reported that Indian employees of the government in some areas had been explicitly restricted from wearing khadi to the office. Would the government stop at nothing in order to discourage the popularity of the khadi cap? Gandhi asked. The rumors initially reported in *Young India* are confirmed by the government's own provincial fortnightly reports from the period. In early August 1921, the Government of the Central Provinces issued a directive restricting civil servants from wearing the Gandhi topi because it was a political symbol that threatened the government's authority.[21] Gandhi rejected the interpretation of the provincial government, clarifying for his readers the meaning of the cap:

> If the white cap is the badge of the Non-Cooperation party, the use of khadi may be equally regarded as such and penalized. . . . I deny that the use of the

white cap is any sign of Non-Cooperation and yet have adopted the white cap as a convenience and as a symbol of pure swadeshi.[22]

Using this case to raise public interest in the cap, Gandhi also criticized increasing clashes between police in Bombay and khadi cap wearers, decrying the unjust behavior of the Bombay police. He claimed, "Respectable young men had their khadi vests and caps torn from them, and had to witness their being burnt. One man had his cap spat into, and was then forced to wear it."[23] Significantly, Gandhi's response to the government's attempts to discourage the wearing of khadi both in government offices and in public relied upon a discourse of law. He questioned the government's right to determine the clothing of its subjects: if the government was allowed to outlaw khadi clothing, he asked, who would stop it from arbitrarily outlawing other kinds of clothing in the future? By connecting the aggressive methods used by local police to curtail the wearing of khadi both in official spaces of government and in general public spaces, Gandhi questioned the legitimacy of the colonial regime's authority to enforce public dress codes.

Once Gandhi had challenged the government's authority to restrict clothing, swadeshi proponents went to work to quickly popularize various forms of dress for public display, including the Gandhi topi. This kind of political work continued to be a mainstay of swadeshi strategy. Several years after the crisis over the cap in Bombay, the All-India Spinners' Association published a Gujarati pamphlet of khadi and marriage songs, which contains nearly two dozen songs relating to the swadeshi movement.[24] Sung to popular prayer music, known as *bhajans,* the songs provide a glimpse both into the movement's primary audience, women, and into the strategies employed to spread swadeshi ideals without relying upon printed publications and widespread literacy. One untitled song explained:

A foreign turban, it's like a basket from hell.

Those who wear foreign (cloth) turbans, why do you put this burden on your head?

A foreign turban, it's like a miserable person on a corpse's stretcher.

Those who wear foreign (cloth) turbans, you have impoverished minds.

Why do you put a foreign turban on your head, you are destroying your duty with your own hands.

Those who wear foreign turbans, all should boycott (foreign cloth).

Why are you adorning your head (with foreign cloth), why are you hurting yourself?

Those who have foreign turbans, why are you putting yourself through hell?

The foreign (cloth) turban you are wearing is short-lived (not durable).

In spite of this, why are you wearing a foreign (cloth) turban?

Gather all the foreign clothes in one place (for a bonfire).

Those who wear foreign (cloth) turbans, they are a heavy burden on your head.[25]

While it is hard to be certain how influential such a song would have been, one can propose some interesting conclusions both about the meanings associated with foreign cloth and men's headdress and the local nature of such nationalist propaganda. The language of the songs, for example, was specifically Surati Gujarati, suggesting that proponents attempted to popularize their ideas through local, rather than regional or "national," languages. Linking one's choice of headdress to evil, death, destruction, impoverishment, duty, economy, and modesty, the song made clear that wearing foreign cloth was not an act to be taken lightly. Although this song did not advocate the wearing of the Gandhi topi specifically, or explain what the hat meant within a nationalist imaginary, its emphasis on the perils of adopting foreign cloth is quite explicit.

From the very beginning, the topi was a flexible symbol of dissent that could be used in a variety of circumstances and for a range of purposes. The degree of its malleability became evident in the context of public protests in cities and towns across British India. The first cases of caps worn in organized public demonstrations occurred in conjunction with non-cooperation demonstrations in the Bombay Presidency in the fall of 1921. Among the earliest sympathizers of Gandhi's swadeshi movement and non-cooperation program were the Khilafatists, who protested the removal of the Ottoman *khilaf* from power by donning khadi clothing and organizing marches during which they carried khadi emblems, especially flags. In following this script in location after location, Khilafat supporters, who viewed the Ottoman sultan as a spiritual leader of all Muslims, used khadi to communicate their dissatisfaction with government policy and to express their desire for the reinstatement of the caliph, an issue which lay beyond the immediate concerns of the Indian National Congress. Nonetheless, the khadi cap quickly became a public symbol used to signal dissatisfaction and dissent, and conflicts between the

residents of towns and cities where the cap was seen in public emerged almost as quickly as the cap appeared.

In an Anglo-Indian neighborhood of Bombay, for example, riots erupted over the wearing of khadi caps on city streets in the fall of 1921. Following the unrest, Gandhi reported that he had "heard that there was firing resulting in deaths . . . and that everyone who passed with khadi on came in for a hard beating if he did not put off his khadi cap or shirt."[26] Those who wore the Gandhi topi, and tried to pass through the Anglo-Indian quarters on their way to work, to the market, or perhaps to protest, were certain to find trouble. On some Bombay streets, members of the foreign resident population and Anglo-Indian community literally stripped the homespun cloth from those whose paths they crossed. Gandhi asserted that such spontaneous behavior was encouraged by the local police, who themselves targeted for public beatings those who wore khadi. In the eyes of local colonial authorities and the foreign and Anglo-Indian resident communities of Bombay, the sight of khadi—and the Gandhi topi in particular—was a direct challenge to British authority.

In December, still another incident involved the topi, this time in the Madras Presidency. With the announcement of the Non-Cooperation Resolution, Gandhi had called upon students to leave government colleges in order to devote themselves productively to the nation's cause. While many acquiesced, often to the displeasure of their families, many others opted to stay. Their decision to continue their education in these institutions, however, did not necessarily signal their satisfaction with or support of foreign rule. Medical students in the Vizagapatnam Hospital and School were suspended when they arrived wearing Gandhi topis.[27] The acting head of the government medical college determined that khadi clothing fell outside the prescribed dress code for students, promptly sending the offending students away. He redistributed copies of the dress code to students of the hospital and school, making clear that khadi in any form was inappropriate apparel, as was any kind of headdress with the exception of a European-style hat or a turban prescribed by the regulation. Unless the offending students were prepared to apologize for disobeying the dress code and to agree to refrain from wearing khadi in the hospital and in the college, the superintendent of the school announced, he would expel every one of the offenders. As a matter of principle, a government-funded medical college could not tolerate the appearance of political symbols questioning the colonial authority. Although we have no evidence about these students' specific motivations, the intensity of the struggle suggests that they wore the khadi cap as some kind of silent, though visible, protest.

At roughly the same time as students in the medical college took up the topi, *Young India* reported still another controversy, one that was far more troubling because it involved the display of the hat not in a public space or in a space only loosely associated with the regime, but within a space of colonial law and authority: a district court. In passing the Non-Cooperation Resolution, Gandhi had also called upon native lawyers to leave government service. Many resigned their official posts and took up cases against accused Congress members. Khadi clothing, particularly the Gandhi topi, thus became an increasing concern of court officials, who found themselves hearing cases in which Congress defendants wore khadi. While the courts could solve this problem by forcing defendants in custody to wear standard-issue prison attire in court, they did not have the same authority over all who appeared before them. It was only a matter of time before the native lawyers defending non-cooperators began dressing in sympathy with their clients and wearing emblems of dissent within the spaces of colonial law and order.

In Ratnagiri, a district located in the Central Provinces, a subdistrict judge took exception to a native lawyer who appeared before him in court wearing a khadi cap. Interpreting the action as disrespectful of the court and government, the judge ordered the lawyer in question to remove his cap. When the lawyer refused, the judge cleared the courtroom and recorded the incident in his official report. He wrote,

> Mr. Vaidya has appeared in court today in a khadi cap, commonly known as the "Gandhi cap." In conformity with the views of the High Court . . . I have told Mr. Vaidya that I consider his appearance to-day in a khadi cap as amounting to disrespect of the court and have ordered him to leave this court at once and not to appear again . . . in a cap unless and until the District Judge or the High Court directs otherwise. . . . [I]f (he) appears in a cap after this order, he will expose himself to all the consequences of a contempt of court.[28]

Extracts of a communiqué from the chief justice of the High Court make clear that the government already concurred that the Gandhi topi expressed disrespect for the regime. Still, the Home Department had not formulated a broad policy on the wearing of the Gandhi topi or khadi clothing in courtrooms, any more than it had issued a policy on such garments in government colleges or on city streets. Managing such situations remained the responsibility of the government's most local representatives.

In the spring of 1922, another controversy erupted when Gandhi topis were worn in a court in the Madras Presidency. This event finally prompted the provincial government to review its policy.[29] It was the opinion of the gov-

ernment of Madras that the four people who wore the Gandhi caps to court had done so with what the Chief Secretary R. A. Graham called "a deliberate intention . . . to show their disloyalty to Government and insult the court."[30] Local officials linked the Gandhi topi worn in court that day to anti-colonial protest because of the widespread civil disobedience in the district over the course of the previous year. According to District Magistrate Vernon of Guntur, during the last half year the district had been experiencing considerable upheaval over land revenue. In the weeks between December 1921 and February 1922, relations between the government and the local population had deteriorated so much that the European and Indian civil servants loyal to the government were repeatedly insulted by people who Vernon alleged were "non-co-operators." These troublemakers, suspected Vernon, were in touch with Gandhi, and

> adopted a kind of uniform one part of which was a head-dress known as the Gandhi cap. . . . In the general opinion of the public throughout the district, there is no doubt that the wearer of a Gandhi cap was regarded as a preacher of revolution and defiance of the authority of the Government.[31]

It is little wonder that, when local protestors appeared in court wearing Gandhi topis, Madras's officials reacted decisively. The presiding judge warned that the khadi caps were considered offensive to the court and ordered them removed. After his order was ignored, he issued penalties for insulting the court. While the government of Madras privately expressed its concerns to local officials that the handling of the incident might have exacerbated the situation, it publicly supported local officials; provincial officials maintained in their communiqués with the Home Department that their representatives had upheld the policy set forth by Delhi.

Eight years later, during the Civil Disobedience Movement (1930–1932), swadeshi proponents in the Guntur District once more filled public space with Gandhi topis. According to local officials, the conflict reportedly began when nine residents of Guntur circulated a seditious pamphlet to their fellow citizens on June 19, 1930. The residents, however, told a different story: their pamphlet was simply an account of their interaction with the collector to whom they had gone to report difficulties that they had faced because they wore khadi attire:

> We all went to the Collector to-day and informed him of the acts of the police and he told us that he will take necessary steps to prevent . . . any acts of vio-

lence by the police on volunteers or other citizens because they wore a Gandhi cap or khaddar.[32]

The district collector apparently reassured the residents of Guntur, promising to speak with the police on their behalf. It is likely that the residents, who maintained that their pamphlet was not seditious, had intended to produce a public record with which they might hold the collector to account in the event of future conflicts over khadi clothing. According to the documents forwarded to the Home Department from the provincial government, the situation was far from resolved by the meeting between the collector and the residents of Guntur.

The day after the meeting, the district magistrate, F. W. Stewart, issued a new order under section 144 of the Criminal Procedure Code, effectively banning the wearing of the Gandhi cap in public. The order read,

> Whereas the public tranquility has been disturbed by the civil disobedience movement and the wearing of the Gandhi cap is a symbol of sympathy with that movement and whereas information has been laid before me that a notice is about to be issued to the public in general which will have the effect of inciting them to wear Gandhi caps and so disturb the public tranquility, I . . . consider that immediate prevention is desirable and direct every member of the [munici-pality] . . . to abstain from wearing a Gandhi cap when in any place frequented by the public within the limits of the Guntur Municipality and a radius of 5 miles there from for a period of two months from this date.[33]

The district magistrate felt compelled to issue such an order over the public display of the Gandhi cap because of its inflammatory nature.

Only three weeks earlier, Stewart had issued two other orders in Guntur, both of which were attempts to maintain order. The first of these prohibited "meetings and processions" for a specific period of time. The local government wished to stop khadi-clad protesters from appearing in public spaces of any kind, most notably the district's streets, because they feared such activities would incite further support for Congress. The second order directed the evacuation of buildings that had been used as "organising centres" of Congress workers, although the order provided no specific criteria for assessing such buildings. It was the experience of enforcing the second of these orders that had influenced the magistrate later in June. When police officials attempted to clear out buildings, including the Congress volunteer headquarters, they met considerable opposition from Congress workers and

Guntur residents—who were indistinguishable because they had taken to wearing the topi as well. The district collector candidly replied to his provincial counterparts that "if people desired to dress like [Congress] volunteers they must take the risk of being mistaken for volunteers."[34] Arguing that the Gandhi cap had never been a typical article of clothing in the district before the Civil Disobedience Movement, the government of Madras explained to the Home Department that the cap was a clear marker of growing sympathy for the Congress volunteers and, therefore, could be legitimately banned.

For the local officials charged with maintaining order, the sight of the topi, or khadi clothing of any kind, was a clear sign of the wearer's support for the nationalist movement. Madras officials explained to the Home Department that "the Police appear to have directed particular attention to those persons wearing khaddar and more especially the Gandhi cap," because the public had been uncooperative with the orders issued by the District Magistrate.[35] How seditious was the pamphlet circulated in Guntur in June 1930? Faced with local officials who admitted they had "directed particular attention to those persons wearing khaddar and more especially Gandhi caps," it is clear that when the nine Guntur residents had lodged their concerns with the district magistrate, their concerns had, in fact, fallen on deaf ears. The sight of the Gandhi topi was driving the response of local officials and law enforcement, and the residents understood this well enough that they made their objections public.

In the case of the Gandhi topi, government records make clear two important trends. First, after conflicts between the government and Gandhi emerged in the early part of the non-cooperation movement, the Home Department was quite careful to avoid developing any broad policy on the appearance of the cap or khadi clothing when worn in public. Correspondence between the Home and Judicial departments makes clear that, as much as the government may have wanted to restrict the wearing of the topi, officials also recognized that there was no precedent in India, Britain, or the larger empire that would allow them to do so. The only exception to this general principle involved the clothing of important officials of the government. Military and civilian officials could be restricted from wearing khadi in any form at work due to their official status. And, as has been seen, the Home Department was willing to tolerate low-paid, low-rank, employees wearing khadi clothes or the Gandhi topi because such dress only served to reinforce the visual message established through the elaborate dress codes the government had set for its important officials.[36] In some ways, the low-rank *chaiwallah*, or tea-bearer, who wore a khadi kurta and Gandhi topi only expressed the visual hierarchy the British sought to create in India.

Second, there was a clear and ongoing tension between the Home Department and provincial governments during this period. The Home Department remained concerned that aggressive policies or actions at the local level would only serve to popularize more generally the symbolic meaning of the cap and khadi.[37] Frustrated by the lack of a consistent policy from the Home Department, provincial officials regularly supported local initiatives, like that of the district magistrate of Guntur, to ban the cap whenever there was a potential conflict. Acting in unison with local police, district magistrates routinely issued temporary restrictions on the display of khadi in public. By and large, these temporary orders were upheld by the judiciary and the provincial and central branches of the government because all agreed that it was "the District Magistrate who was in closer touch than anybody else with the political tension in a district, was in a better position than a distant authority to judge what was required for the preservation of the peace."[38]

The meaning of khadi, ironically, was also the product of an imperial habitus and the agents who exercised authority at the local level to maintain its integrity. At times of political strain, khadi clothing appeared, especially to local officials, as an expression of autonomy from imperial governance and ideals, if not an alternative authority. Britain's civilizing mission itself was called into question when civil servants were seen wearing khadi in public spaces associated with imperial rule, including streets, schools, offices, and courts. As local officials responded to the sight of this cloth in public by restricting its display or destroying it altogether, the imperial regime itself played an important role in defining the significance of khadi and, in so doing, making public space imaginable as national.

Marking National Space

The Gandhi topi taught non-cooperators the ease with which they could transform their bodies from sites marked by colonial rule to sites that threatened the imperial habitus. Nationalists and their supporters extended this awareness, employing khadi symbols, particularly the khadi charka flag, to mark spaces associated with colonial rule. Flying the khadi flag transformed the colonial landscape by clothing the public in a symbol of national, rather than colonial, community. Swadeshi proponents targeted three kinds of public space—exhibitions, city streets, and municipal buildings—because each in its own way was crucial to the imperial vision of British India. As such, they were also those spaces whose meaning, when transformed through the visual display of khadi, enabled the imagining of national community.

Beginning in the spring of 1922, the records of the Home Department are peppered with files dedicated to what were called "flag incidents." The first of these involved the city of Bhagalpur, located in the northeastern province of Bihar and Orissa, where a local industrial exhibition planned by the native and European communities was suddenly jeopardized by the appearance of the khadi charka flag. Having been designed only a year earlier, the flag was unfamiliar to the general population of colonial India. Only those who followed Gandhi's articles in *Young India* or the protests of the non-cooperation movement were likely to have been familiar with the emblem at this time. Nonetheless, when exhibition decorators used this flag among others to adorn the exhibition grounds, Bhagalpur's British and Indian residents found themselves at odds.

In this regional city of approximately 2 million people, a committee composed of both European and Indian residents had planned the exhibition.[39] Industrial exhibitions such as the one planned for Bhagalpur were not new in colonial India. Indeed, as Peter Hoffenberg has demonstrated, they were a key feature of Britain's encouragement of India's economic development and one of the most important expressions of colonial paternalism. Like larger scale efforts in other parts of the colony, the exhibition in Bhagalpur was promoted as a local community event at which many kinds of new products and ordinary wares would be displayed and made available for sale. Because the space for the exhibition belonged to the local government, organizers had sought and received the government's approval for the event. Interest in the exhibition attracted the participation of both British and Indian notables. Even local officials of the administration, including the deputy superintendent of police and the deputy commissioner, B. C. Sen, and his wife, had involved themselves in preparations, agreeing to participate in the opening ceremony. Organizers expected that the exhibition would draw a wide range of the town's residents, as well as visitors from neighboring villages. They had no idea that it would also become a turning point for swadeshi proponents and government officials across British India.

On February 6, 1922, as Deputy Commissioner Sen spent the morning checking on the progress of the exhibition's arrangements,[40] the magistrate and the police commissioner of Bhagalpur informed him of a most serious affair. The local contractor who had been charged with making the exhibits and platforms attractive had done so with hundreds of flags, including the khadi charka flag. As we have seen, the khadi charka flag did not become the official symbol of the Indian National Congress until much later, but before its adoption Gandhi and those sympathetic to his political strategies employed the emblem for a variety of purposes. For example, khadi flags were com-

monly used to literally cover exhibition grounds or meeting places, marking their boundaries, beautifying booths and bandstands, even prominently flying beside a Union Jack on the central platform (see figures 5.2 and 5.3). In his report to his superiors, Sen explained that upon seeing the charka flags throughout the exhibition, he immediately questioned the decorator and ordered their removal. In his own defense, the decorator claimed innocence of intentionally politicizing the exhibition by using the charka flags. Noting that the khadi charka flags were only one of the several flags that adorned the exhibition space, the decorator portrayed himself as a worker simply carrying out the wishes of those whom had contracted his services. Sen tells us that the decorator, while willing to remove the flags, cautioned him that some on the Exhibition Committee would be angered by their removal. Still reflecting upon what to do, Sen informed the assistant secretary of the committee, S. B. Chatterji, that neither would he and Mrs. Sen open the exhibition at the opening ceremony nor would they attend the exhibition so long as the charka flags remained on the exhibition grounds.

Perhaps responding to the decorator's warning, Sen also decided to call a meeting of the Exhibition Committee that afternoon. Before the committee could be convened, however, Sen received a proposition from committee members sympathetic to the Congress, including Chatterji. They were prepared to agree to the removal of the small khadi charka flags that adorned the exhibition. They asked, however, that Sen allow a larger charka flag to remain for the time being. Explaining that the larger charka flag had been hoisted on an unstable tower from which its safe removal would be difficult on such short notice, they proposed that the flag be furled for the duration of the opening festivities and removed that night. Although the khadi charka flag would remain on the central platform of the exhibition on the first day, the Union Jack would not only be raised higher, but would also be the only flag unfurled for exhibition-goers to see. In the hope that the exhibition would not be ruined and that a political confrontation might be avoided, and after consulting with Lord Sinha, a prominent member of the Indian High Court who happened to be visiting Bhagalpur at the time, Sen agreed to the compromise. He also agreed that he and his wife would open the exhibition as planned. The entire situation, it seemed, had been resolved without incident.

But the controversy was not over. The following morning, Sen was informed by one of his subordinates that the charka flag had not, in fact, been removed on the previous evening as had been agreed. The British community of Bhagalpur, in the meantime, had become enraged not only over the appearance of the khadi charka flag in the first place but more specifically over

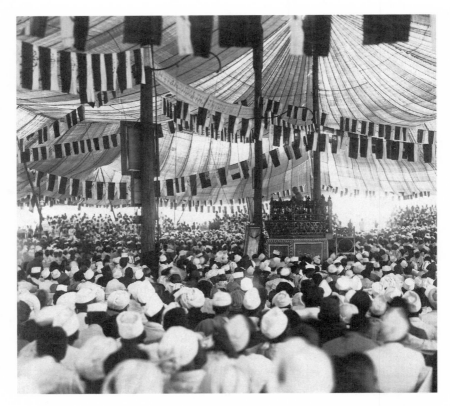

Figure 5.2. Gandhi's presidential speech at the open session of the Belgaum Conference, December 20, 1924. Copyright: Vithalbhai Jhaveri/Gandhiserve.

its position beside the Union Jack. They pointed out that the flag was neither a traditional emblem nor one associated with local politics. Over the course of the non-cooperation movement, British residents had come to recognize that the khadi charka flag was associated with Gandhi and his agitation against colonial authority. They were unsatisfied with Sen's agreement and advocated a boycott of the exhibition. They also reported their concerns about the situation to Sen's superiors in the provincial administration.

Such commotion over a homemade flag—and not a particularly well-crafted one at that—bears considerable significance. The Bhagalpur community—Indian and British—had initially worked together to organize an event that was oriented around their collective home. Something had suddenly disrupted the cooperation that had bound the community together during the planning phase of the exhibition. The problem seems to have appeared lit-

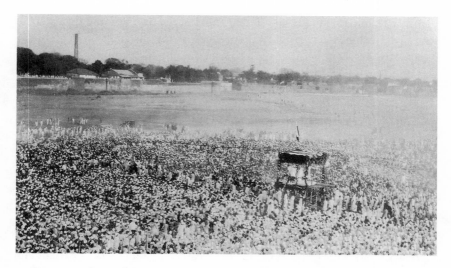

Figure 5.3. Citizens' meeting on the sands of the Sabarmati River where Gandhi was presented with an address and a purse of Rs. 70,000, March 10, 1931. Copyright: Vithalbhai Jhaveri/Gandhiserve.

erally with the khadi flag, an object that clearly stirred deep emotions among Bhagalpur's diverse residents. Reading this flag required neither a common language nor literacy in a written language. For the British residents, even the proximate positions of the khadi charka flag and the Union Jack on the exhibition platform was offensive enough to provoke them to boycott the exhibition. For the Indian residents on the Exhibition Committee, the appearance of the emblem was no less important. The committee had gone to the trouble and expense of acquiring hundreds of charka flags with which to decorate the exhibition, a task that was not easy given that the flags were not widely produced by swadeshi institutions until later in the decade. Moreover, Indian members of the committee clearly believed that native visitors to the exhibition would recognize the khadi charka flag, as well as pennants reading "Swaraj" and "Bande Mataram" (All hail Mother India) as representations of their community.[41] It is noteworthy that khadi emblems were not constrained by the limitations of literacy. In contrast to the way that the rise of nationalism in the West has been linked directly to rising rates of literacy, in India multilingual societies found other means of creating identity. Or, rather, the native organizers of this exhibition and many other comparable situations did not assume literacy in a particular language, and therefore made use of a symbol that was more broadly accessible to their audience. They had not

planned a campaign to explain the meaning of the flag, nor had they sought to use the exhibition for political speeches or the distribution of political pamphlets. Yet even without the khadi pennants, they counted on the fact that the khadi charka flag would be understood by the exhibition-goers, rendering the exhibition a national event.

The incident quickly became the subject of discussion among officials and non-officials alike in Bhagalpur, in New Delhi and, eventually, in London. A full-scale reconsideration of provincial and central government policies on the flag, as well as a series of debates in the British parliament, were among the results of the Bhagalpur flag incident. In the end, Deputy Commissioner Sen received an informal, though stern, rebuke from his superiors in the provincial administration, who concluded that, despite his intentions, his agreement allowing the khadi charka flag to be flown along with the Union Jack had compromised British authority in Bhagalpur. Back in London, the secretary of state for India found himself reassuring members of Parliament that "no charkha flag would be flown in any relation to a Union Jack."[42]

In this regard, the government in London seemed in step with the provincial governments in India. Interestingly, this position was not shared by those in the Home Department in New Delhi. Officials of the central government were far more concerned that incidents be handled without creating further popularity for the flag than they were that a particular emblem appear, or not appear, beside a Union Jack. They reasoned that the creation of further controversy would only increase the flag's symbolic power. Numerous official "incident" files compiled over the course of the next fifteen years suggest just how compelling the sight of the flag was, whether it was seen by a native or a British subject, a nationalist or a colonial sympathizer, or, indeed, whether or not one considered oneself political at all.

The khadi charka flag was increasingly flown at industrial and khadi exhibitions, but its popular significance was more powerfully promoted through processions on city streets and through its display on public buildings. Municipal boards, composed of greater numbers of native members, began to exercise the newfound authority gained in the reform of the government in 1919 by opting to sanction the public use and display of a range of khadi goods. As early as 1924, for example, the city of Lahore purchased khadi cloth rather than manufactured material for the uniforms of its employees. At about the same time, the Ahmedabad municipality exempted khadi goods from the *octroi*, or tax, which had been levied on goods brought into the city. In 1924, the chairman of a municipality in the newly created province of Bihar and Orissa issued instructions to city employees to carry the national flag and for the city's teachers to display the flag in their classrooms and school

buildings.[43] A municipal board's decision to fly the khadi charka flag on its buildings was arguably little more than the next logical step, and in 1928 the Ahmedabad board did just that. Following Ahmedabad's lead, other cities, including Delhi, Lahore, and Bombay, each voted to hoist the khadi charka flag above its municipal offices.[44] From the mid-1920s, municipal boards promoted the charka flag and khadi goods in general. Thus, through municipal action, khadi gained currency in the popular idiom of nationalist India.

Officials of the provincial governments took a wide variety of positions on the public use and display of the flag, directing police in each location to respond differently. The Bombay government opted not to react to the passage of the resolution in Ahmedabad and requested that the Home Department clarify their policy on the flying of the flag on municipal buildings.[45] Despite the appearance of the charka flag at exhibitions in which the Congress participated, the Madras government pursued a relatively liberal policy as well, continuing to offer financial grants to such events as long as Congress accounts were kept separately from those of the general exhibition.[46] The Madras government allowed flag hoistings in particular circumstances; for example, a hoisting might be carried out in the central square of a town on occasions such as a Congress student's conference in Mangalore (see figure 5.4). In Bengal, however, the provincial government was not so generous. Responding to the concerns of law enforcement in the province, officials there declined to sanction any exhibition at which a Congress flag was to be flown. Although the Home Department did not wish to draw further attention to the flag or, indeed, any khadi emblem through unnecessary restrictions that would almost certainly lead to its increased popularity, their review concluded that there was a need for greater "uniformity of practice" between its provincial governments. An uneven treatment of the public display of the khadi charka flag, the government feared correctly, would increase the power of the symbol.[47]

The central government was in the process of revisiting its policy on the charka flag when the mayor of Calcutta announced that the city's municipal board had approved a resolution for the charka flag to be flown above the corporation's buildings on January 26, 1930, in celebration of the newly created Independence Day.[48] In concert with the Indian National Congress and municipalities across the country, the Calcutta Municipal Board had agreed to visually proclaim their national identity to one another and to the world. In the face of widespread celebration, officials of the Home Department cautioned provincial governments and law enforcement against reacting to flag hoistings unless the displays caused a significant public disturbance. In a communication with Bengal's provincial officials, the Home Department

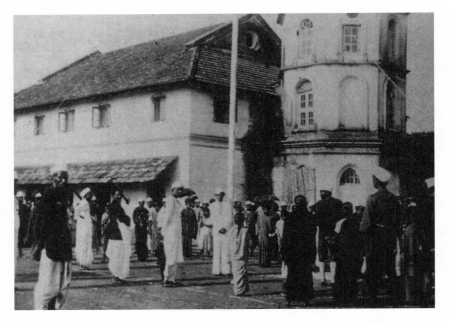

Figure 5.4. Jhanada Vadan (flag hoisting). Photograph courtesy of Dheshbhakta Karnad Sadashiv Rao Memorial Committee.

indicated that they had "no desire to urge the Government of Bengal to take action, particularly as action they presume would be likely to involve, in the case of the Calcutta Corporation, very serious political effects."[49]

At least three distinct parts of the imperial administration held different views on such resolutions. At the highest level, Home Department officials did not want to see further conflict enflame nationalist sentiments. For British officials at the provincial level, the relationship between exercising the will of municipal government and maintaining political power over the colony was increasingly problematic. Both provincial administrators and local law enforcement agents were particularly keen to outlaw the display of the khadi flag in order, they argued, to avoid unnecessary civil disturbance. Given the constitutional changes enacted through the Government of India Act of 1919 and the reform of municipal laws that followed in the subsequent decade, however, municipal bodies had new authority with which to determine the use, and perhaps the meaning, of public space. Local magistrates and police superintendents could temporarily restrict any particular flag hoisting, but their authority was clearly circumscribed by the popular will of the increasingly empowered local governments. Court officials, for example,

could sanction restrictions on the flying of the khadi charka flag only after the police established direct and specific threats to law and order. The provincial governments and their agents had little legal capacity to enforce a ban on khadi flags, a point affirmed by officials in the Home Department. Thus, the discourse about public space and its appropriate use, even as it pertained to the state, was in flux during this period. The reform of the government of India in 1919 had inadvertently served to loosen the moorings of the imperial habitus.

The Calcutta municipality's resolution to fly the khadi flag effectively forced British administrators to express a general policy on the flying of the charka flag on municipal buildings, a position that officials in the Home Department had resisted expressing for nearly a decade. In a letter from the Home Department to the government of Madras, Secretary H. G. Haig explained,

> If a local body is definitely defying the Government, challenging its authority
> and taking active part in a movement aimed against the continuance of British
> rule, this cannot be ignored. . . . But when . . . the flying of the national flag
> made little or no impression on the public and if the administration of the Cor-
> poration is not clearly directed to encouraging hostility to British rule, then the
> Government of India are disposed to think it would be wiser to take no action.[50]

In January 1930, shortly after the Home Department decided not to pursue the further restriction of the flag, the Calcutta Municipal Corporation joined Ahmedabad in flying the "national" flag over the municipal building on ceremonial occasions, including January 26, "Independence Day."[51] When finally undertaken, the flag hoisting drew cries of "Bande Mataram" from the large crowd that had assembled at the municipal building. Mayor Sen Gupta characterized the decision of the city board as one that was "demanded by public opinion, and, I believe, [to be] the minimum which the Corporation of Calcutta can do to show its responsiveness to the opinion of the country and to vindicate its own name."[52] Crucially, his argument for displaying khadi on the municipal building turned on the wishes of the Indian public.

Aside from emphasizing the wide support for the resolution, the mayor made two arguments that were aimed at justifying the decision to the British residents of Calcutta and the local representatives of the colonial government. Sen Gupta placed the decision in a context that might resonate for Britons:

> I mean no disrespect to the British flag. . . . Wherever he [the Britisher] goes,
> [the British flag flies] over every club of which he is a member, over every

business premises which he controls and over every function he organizes. It is only natural that a Britisher should feel it an outrage to his feelings if he sees a foreign flag, say the German flag . . . floating over his institutions.[53]

Sen Gupta's rhetorical strategy was clever; he acknowledged the legitimacy of the Union Jack over all spaces British. He also emphasized his point by making reference to the difference between the British and German flags, a comparison that was charged by the recent experience of the First World War. Having made clear the "natural" emotion linking a people and their flag, he reminded his British audience that Indian sentiment for the khadi charka, or swaraj flag, as he called it, was no different than their own feelings for the Union Jack. With the utmost pragmatism, the mayor concluded, "It is of no use concealing from ourselves the fact that the Union Jack is an affront to our national honour when flown by us over our national institutions."[54]

Significantly, the mayor made explicit the city's need for action. The residents of Calcutta demanded concrete expression of their community identity from members of the Corporation and from Sen Gupta. He explained:

Today we are being called upon to perform a national duty. As a corporated body we must give manifestation of our corporate will. No mere expression of opinion will do. The country demands an act, and today there can be no more supreme act enjoined on us than the hoisting of the national flag in all our solemnity with a full consciousness of our responsibility and the consequences of our act.[55]

The mayor of Calcutta was articulating what the British and Indian residents of Bhagalpur and countless other cities had already come to recognize. As he put it, "The Corporation of Calcutta is an Indian institution. It stands on Indian soil. It is owned by Indians. It is managed by Indians and run in the interest of Indians."[56] The decision of the corporation to fly the national flag was simply a natural expression of nationhood; it was not intended as an insult to the British. The mayor of Calcutta spoke plainly about differences long since codified, as Thomas Metcalf has argued, in the laws and practice of British rule in India. Sen Gupta spoke of differences that were literally in plain view; the charka flag, not the Union Jack, occupied the hearts of Calcutta's population.[57]

Conspicuously absent from the mayor's speech was any mention of the flag as a symbol of swadeshi politics, of Mohandas Gandhi, or of the Indian National Congress. Sen Gupta made no pleas to boycott foreign goods or the imperial government. Nor did he devote any attention to explaining the

meaning of the flag and its various elements. As was the case in Bhagalpur, the meaning of the flag received no explanation from those who sought to raise it because they assumed its significance. Marking the building of the municipal corporation of Calcutta with the khadi charka flag was both a means of assuming the authority associated with the colonial government and establishing the local—and native—government's authority over an increasingly national public.

Inhabiting National Space

Khadi's currency as a symbol exceeded that envisioned by Gandhi. By 1930, khadi had been transformed from a country cloth worn by some of India's rural population and the symbol of a specific form of nationalist politics into a general symbol used publicly by a wide variety of people across British India to visually proclaim injustice. Although the Indian National Congress had been compelled to adopt this particular emblem as its symbol only two years earlier, the use of the flag particularly between 1930 and 1932 proved a significant visual challenge to imperial authority. Government records indicate that in the Bombay Presidency alone flag hoisting on municipal buildings occurred in no less than three dozen towns and cities in a six-month period.[58] These events served as signposts pointing the way toward what might be termed a national habitus, and became a regular feature of life. The appearance of the charka flag, whether over municipal buildings or on streets, was evidence of the Indian people redefining public space as national. Significantly, the boundaries of this redefinition lay beyond mainstream, middle-class nationalist politics, and were open to the imagination and concerns of ordinary people as well. Khadi's significance as a symbol of India lay not simply in the meanings attributed to it by Gandhi and his followers, but to the meanings attached to it in the everyday discourses visually performed in public.

Two examples demonstrate the ways that people used khadi to clothe a new "Indian" public. The first involves a photograph of a Congress procession in Bombay (see figure 5.5), taken between 1930 and 1932 during the Civil Disobedience Movement. Following the decision of the British government to convene a roundtable conference in London on the subject of reform without a representative of the Indian National Congress, Gandhi inaugurated a non-violent protest that galvanized support for Gandhi's politics and, in many ways, for Gandhi himself. The disobedience began with a march from Ahmedabad, where Gandhi resided, to the seaside town of Dandi—a march to the sea to protest against a government tax on salt, over which the British

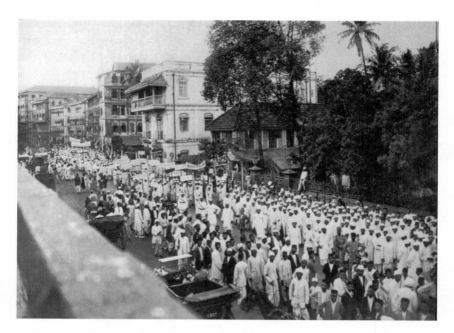

Figure 5.5. Congress procession in Bombay. Photograph by N. V. Virkar. Copyright holder Rajendra Shriram Virkar, D-57, Dharmanagar Society, Shivasrusti, Kurla (E), Mumbai 400 024, Maharashtra, India.

maintained a monopoly. Afterward, Congress workers across the country staged daily marches through the streets of their cities; in Bombay, these marches took people from their neighborhoods to the shore at Chowpatty Beach. There participants commenced making salt in violation of the law, selling salt, and listening to Congress speeches. While we cannot be certain that the procession pictured here is one such march, it is possible.

Like many demonstrations orchestrated by the Indian National Congress, the public protest pictured here involved Congress volunteers who, clothed in khadi, marched through the streets carrying banners and the charka flag. What is so telling about this image and others from this period, however, is not the Congress leaders at the center of the image, but rather those who appear at the procession's edge, many of whom appear to be wearing khadi or, at least, a Gandhi topi. The professional backgrounds and class of these onlookers are not immediately evident. Whether they had planned to join or had stumbled upon this procession cannot be known, but their presence compels us to consider what seeing khadi in public might have meant to them.

Given their khadi clothing, they may have been supporters of the Congress, if not members. It may be that, even if they were not prepared to join the Congress procession themselves or wear khadi daily, they wore khadi to express their support for this particular demonstration. It may be that they had adopted khadi clothing into their lives and only stumbled upon the procession that day. We cannot know for sure, but we can speculate that khadi-clad onlookers contributed to the visual impact of the procession whether they intended to or not. Witnesses of such a protest would have viewed this cloth both as a symbol used by Congress volunteers and as an object used by ordinary people. The photograph suggests the range of people who made use of khadi in public, and hints at its value as a political symbol that could visually express many kinds of affiliation, as well as dissent.

In contrast to the photograph of the Bombay procession, another image captures a non-Congress event (figure 5.6). In 1945, Gandhi attended the mass meeting in Calcutta pictured here. In the context of escalating violence between Hindu and Muslim communities, Gandhi made many public appearances to plead for public calm. This meeting may have been one such event. It is not possible to rule out the possibility that this gathering was closely affiliated with the Congress, but it does not appear that it was an official Congress event. The space is not carefully cordoned off and there is no sign of the Congress flag that commonly marked official "national" space. Years after the Congress had abandoned its commitment to the spinning franchise, it is clear that the people who came out to hear Gandhi on this particular day, whether they were Congress supporters or supporters of Gandhi himself, conformed to the same standard in choosing their dress. Khadi was clearly at least the unofficial dress of this public. Again, by filling the meeting area with their khadi-clad bodies, the people who gathered to hear Gandhi visually proclaimed their allegiances and transformed the space from its colonial context.

By the 1930s and 1940s, even the Congress's political rivals and skeptics, including the Muslim League and the Communist Party, adopted khadi in their own protests. Workers in Sholapur, a mill city located in the Bombay Presidency, also made use of khadi to express their concerns. In the tense political climate of the Civil Disobedience Movement, the Sholapur municipality, like many others, adopted a resolution to fly the charka flag atop its buildings.[59] Assuming the emblems of nationalists as well as those used by their municipal government, Sholapur's laboring poor took to the streets wearing khadi clothing and parading the charka flag to protest their working conditions.[60] Before long, conflicts between workers and police in Sholapur focused upon workers wearing Gandhi topis and displaying khadi

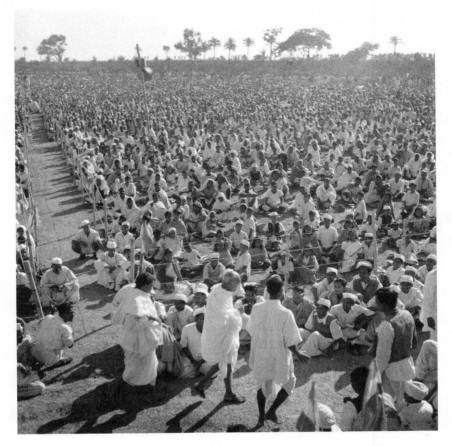

Figure 5.6. Mahatma Gandhi at a mass meeting in Bengal, 1945. Copyright: Kanu Gandhi/Gandhiserve.

in their public demonstrations. It was this working-class agitation and the government's handling of the situation that had prompted a member of Parliament, Brockway, to question the secretary of state for India in 1930 about reports of a government ban on the Gandhi topi. The secretary, in a secret telegram to the viceroy, expressed his own concern about the Reuters' report that claimed that police "were flicking Gandhi caps off heads of passers-by with specially prepared canes furnished with hooks."[61] Why should workers hoping to improve their daily lives adopt khadi? Workers in Sholapur, who were both estranged from Gandhian politics and increasingly sympathetic to radical working-class politics, adopted khadi most likely because it had be-

come an established visual symbol of dissent. Khadi afforded them a means to announce their concerns to the larger public both in Sholapur and beyond.

The occupation of public spaces was a means through which people in colonial India laid claim to the territory of their nation. By introducing khadi in public, people rendered colonial spaces national, accomplishing their goal through two distinct strategies: marking public spaces associated with the colonial regime, whether commercial or administrative, and filling those spaces, including streets, offices, and courtrooms. By decorating and hoisting khadi charka flags in spaces associated with the colonial regime, swadeshi proponents, among others, laid claim to the authority invested in institutions associated with the state. Khadi made it possible to imagine the municipal building or court, for example, as Indian. Those who marked public spaces tended to be closely allied with nationalist politics; many were Congress members and swadeshi proponents. They were more comfortable with politics that placed them directly and openly in conflict with the government. However, the filling of public space was a tactic available to those less inclined to challenge directly the government's legal authority. The filling of public space with one's khadi-clad body certainly announced one's political affiliations, but it did so in a legal manner, employing rights that by 1930 could not easily or legally be curtailed by the government. Visually, khadi not only disrupted the imperial habitus by filling and marking space, but also refigured the ways people visually experienced and used public space. The display of khadi goods in public was one way an imperial habitus was transformed by the material objects of nationalist India. When marked and filled with khadi in these ways and others, an imperial public gave way to a public that could be conceived of as national.

CONCLUSION

In May 1996, the newly elected Bharatiya Janata Party toyed with the idea of ending state subsidies for khadi, which had been guaranteed for nearly fifty years. After news was leaked to the press, the proposal met immediate and significant public opposition; protesters converged upon the parliamentary buildings in New Delhi to vent their anger and marched through one of the capitol's major thoroughfares, Connaught Circle. Faced with this sudden outcry, the party quickly reassured the public that its proposal would go no further; subsidies for khadi would continue. Fifty years after Indian independence, the home-spun, home-woven cloth popularized by the swadeshi movement remains one of the most enduring symbols of the modern Indian nation—so enduring, in fact, that the republic's financial support for it has become virtually sacrosanct.

Nearly a decade later in Babapur, a village located in Amreli District, Gujarat, children and their families gathered at the primary school to celebrate Republic Day. It was January 26, 2005. Seventy-five years earlier to the day, members of the Indian National Congress had assembled at their annual meeting in Lahore and proclaimed the date Independence Day with the hoisting of the khadi charka flag, the taking of the independence pledge, and the singing of national songs. Following India's independence in 1947, that occasion continued to be celebrated, although under a new name. Significantly, the Republic Day celebration in Babapur in 2005 bore remarkable resemblance to Independence Day celebrations of the nationalist period in a few crucial respects: the flag, a pledge, and national songs were central to the occasion. The festivities began in the morning and were organized around the flag. An adolescent boy and young girl were selected from the community to

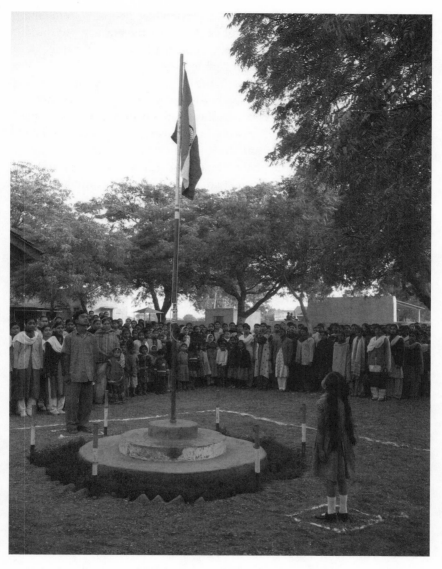

Figure C.1. Celebrating Republic Day, January 2005, Babapur, Gujarat. Photograph by the author.

hoist the flag in a public space and lead the assembled people both in taking the pledge and in singing national songs. Although the boy and girl did not wear khadi, as would have been the case in the nationalist period, they were dressed in school uniforms, and they undertook their responsibilities with the utmost sincerity and seriousness (figure 6.1); as they raised the flag, it was clearly a momentous occasion for both. Although the flag that they hoisted was that of the Indian Republic, not the swadeshi movement, the khadi charka flag was not altogether missing from this particular event. Embedded in the colors, shape, form, and design of the flag of the Indian Republic were significant traces of the khadi charka flag. The nationalist period and its public forms of celebration with khadi resonated as the community took the independence pledge and sang national songs.

This is not to suggest that Babapur's celebration of Republic Day in 2005 was no different from those discussed in this book. In some very important respects everything had changed. The people who assembled did so without the intention of subverting government authority. On the contrary, their celebration reinforced the authority of an independent India and the crucial part that the people played in its legitimacy. The public event also featured dance performances and short skits by village children, as well as the presentation of honors to a village woman who had just completed a doctorate in sociology. There were short speeches by local officials, including the head woman of the village council. In many ways, this celebration marked an expansion of the kinds of activities that communities undertook on such occasions during the nationalist period, but what fundamentally bound the past celebrations with those of January 26, 2005, was the flag—and the rituals surrounding its public display.

The relationship between khadi and the flag of the Republic of India deserves further comment. As we have seen, the khadi charka flag became in its era an important emblem of political dissent. The flag of the republic has not been used in the same manner. It was only in 2002 that Indians were granted the right to display their nation's flag. Previously, its visual deployment had remained under the strict control of the federal government. This situation came to an abrupt end when an Indian industrialist and member of Parliament, Navin Jindal, filed a petition with the Delhi High Court, asking that the court declare it to be a fundamental right of citizens to hoist the flag. As a result of the request, which drew considerable public interest, the government set out to revise two existing laws that had regulated the use of the flag since the writing of the Indian constitution. These two pieces of legislation, the Emblems and Names (Prevention of Misuse) Act of 1950 and the Prevention of Insults to National Honour Act of 1971, had effectively restricted citizens from employing the flag in many of the ways that had been

so important during the nationalist period. Although the 2002 Flag Code of India made it possible for citizens to display the flag, it did so in a closely regulated manner. Significantly, the act took effect on January 26, 2002, the seventieth anniversary of Independence Day.

The Flag Code of India begins with a statement about the significance of the flag and, particularly, its design. Representing "the hopes and aspirations of the people of India," the flag is also defined as "a symbol of our national pride," much as it had been by Gandhi in 1920.[1] Although Indians today will argue that the flag of the republic is different from the khadi charka-turned-Congress flag, the Flag Code's description of today's flag makes clear that its colors and the meanings attached to each color are strikingly reminiscent of the definitions Gandhi attributed to the flag in the 1920s, when he attempted to define the flag in non-communal terms.[2] This was no coincidence; members of the constituent assembly who approved the flag of the Indian Republic borrowed the authority of the khadi charka flag for their new government. The flag of the republic therefore has many things in common with its predecessor. It too features horizontal bands of saffron, white, and green, as did the Congress flag of 1931. In the center is an emblem of a wheel. This is, however, no longer the spinning wheel of the swadeshi movement, but instead the *Asoka chakra,* or dharma wheel.[3] Occupying the central position on the flag as the charka once had, the image of the Asoka chakra must be navy blue and superimposed over the white band in the flag. But most striking is the prescription of the material from which the flag must be made: "The National Flag of India shall be made of hand spun and hand woven wool/cotton/silk khadi bunting."[4] If the flag of the Indian republic is different from that of the swadeshi movement and later the Congress, it certainly is not substantially distinct in its visual appearance, the meanings associated with its characteristics, or the actual material from which it is produced.

Given the significance of khadi and the charka flag during the nationalist period, it is particularly interesting that a newly independent government chose to restrict its citizenry from using the national flag. Or is it? Many of the very same leaders who publicly used the khadi charka flag as a symbol of India's aspirations and dreams perhaps understood the extent of the flag's symbolic power. More significantly, they may have understood that the flag's symbolism exceeded the meaning originally intended for it, and would continue to do so. Members of the Constituent Assembly of India likely recognized that the flag had been used both to express community and to express political dissent. The new national government aimed to use the flag for the purposes of marking out its sovereign nation apart from others, but it appears to have sought to keep the flag from being used as a symbol of dissent within India itself.

The Flag Code of 2002 betrays the fact that politicians remain concerned that the flag of the India might be used as an effective tool of resistance. Although the code begins with the principle that there will be "no restriction on the display of the National Flag by members of [the] general public, private organizations, [or] educational institutions," the use of the flag is still subject to many of the provisions of the 1950 "Prevention of Misuse" act, whose title gives away its purpose.[5] Under that law, any form of the flag—as emblem, seal, insignia, coat of arms, or pictorial representation—was subject to very specific restrictions.[6] Given what we have learned about the use of the flag in the nationalist period, a couple provisions of the 1950 act stand out. The flag is restricted from any commercial use and from being dipped in salute to any person or thing. These restrictions are particularly interesting given the way that swadeshi proponents used the khadi charka flag to frame their exhibitions for consumers and given the controversy at Bhagalpur over the relationship between the Union Jack and the khadi charka flag. Of even greater interest are the provisions of the 2003 amendment to the Prevention of Insults to National Honour Act. It begins by outlawing all public activities in which the flag is ill treated. Such "ill-treatment" includes the burning, mutilating, defacing, defiling, disfiguring, destroying, trampling, showing disrespect for, or bringing contempt to the flag.[7] These terms are further defined through a dozen specific examples of illegal uses of the flag. Among them, the use of "the Indian National Flag as a drapery in any form whatsoever except in state funerals or armed forces or other para-military forces funerals" is prohibited. This prohibition is further developed in at least one later provision, which restricts the flag from being used to cover a statue, speaker's desk, or platform, much as it was commonly used to mark the dais in Congress events. In addition, using the flag as décor of any kind—as it was used not only in khadi exhibitions, but also at Congress meetings to create a sense of national space—is currently illegal. Only the state, not political parties, organizations, or ordinary citizens, is allowed to use the flag in any of its forms in this manner. Most interesting for our study is a provision that prohibits using the flag "as a portion of costume or uniform of any description or embroidering or printing it on cushions, handkerchiefs, napkins or any dress material."[8] This particular provision is often debated publicly because it prevents Indian sportsmen, including those who represent India at the Olympic Games and, more importantly, on the national cricket team from having any form of the flag on their uniforms. As a visual and material symbol that helped people to imagine India apart from its colonial status, the khadi charka flag acquired semi-sacred status, which it continues to maintain today. The hand-spun, hand-woven khadi flag of the Republic of India rep-

resents the nation's independence, but the citizens of the nation are not free to use the flag in any way that they see fit.

This book has argued that India as a nation was imagined through visual and material discourses in which khadi played a significant role. Swadeshi proponents provided a vocabulary for those discourses in the form of material objects—be they khadi clothing, hats, or flags—through which a heterogeneous, multilingual, largely illiterate population could imagine community. The sudden appearance of khadi in demonstrations and processions, beginning with the non-cooperation movement of 1921–1922, made the potential discursive power of swadeshi goods clear. The Congress's Khaddar Board and, later, the All-India Spinners' Association orchestrated the production and distribution swadeshi goods across the subcontinent.

Swadeshi proponents promoted the significance of khadi as a material and visual symbol by using it to mark the territory of their community. By providing articles for newspapers and periodicals that alerted the public to khadi activities across British India, displaying khadi goods in regional tours, and selling khadi at local exhibitions, swadeshi proponents introduced and naturalized this material symbol. These institutional strategies provided a heterogeneous population with a sense of an Indian geography, relocating rural and urban India within a marketplace shaped by common taste and defined by common values. In so doing, nationalists used khadi to make a visual argument that transcended the regional, religious, linguistic, and class distinctions of not only traditional Indian society, but also the British colonial regime. By 1930, nationalists had established the efficacy of khadi goods in resisting colonial rule, and had used khadi to superimpose a visual map of the national community upon the colonial map of India.

Khadi also transformed the bodies of colonial subjects into national subject-citizens.[9] By inventing a new style of dress, swadeshi proponents provided a simple way through which elites could identify themselves with a broader national community. Adopting new forms of dress both challenged colonial and traditional norms of comportment. The so-called "habitual khadi wearer" celebrated the principle of universal labor and self-sufficiency as the basis of political community. Those who chose to dress in khadi clothing were identifying themselves, at least ideally, with a modern political community in which social and economic difference were at least ideally subsumed within the nation. Quite simply, khadi enabled people across colonial India to see each other as members of the same or similar communities. Even if khadi could not completely transform every body into that of an "Indian," it certainly offered a visual rejection of both colonial and traditional norms of comportment.

The transformation of colonized bodies into Indian bodies gave rise to other problems. As men and women adopted khadi clothing, they theoretically surrendered various class, caste, regional, and religious markers in exchange for national ones. Yet, as we have seen, the re-clothing of men and women had different implications, depending upon one's class, community, and gender. Not only did khadi dress serve as a means for elites to establish their affinity with rural people, it also allowed them to visually maintain their distinction from non-elites. By adopting khadi, women could be transformed into Indians, but only under particular circumstances. When nationalists prescribed a new style of dress for an Indian woman, they brought her into the nation only after symbolically de-sexing her.

Khadi was also a crucial way of imagining community by commemorating the birth of the nation and national time. Like revolutionaries in France, Russia, and China, swadeshi proponents attempted to establish a new calendar.[10] Reshaping the calendar was a means through which an alternative future for the nation could be conceived. As people carried khadi in picket lines, demonstrations, and processions, they challenged colonial narratives of progress and charted a new future for their nation. Although it was the leadership of the Indian National Congress who initially declared new holidays, these occasions would have had little meaning if local communities had not undertaken their celebration. The local and repetitive use of swadeshi goods on these holidays, particularly the hoisting of the khadi flag, kept time for the nation at the local level. As the national community stretched beyond one's immediate location and experience, the synchronized, ritual celebration of new occasions and the knowledge of these extra-local practices provided a common temporal experience of the nation.

Finally, nationalists used khadi in the 1920s to challenge colonial officials over the control and use of space. Public thoroughfares, government offices and courtrooms became the battlegrounds of this struggle over the visual discourse of nationhood. In periodic skirmishes across the sub-continent, some orchestrated by the Congress, others the result of local conflicts, swadeshi goods including the Gandhi topi became the weapons of choice to redefine space. Khadi goods were used to challenge the colonial domination of the sub-continent by filling or marking spaces controlled by and associated with the colonial regime. Regardless of the impetus behind the protest, these challenges effectively transformed the imperial habitus, re-claiming the space for the nation. Clearly defining these spaces within the geo-body of the nation was as important to rendering the nation conceivable as was the reshaping of the temporal experience of the nation.[11]

Khadi continues to occupy an important place in popular imagination in

India. However, this does not necessarily mean that khadi currently connotes the same things that it did prior to independence. In the 1960s, khadi became associated with traditional folk art, even as it became the dress of a newly transnational intellectual community living in cities such as San Francisco and Cambridge, Massachusetts. Dipesh Chakrabarty has pointed out that after independence khadi clothing became identified with corrupt Congress politicians who wore high-count, high-quality khadi that lay beyond the means of the majority of India's population. Today, khadi also serves as a kind of "authentic chic" for a cosmopolitan Indian community that moves between London, New York, Sydney, and Hong Kong as much as between Delhi, Bangalore, and Bombay. Through it all, khadi remains a recognizable emblem of identity, clothing the nation through a versatile fabric of tradition that serves an Indian modernity.

NOTES

Shortened citations have been used for all works appearing in the bibliography. Frequently cited works are identified by the following:

AISA AR *The Annual Report of the All-India Spinner's Association*

Autobiography Mohandas K. Gandhi, *An Autobiography: The Story of My Experiments with Truth* (New York: Beacon, 1957)

CWMG Mohandas K. Gandhi, *The Collected Works of Mahatma Gandhi,* 100 vols. (New Delhi: Ministry of Information and Broadcasting, 1994)

Khaddar Work All-India Congress Khaddar Department, *Khaddar Work in India* (Bombay, 1922)

MSA Maharashtra State Archives, Bombay

NAI National Archives of India, London

SAP Sabarmati Ashram Papers

Introduction

1. Bayly, "Origins of Swadeshi," 285–321.

2. Cohn, "Representing Authority in Victorian India," 165–210; also see Cohn, "Command of Language," 276–329. In the latter, Cohn is primarily interested in administrative language as a defining feature of power in colonial India.

3. Thomas Metcalf, *Ideologies of the Raj.*

4. James Forbes Watson wrote a detailed study for the secretary of state for India in 1866 specifically on this subject. See Watson, *Textile Manufactures;* Risely, *Tribes and Castes of Bengal.*

5. Chaudhuri, *Thy Hand, Great Anarch!* 402–403.

6. Spyer, "Tooth of Time."

7. According to K. Sreenivasan, by 1922 the Indian textile industry was producing more manufactured cloth than was being imported from abroad. Sreenivasan, *Indian's Textile Industry,* 13.

8. For a summary of the nineteenth-century crisis over what to wear, see Emma

Tarlo, *Clothing Matters: Dress and Identity in India.* The second chapter, "Searching for a Solution in the Late Nineteenth Century," particularly addresses the debates over dress that preceded Gandhi's reinvention of swadeshi.

9. Sarkar, *Swadeshi Movement.*

10. Gandhi, "Secret of Swaraj," *Young India,* January 19, 1921.

11. Anderson, *Imagined Communities,* 6.

12. Ibid., 140. Anderson's original formulation emphasized the rise of nationalism in Europe as a model for our understanding of the process in the colonized world. Crucial to this process was the development of a world capitalist system characterized by modern states whose power derived from particular technological advances, namely print technology, which allowed the state to supplant the religious authority of the Church through the dissemination of literature, ideas, and information. Because Anderson understood print technology—or, to use his term, "print capitalism"—to have played such a crucial role in the rise of the modern identities and states in Europe, he initially extended this reasoning to the rise of national identities and states in the formerly colonized world.

13. Appadurai, "Numbers in the Colonial Imagination," 314–39; Cohn, "Census, Social Structure, and Objectification"; Edney, *Mapping an Empire;* Hirschman, "Making of Race," 330–361; Hirschman, "Meaning and Measurement of Ethnicity," 555–582; Khalid, *Politics of Muslim Cultural Reform;* Rowe and Schelling, *Memory and Modernity;* Winichakul, *Siam Mapped.*

14. Chatterjee, *Nation and Its Fragments.*

15. In describing the nationalist experience of Western nations as "modular," Anderson originally meant that they were models of the way that national identities and states developed.

16. Ramaswamy, ed., *Beyond Appearances?*

17. Freitag, "Visual Language of the Nation"; Anderson acknowledges the importance of the visual in a fleeting reference at the end of *Imagined Communities.* See p. 146.

18. Goswami, *Producing India.*

19. Ray, *The Felt Community.*

20. De Certeau, *Practice of Everyday Life,* xi–xii.

21. Ibid.

22. Thomas Metcalf made this observation to the author in 1997.

23. Iyer, *Moral and Political;* Brown, *Gandhi and Civil Disobedience.* Cambridge: Cambride University Press, 1977; Ashis Nandy, "From Outside the Imperium: Gandhi's Cultural Critique of the West" in *Traditions, Tyranny and Utopias;* Fox, *Gandhian Utopia;* Nandy, *Intimate Enemy;* Patel, "Construction and Reconstruction"; Brown, *Gandhi: Prisoner of Hope;* Thompson, *Gandhi and His Ashrams;* Skaria, "Gandhi's Politics," 955–986; Parama Roy, "Meat-Eating, Masculinity and Renunciation in India," 62–91.

24. Amin, "Gandhi as Mahatma." Pandey, *Ascendancy of the Congress.*

1. A Politics of Consumption

1. CWMG, 19:202–205. Text from a speech at Chindara, January 6, 1921.

2. The passage of the Non-Cooperation Resolution initiated a Congress agitation against the authority of the British government in India. This resolution and the movement that followed marked a significant break in the nature of political struggle in India, heralding the beginning of the mass phase of nationalist politics. No longer the sole domain of Indian elites, the new resistance—and the non-cooperation movement in particular—drew from a wider spectrum of society, especially from the middle classes who had found employment in the colonial administration.

The period of India's quest for independence has been dated from as early as 1857, when an army mutiny that transformed into a general uprising across north and central India, to August 1947, when British India was partitioned and the modern states of Pakistan and India were created. This nationalist reading of nineteenth-century politics and resistance to British rule tends to both flatten the range and quality of politics that existed in the nineteenth century and conflate them with struggles for independence, which arose much later. Following the rebellions of 1857–1858, the British Crown assumed control of the administration of territories in the Indian subcontinent that had been previously overseen by the East India Company.

Two decades after the transfer of authority to the British Parliament and Crown, the Indian National Congress (Congress) was founded by a Scot, Allan Octavian Hume. It was Hume's intention to create a body that would discuss the public matters of the day and that would offer educated Indians an opportunity to play a role in the their own governance. The Congress remained a small, elite organization, meeting once a year until just after the turn of the twentieth century when Indians found themselves at odds with the conservative leadership of Viceroy Curzon. In response to Curzon's decision to partition the eastern province of Bengal without any consultation with his subjects, the Indian National Congress spit into two factions: moderates, who favored constitutional methods for reform of the government, and extremists, who supported radical approaches like strikes and boycotts to bring about change. The range of political strategies is testimony to a key characteristic of the Congress that is often misunderstood; it was from its beginning an umbrella organization, rather than a traditional political party. Despite the differences in political ideology of its members, the stated aim of the Indian National Congress until 1930 was the obtainment of home rule, or responsible government, within the British Empire. It was only in 1930 that the Congress revised this goal, adopting "Purna Swaraj," or complete independence from the British Empire, as its stated aim. The struggle for Indian independence is thus better seen as opposition to the rule established following the turmoil of the late 1850s and more particularly to a period of mass politics.

3. Central to understanding the development of a desire for independence and the rise of mass politics are the roles of the Indian National Congress, Mohandas

Gandhi, and the political movements he organized. Mohandas K. Gandhi's relationship to the independence movement generally, and to the Congress in particular, has been a challenge for scholars of modern South Asia. Quite simply, Gandhi is a figure larger than life; he is at once considered the father of the nation and a saint. Gandhi's chief significance for the struggle for independence lies in his orchestration and popularization of alternative forms of political struggle. He oversaw a variety of what may be termed Civil Disobedience campaigns between 1917 and 1948, three of which are of particular significance: the non-cooperation movement (1920–1922), the salt satyagraha (1930–1932), and the quit India movement (1942–1943). Each in its own way eroded the legitimacy of the foreign government, and within each movement Gandhi laid out specific activities and goals for his fellow-countrymen in an attempt to develop a more disciplined citizen for a future nation. The swadeshi movement was conceived before the non-cooperation movement, however, and became a central part of this particular attempt to win reform from the government. The revival of hand-spun, hand-woven cloth was seen as an important way not only of rejecting British goods and undermining British economic power over India, but also of rendering Indians self-sufficient. Long after the non-cooperation movement was over, swadeshi politics continued to garner the attention of Gandhi and many of his closest followers. In another form, the movement even survived the independence movement itself as it was refigured by the Republic of India as the All-India Khadi & Village Industries Board that continues to exist today.

4. Washbrook, "Progress and Problems," in Thomas Metcalf, ed., *Modern India,* 203.

5. Sarkar, *Swadeshi Movement,* 95.

6. Ibid., 3–4.

7. Cited in Sarkar, *Swadeshi Movement,* 35 and 43–45.

8. Gandhi, *Hind Swaraj.*

9. Fox, *Gandhian Utopia,* 88–90.

10. Gandhi established the *Indian Opinion* in South Africa in 1903.

11. Gandhi, *Hind Swaraj,* 35.

12. Thompson, *Gandhi and His Ashrams,* 108.

13. CWMG, 13:91–93, discusses the swadeshi pledge; Thompson, *Gandhi and His Ashrams,* 111, addresses ashram priorities.

14. Thompson, *Gandhi and His Ashrams,* 108.

15. CWMG, 13:95.

16. "Circular Letter for Funds for the Ashram," in CWMG, 14:455–463. For a discussion of the daily activities of the ashram community, see Gandhi, *Ashram Observances,* appendix A, 116–119.

17. *Autobiography,* 489–496; CWMG, 14:31–36. We know very little about either this program or the participants in this conference, aside from the fact that Majmundar met Gandhi at Broach. Gandhi's autobiography briefly discusses the meeting; the speech that Gandhi delivered at the conference is included in his collected works.

18. Majmundar was likely the product of the nineteenth-century Maharashtrian

movement to reform the treatment of Indian widows. See Chakravarti, *Rewriting History;* O'Hanlon, "Issues of Widowhood," 23–61; Kosambi, *Pandita Ramabai.*

19. *Autobiography,* 492–93.

20. Cited in Thompson, *Gandhi and His Ashrams,* 122.

21. CWMG, 18:59–60.

22. Thompson, *Gandhi and His Ashrams,* 140.

23. Grant and Trivedi, "A Question of Trust"; Minault, *Khilafat Movement.* At the time Gandhi launched the non-cooperation movement, he had a precarious relationship with the Indian National Congress and its leadership. Certainly there were those in the Congress who were already inclined toward Gandhi, who had received the confidence of one of its most important leaders, Gokhale. However, there were many others who were suspicious of his claims, not only because of the constructivist approach, but also because of its focus on India's broader population. Gandhi held neither an official post in the leadership structure of the organization nor was he a member. Following his return from South Africa, he addressed the Congress, but had found little interest for his particular style of politics, and had therefore concentrated his efforts on the ashram community in Ahmedabad.

The shocking triad of abuses leveled against Indians in 1919 appears to have broken the illusion of moderate politicians with regard to their approach to reform through the official channels of the British government of India. Muhammad Ali Jinnah, a prominent member of both the Congress and a parallel organization, the Muslim League, resigned a seat to which he had been appointed by the viceroy in protest. Congress leaders found themselves disillusioned and seeking an alternative approach, one which they found in the quiet power of Gandhi's program. It was these particular circumstances that cast Gandhi's political approach in a new light. The Indian National Congress found in Gandhi the alternative it was seeking, and Gandhi found in the Congress a platform to popularize his style of political dissent.

Gandhi's approach, called non-cooperation, was based upon the simple premise that without Indian cooperation, the maintenance of British power in India was doomed to failure. Gandhi would eventually sell a number of different activities as "non-cooperation," among them the withdrawal from participation in government and government colleges, the expansion of the membership of the organization, and the boycott of British goods; swadeshi politics had found its way into the Indian National Congress's political platform.

24. CWMG, 20:37–38.

25. CWMG, 21:78. *Amrita Bazar Patrika* also covered a speech given by Gandhi in Calcutta's Harish Park on September 8, 1921: "Mr. Gandhi said that there was a good deal of difference between the swadeshi movement in the days of the partition of Bengal and the present movement. . . . At that time the movement was set on foot to get redress of certain grievances but the present had a higher and nobler object in view, namely, the attainment of swaraj."

26. *Khaddar Work,* 1.

27. See *Khaddar Work,* 1–2, and AISA annual reports for 1925–1926.

28. *Khaddar Work,* 7. The budget for 1922 All-India Khaddar Board: Technical Instruction-Rs. 25,000/-; Production Department-Rs. 20,000/-; Sales Department—Rs. 200,000/-; Propaganda and Information Bureau—Rs. 100,000/-, Loans to Provinces—Rs. 1,355,000/-.

29. Papers of the All-India Khaddar Board, January 31–February 1, 1924. The Nehru Memorial Library collection on microfilm contains minutes from fifteen meetings of the Board held between January 2, 1924, and September 24, 1925.

30. *Khaddar Work,* 1.

31. Nanda, *In Gandhi's Footsteps.* This is the seminal biography of Bajaj.

32. Examination of the papers of the All-India Khaddar Board cited above in n. 27 supports this observation.

33. *Khaddar Work,* 1–5.

34. Bombay Swadeshi League, *Classified List of Manufacturers.*

35. *Khaddar Work,* 3.

36. Ibid., 5.

37. Records of the sudden proliferation of khadi goods in public appear in the *Fortnightly Reports of the Government of India,* Home Department, NAI.

38. The criticism that emerged in the 1920s followed the movement in subsequent decades and may in large part explain the scant attention historians have paid to the movement in contrast to some of Gandhi's other efforts.

39. Ashis Nandy, *Illegitimacy of Nationalism,* 1–8 and 80–90.

40. *Autobiography,* 492; Anil Baran Roy, *Khadi under searchlight.* Gandhi's autobiography tells us that the cost of khadi was high in the early days of production. The first piece of khadi manufactured in the Satyagraha Ashram cost 17 annas per yard. Roy's text is a collection of his articles written over the course of the 1920s. Many were published in the *Bombay Chronicle.* Khadi was approximately 30 percent more expensive than its mill-made counterparts during the 1920s. The khadi institutions in Andhra, for example, recorded that the cost of one yard of 45"–50" khadi (approximately 4.5 meters were needed for a dhoti and 5.5 meters for a sari) was 12 annas in 1922, 11 annas 6 pies in 1923, 11 annas in 1924, 11 annas 6 pies in 1925, 10 annas 6 pies in 1926 and 9 annas in 1927. The Spinners' Association claimed that the price of khadi had decreased by 25 percent or more over the course of the decade. For the comparable cost of khadi in other areas of India, see AISA AR for 1924–1931.

41. Papers of the All-India Khaddar Board, no. 3501, reel 3. Sixth meeting of the board, August 1, 1924.

42. Ibid.

43. Majumdar et al., *Advanced History,* 985–987.

44. AISA AR for 1925–1926, 1.

45. Krishna, "Development of the Indian National Congress," 413–430. A larger body of scholarship explores the transformation of the Congress into a mass organization during this period, including works by scholars of the Cambridge school and the Subaltern Studies Collective.

46. Zaidi, *INC* 3:257–324.

47. Ibid., 274–276.

48. Ibid., 257–258.

49. Ibid., 314–319. Also note that the resolution addresses the duties of men and women. Clause 3 of part A of the Congress Unity Resolution reads, "the Congress expects every Indian man and woman to discard all foreign cloth and to use hand-spun and hand-woven khaddar to the exclusion of all other cloth and personally to spin at least half an hour a day till boycott of foreign cloth and foreign yarn is attained and hand-spinning has been restored to its original status as the universal cottage industry of India." Clause 4 continues, "the Congress expects all Congress men and Congress women to concentrate their attention on the spread of hand-spinning and the antecedent processes and the manufacture and sale of khaddar."

50. Ibid., 355. Resolution passed by the All-India Congress Committee Meeting at Patna on September 22, 1925.

51. Ibid., 351–357. Under the spinning franchise, members were supposed to contribute 24,000 yards of hand-spun thread. After the repeal of the franchise, the Congress required only 2,000 yards of thread annually for Congress membership.

52. See Spinners' Association annual reports for 1926–1927; 1925–1926, 9; 1926–1927, 12; and 1934–1935, 30. The reports of the Spinner's Association were published in English and therefore aimed at the educated class in India. The 1926–1927 report specifies that there were 627 carders, 83,339 spinners, and 5,193 weavers employed in the movement by the end of 1927.

53. AISA AR for 1930, title page.

54. AISA AR for 1925–1926.

55. An announcement that Maganlal Gandhi awarded the first prize for an improved spinning wheel appeared in *Young India,* October 18, 1920.

56. AISA AR for 1925–1926. This report notes that the association set out to reorganize khadi production through three basic strategies: (1) the association was to be made up of provincial branches and departmental centers of work, (2) the association was to be made up of independent public organizations which were nonprofit, (3) the association was to be made up of a few for-profit organizations/businesses that the association certified but did not fund.

57. Jaju, *All India Spinners' Association and Its Work,* 10.

58. AISA AR for 1925–1926. The report indicates that funds for the year 1925–1926 came from the Deshbandhu Memorial Fund (Rs. 213,600) and a private donation made by Jamnalal Bajaj (Rs. 50,000). In that year, the production and sale of khadi more than doubled. While the association did not have what it considered to be complete figures, the report promises a more accurate accounting once the new system of accounts was established, and indicates that khadi prices had fallen between 7 and 8 percent over the course of the previous year, possibly causing an overestimation of the amount of khadi sold.

59. AISA AR for 1925–1926, 4–5. According the annual report, the association decided to increase funding of its own stores in those regions with recent improvements. Provinces including Tamil Nadu, Behar, and Bengal that had had consistent

success were not funded at the same level as the newcomers. Institutions in these regions were asked to continue based upon their own success.

60. AISA AR for 1926–1927.

61. When Gandhi decided to admit untouchables to his ashram, he met resistance from those who had financially supported his experimental community. The result was a social boycott against the admission of untouchables. The ashram would likely have closed but for the appearance of a new supporter, Sheth Ambalal Sarabhai, who offered to deliver a donation. As Gandhi recalled, "Next day, exactly at the appointed hour, the car drew up near our quarters, and the horn was blown. . . . The Sheth did not come in. I went out to see him. He placed in my hands currency notes of the value of Rs. 13,000, and drove away." See *Autobiography*, 397–399.

62. A takli is a handheld spindle used for spinning khadi thread. The takli was the least expensive and most basic of all spinning implements used during the period. At the expense of the Spinners' Association, taklis were often supplied to villagers and distributed to municipal schools for children to use.

63. Cited in Leadbeater, *Politics of Textiles*, 115.

64. Lokamanya Tilak was a Maharashtrian social reformer, activist, and nationalist who was well known for having led the extremist factions within the Indian National Congress in the late nineteenth century. As an outspoken advocate of terrorism in the Bengal swadeshi movement, Tilak was jailed. He was known also for having said "Swaraj is my birthright." After the conclusion of the non-cooperation movement, Gandhi used the Tilak Swaraj Fund for a variety of purposes, including the swadeshi movement.

65. Cited in Leadbeater, *Politics of Textiles*, 97.

66. According to the AISA AR for 1925–1926, the fund was established specifically for the All-India Spinners' Association. Along with Motilal Nehru, Chitta Rajan (Deshbandhu) Das (1870–1925) was a leading force behind re-establishing dialogue with the British following the suspension of the non-cooperation movement, a position that put him at odds with Gandhi. A barrister in the Calcutta High Court, Das had first gained national attention for his defense of several Indians accused of sedition. Between 1917 and 1925, he became an increasingly influential nationalist leader.

During its first three years, the annual reports of the Spinners' Association indicate that the D. D. F. contributed substantial sums of money to the Association; it gave Rs 213,600 in 1925–1926, Rs 227,600 in 1926–1927 and Rs 344,612 in 1927–1928.

67. Mahadev Desai, "With Gandhi in Gujarat," *Young India*, April 23, 1925. Desai's account gives some examples of their local fundraising. He wrote, "That brings me to Broach and the cotton collections made there. Altogether something over Rs 7000/- was collected in two days, very small villages contributing handsomely."

68. My analysis here follows that of Shahid Amin in "Gandhi as Mahatma," 1–62.

69. Gandhi made appeals to women to support the movement by donating their ornaments. Cf. "To Women," *Navajivan*, November 28, 1920, "How to Finance the [Swadeshi] Movement," *Young India*, January 12, 1921, "Speech at Patna," February

6, 1921, and "Rawalpindi Sisters," *Navajivan,* Febrary 29, 1921. All of these articles are included in Joshi, ed., *Gandhi on Women.*

70. SAP, nos. 10650 and 10242. Many of the papers of the All-India Spinners' Association remain within the archives at Sabarmati Ashram (formerly Satyagraha Ashram) in Ahmedabad, Gujarat.

71. Gregg, *Economics of Khaddar.* Gregg explains that the spinning wheel was used in famine relief near Ahmednagar in 1920–21, Adhradesh in 1922, Coimbatore in 1924, North Bengal in 1923–24, and Talmil Nadu in 1925. He also notes that it was used in flood relief in South Kanara in 1924, in Bengal's Hoogly District in 1922, and in the Rajshahi and Bogra districts in 1922–1923.

72. Cited in Thompson, *Gandhi and His Ashrams,* 149. According to Thompson, this article appeared in *Young India* on April 13, 1927.

73. Zaidi, ed., *Story of Congress Pilgrimage,* 3:155.

74. AISA AR for 1931, i.

2. Technologies of Nationhood

1. Gandhi, "The Exhibition," *Young India,* July 14, 1927.

2. Winichakul, *Siam Mapped;* Edney, *Mapping an Empire.* It is important to remember that India's contemporary boundaries were not established until after the partition and independence of India in August 1947. Instead what you see in visual representations of India in the 1920s to the 1940s is a nation imagined to include both the territories of British India and of the Princely States, as well as Burma and often colonial Ceylon. In such maps, the northwestern and eastern boundaries of India were more often suggested than delineated.

3. Ramaswamy, "Catastrophic Cartographies," 92–129; Ramaswamy, "Maps and Mother Goddesses," 97–114.

4. Freitag, "Visual Language."

5. Sandria Freitag, "State and Community," 226–227.

6. During the period under consideration, the Indian subcontinent was divided into two distinct areas. British India, made up of administrative units that were sometimes called provinces and sometimes called presidencies, was administered on behalf of the Crown by the British Parliament. Princely India comprised roughly one-third of the subcontinent and was governed by local, hereditary rulers who had negotiated treaties with the East India Company and the Crown, allowing them to retain hereditary rights in close cooperation with British representatives.

7. MSA Education Department, files no. 675/1920 and 675/1921.

8. Memorandum by K. A. Bala, principal, PR Training College for Men, to V. S. Toro, deputy education inspector for visual instruction, May 7, 1921, MSA Education Department, file no. 675/1921, memorandum no. 292.

9. MSA Education Department, file no. 675/1921.

10. Winichakul, *Siam Mapped.* Winichakul's concept of the geo-body illuminates an important aspect of the way nations are imagined. Although he suggests that the

geo-body of a nation appears to be "a certain portion of the earth's surface which is objectifiable," he explains that it is actually an "effect of modern geographical discourse whose prime technology is a map" (17). Extending Winichakul's formulation, our idea of India is itself a product of our idea of India on a map. In other words, the geo-body of the Indian nation had to be imagined through classification by area, communication by boundary, and an attempt to enforce that boundary before the nation—an entity for which people would sacrifice, endure violence, and die—could be conceived.

11. Duara, *Rescuing History,* 55.

12. Ibid., 65. Duara explains that historical groups consolidate several societies into one by "the hardening of social and cultural boundaries around a particular configuration of self in relation to an Other. . . . This process of closure is relevant to both historical and modern communities; . . . It reveals how historical and cultural resources are mobilized in the transformation."

13. For a comparable study of the rhetoric of contemporary print media, see Israel, *Communications and Power.*

14. Pinney, "The Nation (Un)Pictured?" 835–867. A sample of Gandhi's opinions of women's roles in national regeneration can be found in Joshi, ed., *Gandhi on Women,* 1691–1702; and in Patel, "Construction and Reconstruction of Women in Gandhi," 377–387.

15. *Khaddar Work,* 1.

16. Manu Gosawami has made a similar point about the way in which territoriality of the nation was imagined as an economic space. See Goswami, "From Swadeshi to Swaraj," 609–636.

17. Dutt, *Economic History of India.*

18. Das Gupta, *Cotton.*

19. Williams, *Dream Worlds.*

20. Bayly, *Raj.*

21. MSA Home Department (Political), file no. 262/1922.

22. Personal communication with Hasumati Purohit, March 1996. The spinning implement pictured here is a takli, the most common and least expensive spinning instrument used during the period. Swadeshi proponents distributed takli to school children during the nationalist period and afterwards.

23. Pinney, *Camera Indica.*

24. Lelyveld, "The Fate of Hindustani"; Christopher King, "Forging a New Linguistic Identity," 179–202. Although Urdu had been the language of the ruling elites in north India for centuries, the redefinition of Hindi as Hindu and Urdu as Muslim, because of their scripts, was already underway by the 1920s.

25. MSA Home Department (Political), file no. 262/1922. Song no. 9 in a booklet called *Swaraj Darshan.*

26. SAP, no. 8054. Included in this file were also clippings from the *Khilafat, New Times, Searchlight, Swarajiya,* and *Young India.*

27. An exception was the paper *Janmabhumi,* which was published in both English and Hindi.

28. *Swadeshi no Ghero;* Kalelkar, *Swadeshi Dharma;* Punatambekar, *Khadi Ni-bandha.*

29. Several scholars of nationalist India have commented upon the extensive discussion of swadeshi politics and khadi in other Hindu-speaking areas. Both Shahid Amin and Gyanendra Pandey discuss Hindi-language newspapers and pamphlets in their regional studies of the United Provinces. See Amin, *Event, Metaphor, Memory,* 225, n. 87; Pandey, *Congress in Uttar Pradesh,* 30–113.

30. AISA AR for 1926–1927, 7. The report refers to the Abhoy Ashram and the Khadi Pratisthan, two prominent centers of swadeshi political organization.

31. Anderson, *Imagined Communities,* 44–45.

32. Duara, *Rescuing History,* 71.

33. C. Rajagopalachariar assumed the role of editor for the newspaper *Young India* following Gandhi's arrest for his involvement in the non-cooperation movement.

34. Goswami, *Producing India.*

35. "Khadi Exhibitions," *Young India,* October 14, 1926.

36. MSA Education Department, files no. 675/1920 and 675/1921.

37. Zaidi, *INC,* 3:314–315.

38. This sales figure only an estimate, as it does not include what the report vaguely labels "regular propaganda tours." See AISA AR for 1925–1926, 8.

39. AISA AR for 1926–1927, 16 and 29.

40. AISA AR for 1927–1928, 1 and 23. The extent of this tour in Mysore was exceptional. Gandhi aimed his Civil Disobedience movements at British India, rather than Princely India, because he viewed foreign rule as India's greater problem. Moreover, Gandhi and Congress leaders made a strategic decision not to open conflicts on multiple fronts. Instead, they opted to conserve their energies and hoped in time to attract the support of princes, thereby drawing upon them both to legitimize their goals and to demonstrate the capacity of Indians to govern themselves (see Ramusack, *Indian Princes*). Evidence suggests this strategy was successful. Perhaps because Gandhi and the Congress had not confronted native princes about their authority, in due course some rulers warmed to the nationalist cause. While some princes remained fiercely loyal to the British Crown and some held both nationalist politics and British authority at arms' length, others became sympathetic enough to Congress politics that they provided safe refuge from British officials who regularly chased suspected political opponents into princely states where they had no jurisdiction. Still other princes, like those of both Jaipur and Mysore, underwent their own awakening and became active supporters of nationalist politics.

41. Pinney, *Camera Indica.*

42. SAP, no. 12320. Indian currency comprised rupees, annas, and paise. There were 16 annas to each rupee and 100 paise to each rupee.

43. Hansen, "Birth of Hindi Drama."

44. Pandey, "Rallying Around the Cow," in R. Guha, ed., *Subaltern Studies,* 2: 60–129. This strategy was not entirely new to the Indian political and religious world. The movement for cow protection in the 1890s did much the same thing in gathering a cross-section of society. This earlier campaign worked primarily with posters,

rather than lantern slides. Moreover, in previous gatherings there were customs that determined how people of various social standing participated.

45. SAP, no. 12320. Another description of lantern slides may be found in the article "Who's Who" in *Young India*, March 12, 1930. This collection appears to be focused on images of people of national interest. It includes pictures of Gandhi, but also pictures of khadi workers and professors at national colleges, as well as Muslim and untouchable weavers. All of those pictured were engaged in swadeshi politics.

The lantern slides available from the Pratisthan were still being expanded in 1927. See "Report of Bengal Khadi Pratisthan," *Young India*, December 22, 1927.

46. Cohn, "Census, Social Structure, and Objectification in South Asia."

47. Satis Das Gupta to Maganlal Gandhi, December 16, 1926, SAP, no. 12320.

48. Skaria, "Gandhi's Politics," 955–986.

49. AISA annual reports from 1925 through 1934. Khadi exhibitions held under the auspices of the All-India Spinners' Association included Bihar, Maharashtra and U. P. exhibitions in 1925–1926; Bombay Agricultural Show, Bangalore, Hardwar and Bharatpur exhibitions in 1926–1927; and Madras, Baroda, Kapdranj, Ajmer, Cochin and Rohat exhibitions in 1927–1928. Khadi enthusiasts combined their use of lantern slides with traveling exhibitions.

50. Hoffenberg, *Empire on Display*. For additional insightful works on the history of exhibitions in the colonial world, see Ezra, "The Colonial Look," 33–49; Kusamit-su, "Great Exhibitions," 70–89; Mitchell, *Colonising Egypt*; Nunes, "Exploring Less Charted Terrains," 99–126; Tenkotte, "Kaleidoscopes of the World," 5–29; Woodham, "Images of Africa," 15–33; Yengoyan, "Culture, Ideology, and World's Fairs," 62–83.

51. Maganlal Gandhi, "Khadi Exhibition," *Young India*, January 18, 1923. Accounts of khadi exhibitions regularly appeared in *Young India*.

52. "The Cawnpore Khadi Exhibition," *Young India*, January 14, 1926. Durries and assans are inexpensive household rugs or mats which may be used for sitting comfortably on the floor.

53. Richard Gregg, "The Congress Khadi Exhibition," *Young India*, January 14, 1926.

54. Jamshedpur and Ahmednager figures were reported in "Khadi Exhibitions," *Young India*, October 14, 1926. Figures for the Madras exhibition were reported in "Madras Khadi Exhibition," *Khadi Patrika*, February 1, 1928.

55. "Khadi Exhibition in Behar," *Young India*, July 1, 1926.

56. The planning of the exhibition in Bangalore can be reconstructed through correspondence of the Spinners' Association. See SAP, nos. 11855 n.d.; 11857 dated May 31, 1927; 11858 dated June 6, 1927; 11860 dated June 11, 1927; 11861 dated June 13, 1927; 11862 dated June 10, 1927; 11664d; 11865 dated June 27, 1927; 11866 dated June 17, 1927; 11870 dated June 28, 1927.

57. AISA AR for 1926–1927, 16. The tone of Maganlal Gandhi's response to local requests for signs, maps, and charts suggests that such appeals were not out of the ordinary. The annual report for the previous year, for example, notes that the general secretary of the All-India Spinners' Association, Laxmidas Purshottam, had provided

spinning and carding demonstrations while on tours of Bengal, Utkal, Andhra, Tamilnad, Karnatak, Punjab, the United Provinces, and Ajmer. "The demonstrations given by Sjt. Laxmidas Purshottam of carding and spinning were much appreciated by the workers as well as the spinners themselves and conveyed to them as nothing else could have done the need as well as the practicability of effecting the improvement required."

58. The khadi exhibitions of Bihar in 1926 were discussed in *Young India* from July through October 1926. Exhibitions were carried out at 1) Bihar Vidyapith outside Patna, 2) Bihar Young Men's Institute, 3) Arrah, 4) Muzzafarpur, 5) Chupra, 6) Maunea, District Chupra, 7) Gaya, 8) Bettiah, 9) Motihari, 10) Laherea Serai, Darbhanga, 11) Debghar, 12) Hazaribagh, and13) Jamshedpur.

The Spinners' Association annual report for 1925–1926 described the exhibitions held that year: "The Bihar Department organized khadi exhibitions at several centers within the province and this served not merely to dispose of large quantities of their khadi stock, but to create sentiment in favour of khadi in individuals and in regions that had stood so far unaffected by the movement. Khadi exhibitions were also organized with good results at a number of centers in Maharashtra. The U. P. Khadi Department is also arranging to organize exhibitions with this object at a number of important places in the province."

59. Maganlal Gandhi, "Khadi Exhibition," *Young India,* January 18, 1923.

60. "Madras Khadi Exhibition," *Khadi Patrika,* February 1, 1928. The layout of the exhibition's displays was as follows: 1) Sjt. V. R. Kamath's Stall—goods from across the country; 2) Bihar Gandhi Kutir—featuring Kokti cloth made in Bihar; 3) A. I. S. A., Punjab Branch—featuring pictures, tablecloths and carpets; 4) Bombay Khadi Bhandar—goods from across the country; 5) Deshi Vanijya Sabha, Masulipatnam Madras—khadi goods popular in middle class; 6) A. I. S. A., Karnatak—specialized in cheaper, medium-weight khadi; 7) Khadi Printing & Dying Works, Bombay; 8) Khadi Pratisthan, Calcutta, Bengal—high count khadi like Dacca-style saris and dyed khadi, also a map indicating the centers of production in Bengal; 9) Rashtriya Stree Sabha, Bombay—women produced cloth and then embroidered. Also featured clothing specifically for children and the home; 10) A. I. S. A., Andhra, Guntur Branch—wide range of Andhra stock; 11) Konzu hand-spinning & weaving Co. Ltd., Tirupur, Madras; 12) Kamma Khadi Vastralayam, Rajapalayam; 13) R. A. Riddhi Raji, Raja Khadi Vastralayam, Rajapalayam; 14) Gandhi Ashram, Tiruchendodu; 15) K. R. Siddharaju Khadi weaving factory, Salem; 16) C. V. Jayagopala Chetty, Salem; 17) Shri Gandhi Khadiaralavam, Tirupur; 18) K. Vishvanatham, Masulipatam; 19) Khadi Vastralayam, Tirupur.

61. "South India Khadi Exhibition," *Young India,* December 22, 1927. My italics.

62. This idea derives specifically from Rosalind Williams' work on mass consumption in France. See Williams, *Dream Worlds,* 65–106. British and French historiography has proved helpful in thinking about consumption in modern society. See McKendrick, Brewer, and Plumb, eds., *Birth of a Consumer Society;* Michael Miller, *Bon Marché.*

3. The Nation Clothed

1. "No and Yes," *Young India,* March 17, 1927.

2. See international press coverage of the period on the swadeshi movement. Parker, "Gandhi's Spinning-Wheel"; Cornelius, "Mahatma Gandhi and His Charka," 17; Taraknath Das, "Gandhi and the Spinning Wheel"; Gertrude Marvin Williams, "Gandhi Sets India Spinning"; Parker, "Salvation by Thread." On the British government of India, see records from the Home Department in the previous chapter.

3. Cohn, "Representing Authority in Victorian India," 312–313.

4. Bayly, "Origins of Swadeshi"; Appadurai, *Social Life of Things,* 30.

5. Bean, "Gandhi and Khadi."

6. Tarlo, *Clothing Matters.*

7. Other important scholarship on clothing includes Kroeber, "On the Principle of Order," 235–263; Simmel, "Fashion," 541–558; Kuper, "Costume and Identity," 348–367; Joseph, "Uniforms and Non-Uniforms"; McCracken, "Culture and Consumption"; Davis, *Fashion, Culture and Identity;* S. Iyengar and W. J. McGuire, eds., *Explorations in Political Psychology;* Spyer, "Tooth of Time."

8. Judith Butler, *Gender Trouble: Feminism and the Subversion of Identity* (London: Routledge, 1990); De Certeau, *Practice of Everyday Life;* Pinney, "The Nation (Un)Pictured?" 834–867.

9. Tarlo, *Clothing Matters,* 68–75.

10. Foucault, *Discipline and Punish,* 136–138. These ideas are developed in the chapter "Docile Bodies."

11. Gandhi, *Hind Swaraj.*

12. Gandhi, *Hind Swaraj,* 33–34.

13. Gandhi's critique of modernity was developed in a series of articles written for his newspaper *Indian Opinion* and later published under the title *Hind Swaraj, or Indian Home-Rule.*

14. I owe this connection to Laura Ring's paper "Gender, Consumption and the Problem of Desire: Gandhi's Critique of Modernity." Unpublished paper. 12 June 1992.

15. As cited in Ring's paper. See also *Autobiography,* 24–26.

16. As cited in Ring, 15. See also Joshi, ed., *Gandhi on Women,* 78.

17. "The Secret of Swaraj," *Young India,* January 19, 1921.

18. Gandhi's phrasing in the article "War on Khaddar," *Young India,* July 3, 1930.

19. For example, see: NAI Home Department (Political), file no. 290/1921, Home Department (Political), file no. 858/1922; Home Department (Political), file no. 173/1924; Home Department (Political), file no. 10/XXXIII/1927; Home Department (Political), file no. 12/VIII/1930.

20. "The Self-Spinner's Table," article attributed to Devdas Gandhi, *Young India,* April 14, 1927. Devdas Gandhi was the son of Mohandas Gandhi.

21. My attention to this kind of detail has been greatly influenced by Carole Patemen's *Sexual Contract.*

22. Photographs of Motilal Nehru appear in *The Dynasty: The Nehru-Gandhi Story* courtesy the Nehru Memorial Museum and Library. Photographs of Mohandas and Kasturba Gandhi appear courtesy the National Gandhi Museum, New Delhi.

23. "The Function of Women," *Young India*, October 18, 1928.

24. "A Sister's Difficulty," *Young India*, 2 February 1928. Letter first published in *Navajivan*, January 29, 1928.

25. *Elite*, except when it is distinguished specifically from *middle class*, is a broad term used to describe people who had high status because of class or religion. Among the elites, then, were large landowners and industrialists, as well as high-caste Hindus and Muslim religious and cultural leaders. *Ordinary people* is used throughout to describe Indians who had not yet been integrated into Congress or other kinds of nationalist politics. The term is used specifically to draw forward the point that those who carried out Gandhi's strategies were not limited to those who accepted his larger political program. Instead, in the case of the celebrations of holidays, the form of protest drew in a broad range of people that extended beyond active Congress membership.

26. "A Sister's Difficulty," *Young India*, February 2, 1928. Letter first published in *Navajivan*, January 29, 1928.

27. Chaudhuri, *Thy Hand, Great Anarch!* 402–403.

28. We see this in Gandhi's writings on spinning. Throughout the period under consideration, Gandhi addresses his pleas for women to return to spinning as a means of uplifting prostitute and widowed women. Cf. "Our Fallen Sisters," *CWMG* 21:104–106; "Speech at Madras," *CWMG* 21:23; "Our Unfortunate Sisters," *CWMG* 26:516–517; "Fallen Sisters," *CWMG* 27:290–291.

29. Chatterjee, *Nation and Its Fragments*; 159.

30. See Mani, "Contentious Traditions: The Debates over Sati in Nineteenth-Century Colonial Bengal," 88–179.

31. "The Secret of Swaraj," *Young India*, January 19, 1921. "In hand-spinning is hidden the protection of women's virtue, the insurance against famine, and the cheapening of prices. In it is hidden the secret of swaraj."

32. These are periods, I might point out, similarly targeted as significant by colonial officials concerned with the "Moral and Material progress of India."

As one prominent khadi supporter, C. Rajgopalichariar, wrote about the benefit of spinning, especially for rural women, "I deprecate attempts at giving facilities for factory employment to our female agricultural population. We can and should find such occupations for them as will not involve separation from the family for continued duration. Our experience of the effects of ginning and other factories near rural areas on the life and character of the female rural population warns us against any extension in that direction in order to solve the problem of rural employment." "The Wheel of Life," *Young India*, December 2, 1926.

33. This follows from Partha Chatterjee's argument that nationalists had to re-interpret native customs to combat the colonial discourse that portrayed Indian culture as inferior to the West based upon the treatment of its women.

34. "Enforced Widowhood," *Young India*, August 5, 1926.

35. "Khadi in the Hyderabad State," *Young India,* December 20, 1928.

36. "A Creeper in Peridiniya," *Young India,* March 29, 1928.

37. "Khadi work in Tamil Nad," *Young India,* January 9, 1930.

38. "Weekly Letter," *Young India,* February 10, 1927.

39. "Deshbandu Day at Darjeeling," *Young India,* July 7, 1927.

40. "The Function of Women," *Young India,* October 18, 1928. Written by Mahadev Desai.

41. Nehru, *Toward Freedom.* They are Jawaharlal Nehru's sister and wife.

42. The bureaucratic structure of the colonial state solidified and polarized identities through projects like the Census over the course of the previous fifty years. Also, during the period under study, community identities were being given new meaning through the reforms put into place in anticipation of self-government. See Cohn, "Census, Social Structure and Objectification." See also Appadurai, "Number in the Colonial Imagination."

43. Anil Baran Roy, *Khadi under Searchlight.* Anil Baran Roy was one of the swadeshi movement's most vocal critics in Western India.

44. While there are no official records that can substantiate this claim, I draw my conclusions from more than a dozen interviews with people who took up khadi during the nationalist period and shortly thereafter.

45. I owe this observation to Krystyna von Henneberg. See "The Construction of Fascist Libya."

46. Naidu was the first woman to address the Indian National Congress in 1906, and she was the first Indian woman elected, in 1925, as president of the organization. Naidu was also a founding member of the All-India Women's Conference that worked over a decade to assure women's enfranchisement, eventually codified in the 1935 Government of India Act.

A comprehensive collection of Naidu's life and work may be found in Natesan, ed., *Speeches and Writings of Sarojini Naidu;* Makarand Paranjpe recently published *Sarojini Naidu: Selected Letters.* In addition, there are several significant biographies on Naidu, the three most important being Padmini Sengupta's *Sarojini Naidu: A Biography;* Tara Ali Baig's *Builders of Modern India: Sarojini Naidu;* and S. R. Bakshi's *Sarojini Naidu: Struggle for Swaraj.* Bakshi's biography, though widely cited, is largely drawn from the Sengupta biography.

47. Quoted in Sengupta, *Sarojini Naidu,* 258–259.

48. Ibid., 259. My emphasis. "Though Sarojini was strictly Swadeshi in all she wore or purchased, and she was pledged to it, she never associated 'drab white' as the only form of clothing Swadeshi could produce. Even when she went on Khadi campaigns, her Khaddar was often coloured and gay." Sengupta, *Sarojini Naidu,* 317.

49. Tarlo, *Clothing Matters,* 108.

50. There is no doubt that the elite nationalists imagined India, as Anderson has suggested, through her relation to an international community of nations. Jawaharlal Nehru, for example, writes quite directly about this subject in his memoir: "What is this India, apart from her physical and geographical aspects? What did she represent

in the past; what gave strength to her then? . . . Does she represent anything vital now, apart from being the home of a vast number of human beings? How does she fit in to the modern world?

"This wider international aspect of the problem grew upon me as I realized more and more how isolation was both undesirable and impossible. The future that took shape in my mind was one of intimate co-operation, politically, economically, culturally, between India and the other countries of the world." Nehru, *Discovery of India*, 37–40.

51. That elite nationalists including Naidu and Nehru were able to enlarge the definition of swadeshi broadly enough to include expensive or traditionally produced goods, does not mean that the meaning of khadi clothing was solely transformed by elites. An example of challenges by non-elites follows in the case of contestation over the nature of gender relations within the nation.

My thinking here has been shaped by Carole Pateman's conceptualization about the new patriarchy established under the bourgeois liberal state. See Pateman, *Sexual Contract*, 77–115.

52. *Young India*, August 25, 1921. This particular letter was written to Gandhi rather than the AISA in large part because there was no institution to write to about khadi. The Congress's Khaddar Board had only just been established; the AISA was not established until 1925. Gandhi responded to this letter in the pages of *Young India*: "I share the correspondent's feeling that the Tamil woman is overfond of her silk sari. There is no more unwholesome garment than silk in a hot climate like that of Madras. And one hundred rupees for a sadi is a criminal waste of money in a poor country like India. . . . Strange as it may appear, absorbent khadi is cooler than the fine garments which are so prized by men."

53. "Sisters in Tamil Land," *Young India*, July 27, 1922. Written by C. Rajago-palachariar. "It is wrong and thoughtless to wear silk when our dearest are in jail, suffering. It is wrong to waste Rs. 60 to 150 on a few yards of cloth. You can buy a gandhi pudafai 18 cubits long for less than Rs. 12, coloured and spotted, if you like by experts from Madura, and thereby save your family all the waste which your silks mean. The women of no other part of India spend so much as you do in mere cloth. To your sisters in the Deccan, in Maharashtra, in Gujerat, in Bengal or anywhere else in India, the money that the poorest among you spend on your silk clothing is, simply unthinkable; the proportion of the family's earnings which your clothing takes up would be declared monstrous by the much wealthier ladies of Bombay and Bengal."

54. "With Gandhi in Gujarat," *Young India*, April 23, 1925. Written by Mahadev Desai, this account was likely communicated in Gujarati and translated into English and Hindi for the various editions of *Young India*. The village woman quoted above was using "stuffs" to refer to the goods that comprised a woman's dowry when she went on to her new home. The "stuffs" to which she was likely referring might include saris, jewelry, kitchen utensils, and bedding of various kinds.

55. Quoted in Wolpert, *Nehru: A Tryst with Destiny*, 48–49. While we may today think that intercommunal would refer only to Hindu-Muslim marriages, Vijayalak-

shmi and her family at the time characterized the marriage of people from different regions of India as intercommunal also. This suggests that idea of community was much more locally oriented than we generally assume.

56. Ibid.

57. "Be in Time," *Young India,* February 10, 1927.

58. The population of India in 1921 was estimated at 305,693,000. In 1931 it was estimated at 338,119,000. B. R. Mitchell, *Institutional Historical Statistics,* 7.

4. Rituals of Time

1. MSA Home Department (Spl.), file no. 1018 (10) 1939–1940. "Bombay Takes Pledge of Independence," *Bombay Chronicle,* January 27, 1940.

2. The "holidays," as they were called in the period, that comprised the nationalist calendar were intended to be festive occasions celebrated with public gatherings, processions, flag hoistings, songs, pledges, and speeches. Festivities were ordinarily organized for the early morning or evening to accommodate the work schedules of potential participants.

3. India Office Library, Home Department (Political), R/3/1/335, R/3/1/335, R/3/1/346.

4. Masselos, "Spare Time and Recreation," 34–57.

5. Atkins, "Kafir Time," 229–244.

6. On Gandhi's views towards the labor of the ashram community, see *CWMG* "Draft Constitution of the Ashram," *CWMG* 13:91–98; "Ashram Vows," *CWMG* 13:225–35. On the spinning franchise, see Zaidi, *INC,* 3:257–324.

7. Jitendra Prasada, ed., Centenary Commemorative Volume Congress Varnika: Official Journal of the AICC (I). 2, no. 12 (December 1985): 123.

8. Independence Day was announced at midnight between December 31, 1929, and January 1, 1930, by Jawaharlal Nehru at the Lahore Session of the Indian National Congress. On that occasion, the khadi charka flag, or tri-color flag, which had just been adopted by the organization as its official emblem was unfurled for the first time before the assembly. A pledge was introduced that Congress would strive for the establishment of a sovereign, democratic republic independent of the British Empire. This pledge was taken each subsequent year of the independence struggle and renewed on 26 January 1950, the official day that the Indian Constitution went into effect.

Gandhi resisted supporting the aim of complete independence from the British Empire for some time. The declaration of Independence Day should not be seen as a policy of his particular influence, but one that marks the rising influence of Jawaharlal Nehru within Congress circles. Nonetheless, Independence Day became an important occasion for the use of khadi. Not only did Indians adopt khadi on this particular day to attend public celebrations, but the khadi charka flag figured prominently in the functions surrounding the holiday. Independence Day became a common day

of celebration, taking the form of processions, pledges, singing of nationalist songs, and the hoisting of the khadi charka flag.

9. The home rule movement occurred during the First World War and sought to establish a link between moderate and extremist politics. In the face of repressive measures carried out by the government of India, home rule proponents sought self-government within the British Empire.

10. Nationalists used "reconstituted" as a rhetorical sleight of hand, arguing the reconstitution of India even though they were in fact involved in creating a nation quite new.

11. Files that make reference to the celebrations of these national heroes include Lajpatrai Day: MSA Home Department (Spl.), file no. 800 (72) Pt. 10 1932; Bhagat Singh or Martyrs Day: India Office Library, Home Department (Political), R/3/1/357–358; and Gandhi Days: India Office Library, Home Department (Political), JP/6/1338 1922, R/3/1/357/1942 and MSA Home Department (Spl.), file no. 750 (28) 1930.

12. There were a variety of new occasions associated with Mohandas Gandhi. March 4, April 4, and May 4 were each celebrated as Gandhi Day in 1932. See, MSA Home Department (Spl.), file no. 800 (72) Pt. 2 1932; MSA Home Department (Spl.), 800 (72) Pt. 3 1932; MSA Home Department (Spl.), file no. 800 (72) Pt. 4 1932. September 18, 1941, was celebrated as Gandhi Jayanthi, although it was not the Mahatma's actual birthday. See MSA Home Department (Spl.), file no. 800 (74) (3) III 1941–43.

13. MSA Home Department (Spl.), file no. 1018 (10) 1939–40.

14. This particular pamphlet was published by the Emergency Council of the Bombay Provincial Congress Committee. MSA Home Department (Spl.), file no. 800 (72) Pt. 10 1932. In addition to Lajpatrai Day, the celebration of other martyrs' days was also used to narrate the history of the nation. Cf. MSA Home Department (Spl.), file no. 862 1935, which similarly discusses Rani of Jhansi Day.

15. For example, the celebration of Independence Day in 1940 was preceded by meetings across the Bombay Presidency. MSA Home Department (Spl.), file no. 1018 (10) 1939–1940.

16. MSA Home Department (Spl.), file no. 800 (III) A 1937. "Independence Day and Bombay's Duty." *Bombay Chronicle,* January 23, 1937. MSA Home Department (Spl.), file no. 212 III 1945–1947.

17. The announcement of the timetable appears also in Congress pamphlets. MSA Home Department (Spl.), file no. 800 III A 1937.

18. January 1937. B.P.C.C. (Bombay Provincial Congress Committee) Program for Independence Day

Mr. S. K. Patil spoke on the first item on the agenda—arrangements regarding Independence day. On the 26th of this month thousands of button flags would be sold from an early hour in the morning by men and women volunteers. Flag salutation ceremonies would be held in different places in the city and in the afternoon processions would be

taken out. In the evening on big meeting would be held at a central place while several ward meetings would be organized. At these meetings the Independence resolution of 1930 would be read with certain modifications and passed. The people in the City will be requested to hoist national flags on their buildings.

MSA Home Department (Spl.), file no. 800 (74) (3) III 1941–43. Secret Express Letter, A'bad, February 6, 1941.

"Independence Day" celebrations commenced here on the morning of the 26th January by holding flag salutations in different wards of the city. Some of the Congressmen were found selling tiny Congress flags and some distributed leaflets containing statements of M. Gandhi. . . . Beyond Ellis Bridge persons residing in different societies decorated their houses by housing Congress flags. . . .

Secret Express Letter, A'bad, April 17, 1941.

The National Week was celebrated here from 6th to the 13th April. The celebrations commenced here from 6th to 13th of April. The celebrations commenced with hoisting tiny congress flags on certain houses. During the Week six meetings in different wards of the city were held . . . at which the present political situation was explained tracing the history of the Jallianwallah Bagh tragedy. . . . sale of Khaddar and enrollment of Congress members were also chief features of the program.

Secret Express Letter, A'bad, September 23, 1941.

In furtherance of the program chalked out by the A'bad City Congress Committee for the celebration of the "Gandhi Jayanthi," Prabat Feris were taken out in 3 different wards in the morning of 18/9/41. Also flag salutation ceremonies were performed at 11 different places in the city before 8:00 a.m. and later a general flag salutation function was performed by Mahadev Desai in the district local Board compound. Unfurling the tricoloured flag, Mr. Desai said that their struggle for independence was in progress.

19. MSA Home Department (Spl.), file no. 800 (III) A 1937; Home Department (Spl.), 800 (72) Pt. 9 1932; Home Department (Spl.), file no. 800 (74) 3 (III) 1941–1943.

20. MSA Home Department (Spl.), file no. 800 (72) Pt. 1 1932. Head Police Office, Bombay, no. 1101/H/3717 (All-India Congress Day), February 22, 1932.

21. MSA Home Department (Spl.), file no. 1018 (10) 1939–1940. Report of a District Magistrate.

22. MSA Home Department (Spl.), file no. 800 (72) Pt. 2 1932.

23. Freitag, *Collective Action and Community,* 230–237.

24. The text of the Independence Pledge reads: "We believe that it is the inalienable right of the Indian people, as of any other people, to have freedom and to enjoy the fruits of their toil and have the necessities of life, so that they may have full oppor-

tunities of growth. We believe also that if any government deprives a people of these rights and oppresses them, the people have a further right to alter it or to abolish it. The British Government in India has not only deprived the Indian people of their freedom but has based itself on the exploitation of the masses, and has ruined India economically, politically, culturally and spiritually. We believe, therefore, that India must sever the British connection and attain Purna Swaraj or complete independence." Pandit, *Scope of Happiness,* 94.

One collection of Gujarati khadi songs is included in a booklet published in 1930: R. J. Doshi, *Khadi Tya Lognno Gito.*

25. Pandit, *Scope of Happiness,* 93–94.

26. India Office Library, Home Department (Political), R/3/1/356.

27. MSA Home Department (Spl.), file no. 958-I 1939–1940. "Nation's Pledge to Independence: Impressive Celebration Everywhere," *Bombay Chronicle,* January 27, 1939. An article from the *Times of India* for the same day reported that nearly 100,000 school children were on holiday from school to celebrate the occasion.

28. MSA Home Department (Spl.), file no. 800 (72) Pt. 1 1932; Head Police Office memo no. 792/H/3717, February 7, 1932. See also MSA Home Department (Spl.), file no. 800 (72) Pt. 9 1932; No. 5519/H/3717. Head Police Office, Bombay, October 5, 1932.

29. MSA Home Department (Spl.), file no. 800 (72) Pt. 1 1932. Head Police Office, Bombay. February 8, 1932. N. 792/H/3717; MSA Home Department (Spl.), file no. 800 (72) Pt. 3 1932. Head Police Office Bombay, April 5, 1932, No. 1933/H/3717 and Head Police Office Bombay, April 7, 1932, 1993/H/3717; MSA Home Department (Spl.), file no. 1018 (10) 1939–1940. Report of a District Magistrate.

30. Here I am drawing upon Gyanendra Pandey's formulation in *The Construction of Communalism in North India.* MSA Home Department (Spl.), file no. 800 (72) Pt. 3 1932. No. 1933/H/3717 Head Police Office, Bombay, April 5, 1932

31. MSA Home Department (Spl.), file no. 800 (72) Pt. 4 1932. No. 2629/H/3717.

32. MSA Home Department (Spl.), file no. 800 (72) Pt. 1 1932. No. 792/H/3717. Head Police Office, February 8, 1932.

Boycott Day: At 5:30 p.m. yesterday a small procession of about 25 persons led by Kanji Bhagwardas and Vasant Daulat started with a Congress flag from Tamba Kanta. A crowd of about 500 persons witnessed the procession from a distance. The leaders of the procession were dispersed and the rest dispersed. . . .

About 200 persons collected at Chowpatty sands opp. Wilson College in the evening and one Ramchandra Pandurang Bhole, the dictator of the D ward, made a bonfire of rags and rubbish. The police arrested him and his two companions and put out the bonfire. After the police were withdrawn about 200 persons went in procession towards Prarthana Samaj where a police party chased them away. One Bhika Sakharam was suspected to be a C.I.D. man and was assaulted on Sandhurst Road by the processionists who were eventually dispersed at Prarthana Samaj.

About 250 persons assembled at Lal Bagh last evening to celebrate 'Boycott Day'

Three persons took a leading part in organizing the meeting, were arrested and the rest dispersed. Later on some others came forward with a Congress flag. They were chased away after flags were taken from them. About 100 persons formed a procession after the police at Lal Bagh were withdrawn but they were chased away by the police at Lal Bagh Chowki.

About 200 persons collected at Nagu Sayaji's Wadi yesterday evening in connection with Boycott Day. Five persons who tried to hold the meeting in spite of the warning given by the police were arrested and the crowd dispersed.

33. India Office Library, Home Department (Political), R/3/1/346. Appendix I: Letter to Provincial Governments, No. 3/13/40—Poll. I. "It is obvious that any threat to the maintenance of law and order in India . . . would have the effect referred to above [e.g., hindering the war effort]. The possibilities are numerous—ranging as they do from an organized campaign of open defiance of constituted authority promoted by some political party, to less recognizable, but none-the-less dangerous, activities which may lead to the undermining of authority. . . ."

34. India Office Library, Home Department (Political), R/3/1/346. One of the responses to the government's instructions in the Bombay Presidency was the revision of a provincial manual which not only outlined the strategies mentioned above, but also contained the names of people who should be arrested and institutions which should be seized. This instruction led one colonial official to voice his concern that his associates were viewing all expressions of politics as potentially active. He was also uncomfortable specifically with the creation of lists of people to be arrested because they preceded actions that the state might, or might not, deem illegal. India Office Library, Home Department (Political), R/3/1/335.

35. MSA Home Department (Spl.), file no. 800 (74) (3) III 1941–43. Secret Express Letter, Ahmedabad, March 27, 1941.

36. Sarkar, "Conditions and Nature of Subaltern Militancy," 304–305.

37. Haynes, "Imperial Ritual in a Local Setting," 493–527.

5. Inhabiting National Space

1. Tarlo, *Clothing Matters.*

2. Civil Disobedience Movement is a general term often used to describe two periods of Gandhi's political struggles. The first period is associated with the non-cooperation movement, which took place between 1920 and 1922. The second period (1930–1932) is associated specifically with the salt satyagraha which followed the Dandi March. One of the key differences between these two periods is the aim of the protest. In the case of the non-cooperation movement, Congress withdrew from participation with the government of India as a means of achieving meaningful reform within the context of the British Empire and through constitutional means. It was characterized not only by the resignation of Congress members from the colonial administration, but also by students leaving government colleges in favor

of national colleges established in large part to encourage constructive work among India's broader population. In the case of the salt satyagraha, the aims were both more specific and had greater consequence. On the one hand, the Dandi March and subsequent salt satyagraha were means of drawing public attention to the illegitimacy of a government monopoly on salt production and sale. On the other hand, the salt satyagraha was more aggressive than the movement a decade earlier. Whereas during the non-cooperation movement the strategy was withdrawal, the salt satyagraha involved actively breaking laws viewed by nationalists as illegitimate. The salt satyagraha was carried out in a context in which the Indian National Congress sought complete independence from the British Empire, rather than reform within it.

3. Freitag, "Visual Language of the Nation." See also Freitag's essay "Visions of the Nation."

4. Freitag, "Introduction," *South Asia* 14, no. 1 (1991): 1.

5. Bourdieu, *Outline of a Theory of Practice,* 81.

6. Asher, *Architecture in Mughal India.* On the subject of Mughal nobility and building, see Asher's essay "The Architecture of Raja Man Singh: A Study in Sub-imperial Patronage," in Barbara Miller, ed., *Powers of Art,* 183–201.

7. Bayly, "Origins of Swadeshi."

8. Cohn, "Representing Authority in Victorian India."

9. Oldenburg, *Making of Colonial Lucknow;* Thomas Metcalf, *Imperial Vision.*

10. Frykenberg, ed., *Delhi Through the Ages.*

11. Thomas Metcalf, *Imperial Vision.*

12. Ibid.

13. Ibid. Drawing upon the work of Bernard Cohn, Tarlo argues that the headgear of Indian men was one of the primary ways in which the British came to understand the heterogeneity of South Asian communities. In her chapter on clothing in the nineteenth century, Tarlo explores British studies and publications that set out to define South Asian community through perceived differences in clothing.

14. Hobsbawm and Ranger, eds., *Invention of Traditions.*

15. Cf. Bean, "Gandhi and Khadi."

16. Cited in Tarlo, *Clothing Matters,* 82–83.

17. Drawing upon Cohn's argument in "Cloth, Clothes and Colonialism," Tarlo concludes, "Not only was the head regarded as the centre of purity in Indian culture, but a man's headdress was also his most distinctive badge of affiliation to different caste or religious groups." Tarlo, *Clothing Matters,* 57.

18. Ibid., 83.

19. "The White Cap," *Young India,* July 28, 1921.

20. Ibid.

21. "The White Cap in C. P.," *Young India,* August 11, 1921.

22. Ibid.

23. "The Crime of Wearing Khadi," *Young India,* September 29, 1921.

24. Doshi, *Khadi Tya Lognno Gito.* My translation.

25. *Swadeshi and Marriage Songs,* song no. 7. My translation.

26. "Notes," *Young India,* November 24, 1921.

27. "War On Khadi Caps," *Young India,* December 1921.

28. "Ban On Khadi Caps," *Young India,* December 15, 1921.

29. NAI Home Department (Political), file no. 858/1922.

30. Ibid.

31. NAI Home Department (Political), file no. 858/1922. As Graham then explained in his response to the Home Department, the residents were sentenced to ten days' imprisonment only after they refused to pay the Rs. 15 fine imposed upon them.

32. Ibid.

33. NAI Home Department (Political), file no. 12/8/1930.

34. NAI Home Department (Political), file no. 12/8/1930.

35. NAI Home Department (Political), file no. 12/8/1930.

36. Bhabha, "Of Mimicry and Man."

37. The government's commitment to this policy continued through at least 1927 when another question was posed to the government by Sarabhai Nemchand Haji: "Will Government be pleased to state if they have in any way prohibited Government servants from wearing khaddar." See NAI Home Department (Political), file no. 10/33/1927.

38. Ibid.

39. Tallents, *Census of India, 1921,* 12.

40. NAI Home Department (Political), file no. 650/1922.

41. Ibid.

42. NAI Home Department (Political), file no. 650/1922.

43. NAI Home Department (Political), file no. 270/1924.

44. NAI Home Department (Political), "Fortnightly Reports," files no. 12/2/1930, 12/3/1930, 12/7/1930, 12/8/1930, 12/13/1930, and Home Department (Political), file no. 254/1929.

45. NAI Home Department (Political), file no. 163/1929 with reference to file no. 941/1922.

46. NAI Home Department (Political), file no. 163 K & W/1929.

47. Ibid.

48. NAI Home Department (Political), file no. 86/1930. MSA Home Department (Spl.), file no. 750 (28) A 1930, pp. 23–4, 52–65. *Corporation* is the term used for "city" or "municipality." It refers here to the Calcutta Municipal Corporation. The building described was equivalent to a city hall.

49. Ibid.

50. NAI Home Department (Political), file no. 86/1930.

51. January 26 was known as Independence Day until after partition and independence—when it was renamed Republic Day in India. During the period under consideration, the twenty-sixth of January was one of the most important days in the new national calendar. Flags were hoisted across the subcontinent at both public and private ceremonies alike. Following the flags' unfurling, people often sang patriotic songs and recited the pledge of independence. For a comparison of how public space was used in Bombay during this same period, see Jim Masselos's excel-

lent essay "Audiences, Actors and Congress Dramas: Crowd Events in Bombay City in 1930," 71–86.

52. NAI Home Department (Political), file no. 86/1930. Quote was taken from an article that was carried in the *Statesman:* "Unfurling the Congress Flag. Corporation Plans. Moslems vote against the Resolution."

53. Ibid.

54. Ibid.

55. Ibid.

56. Ibid. My italics.

57. Metcalf, *Ideologies of the Raj.* Chatterjee argues that nationalism in colonized regions depended upon the definition of difference: *Nation and Its Fragments,* 3–13.

58. MSA Home Department (Spl.), file no. 750 (28) 1930.

59. MSA Home Department (Spl.), file no. 750 (28) 1930, pp. 51, 73–75.

60. NAI Home Department (Political), "Fortnightly Reports," file no. 18/7/1930.

61. NAI Home Department (Political), file no. 86/1930 and file no. 12/8/1930.

Conclusion

1. Flag code of India, 2002. http://mha.nic.in/nationalflag2002.htm (accessed October 30, 2006).

2. Flag Code of India, 2002. Part I, 1.1.

3. The charka, or spinning wheel, and the Asoka chakra are two distinct symbols, which share the wheel as a common feature. The charka was depicted in full form, including spindle, on the flag of the Indian National Congress. The most prominent part of the charka image on the flag was its wheel. The Asoka chakra is a design element found on the pillars erected across the subcontinent by the Emperor Asoka Maurya (273-232 BCE), but particularly on the pillar located at Sarnath. This wheel represents the dharma, or eternal law, of Buddhism.

4. Flag Code of India, 2002. Part I., 1.2.

5. Flag Code of India, 2002. Part II. Section I. Article 2.1.

6. Flag Code, 2002. Part II. Section I. Article 2.1.a.

7. The Prevention of Insults to National Honour Act, 1971. Amended by the Prevention of Insults to National Honour (Amendment) Act, 2003. This language is included in the preamble.

8. The Prevention of Insults to National Honour Act, 1971. Amended by the Prevention of Insults to National Honour (Amendment) Act, 2003. 2 (e).

9. Foucault, *Discipline and Punish.*

10. Hunt, *Politics, Culture, and Class.*

11. Winachukal, *Siam Mapped.*

BIBLIOGRAPHY

Manuscript Sources: Official

India Office Records, British Library, London
Maharashtra State Archives, Bombay
 Bombay Presidency, Education Department
 Bombay Presidency, Home Department (Political)
 Bombay Presidency, Home Department (Spl.)
National Archives of India, New Delhi
 Government of India, Home Department (Political) Proceedings
 Government of India, Home Department (Public) Proceedings
 Government of India, Home Department (Judicial) Proceedings
 Government of India, Department of Industry and Labour
 Government of India, Commerce Department

Manuscript Sources: Unofficial

Nehru Memorial Library, New Delhi
Papers of the All India Congress Committee
Papers of the All-India Spinners' Association, 1925–1944
Papers of the All-India Khaddar Board
Papers of the Textile Labour Association, Ahmedabad
Personal Papers: Jamnalal Bajaj, Devdas Gandhi, Mirabehn, C. Rajgopalachariar, J. C. Kumarrappa
Sabarmati Ashram Papers, Sabarmati Ashram, Ahmedabad (particularly papers of the All-India Spinners' Association)
Textile Labour Association, Ahmedabad

Printed Sources: Official Publications

Census of India. Reports and tables for India, 1921 and 1931.
District Gazetteers for United Provinces, Bihar, Bombay, Bengal, Punjab, Central
Provinces (Hindi), Central Provinces (Marathi), Madras.
Report on an Enquiry into Conditions of Labour in the Cotton Mill Industry in
India, 1946.

Newspapers

Amrita Bazar Patrika
The Bombay Chronicle
The Hindu
The Independent
The Khadi Patrika
Navajivan
Young India

General Works Cited

All-India Congress Khaddar Department. *Khaddar Work in India.* Bombay, 1922.
All-India Spinner's Association. *A Khadi Tour, 1924.* Ahmedabad: A. I. S. A., 1925.
————. *The Annual Report of the All India Spinners' Association, 1925–1926.* Ahmed-
abad: A. I. S. A., 1926.
————. *The Annual Report of the All India Spinners' Association, 1926–1927.* Ahmed-
abad: A. I. S. A., 1927.
————. *The Annual Report of the All India Spinners' Association, 1927–1928.* Ahmed-
abad: A. I. S. A., 1928.
————. *The Annual Report of the All India Spinners' Association, 1930–1931.* Ahmed-
abad: A. I. S. A., 1931.
————. *The Annual Report of the All India Spinners' Association, 1934.* Ahmedabad:
A. I. S. A., 1935.
Althusser, Louis. "Ideology and Ideological State Apparatus: Notes Towards an Inves-
tigation." In *Lenin and Philosophy.* New York: Monthly Review, 1979.
Amin, Shahid. *Event, Metaphor, Memory: Chauri Chaura 1922–1994.* Delhi: Oxford
University Press, 1995.
————. "Gandhi as Mahatma: Gorakhpur District, Eastern UP, 1921–2." In R. Guha,
ed., *Subaltern Studies: Writing on South Asian History and Society.* Delhi: Oxford
University Press, 1984.
Anderson, Benedict. *Imagined Communities: Reflections on the Origins and Spread of
Nationalism.* London: Verso, 1991.

Appadurai, Arjun. *The Social Life of Things: Commodities in Cultural Perspective.* Cambridge: Cambridge University Press, 1986.

————. "Number in the Colonial Imagination." In C. Brekenridge and P. Van der Veer, eds., *Orientalism and the Postcolonial Predicament.* Philadelphia: University of Pennsylvania Press, 1993.

Arnold, David. *Police Power and Colonial Rule in Madras, 1859–1947.* Delhi: Oxford University Press, 1986.

————. *Colonizing the Body: State Medicine and Epidemic Disease in Nineteenth-Century India.* Berkeley: University of California Press, 1993.

Asher, Catherine. *Architecture in Mughal India.* Cambridge: Cambridge University Press, 1992.

Atkins, Keletso. "Kafir Time: Preindustrial Temporal Concepts and Labour Discipline in Nineteenth-Century Colonial Natal." *Journal of African History* 2 (1988): 229–244.

Bahadur, Muntazih, and V. A. Talcharkar. *The Charkha Yarn, or the Superiority of Handspun Yarn and the Causes Why that Superiority is Everlasting.* 3rd ed. Bombay: V. A. Talcharkar, 1925.

Baig, Tara Ali. *Builders of Modern India: Sarojini Naidu.* Delhi: Ministry of Information and Broadcasting, Government of India, 1974.

Baker, Christopher. *The Politics of South India, 1920–1937.* Cambridge: Cambridge University Press, 1976.

Bakhtin, Mikhail. *The Dialogic Imagination: Four Essays.* Austin: University of Texas Press, 1981.

Bakshi, S. R. *Gandhi and the Non-Cooperation Movement, 1920–1922.* Delhi: Capital, 1983.

————. *Sarojini Naidu: Struggle for Swaraj.* Indian Freedom Fighters Series, 15. Delhi: Anmol, 1991.

Battacharya, Sachchidananda. *A Dictionary of Indian History.* New York: George Braziller, 1967.

Bayly, Christopher. *Local Roots of Indian Politics: Allahabad, 1880–1920.* Oxford: Clarendon, 1975.

————. "The Origins of Swadeshi (home industry): Cloth and Indian Society, 1700–1930." In Arjun Appadurai, ed., *The Social Life of Things: Commodities in Cultural Perspective.* Cambridge: Cambridge University Press, 1986.

————. *Raj: India and the British, 1600–1947.* London: National Portrait Gallery, 1990.

Bean, Susan. "Gandhi and Khadi: The Fabric of Independence." In A. Weiner and J. Schneider, eds., *Cloth and Human Experience.* Washington, D.C.: Smithsonian Institution, 1989.

Bhabha, Homi K. "Of Mimicry and Man: The Ambivalence of Colonial Discourse." *The Location of Culture.* London: Routledge, 1994.

————. *The Location of Culture.* London: Routledge, 1994.

Bhagini Samaj. *Mahatma Gandhiji ni Jayanti, Striyono Sandesh.* Bombay: Bhagini Samaj, 1921.

Bombay Swadeshi League. *A Classified List of Manufacturers of Swadeshi Goods and Their Agents and Dealers.* Bombay: Bombay Swadeshi League, 1931.

Borthwick, Meredith. *The Changing Role of Women in Bengal, 1849–1905.* Princeton: Princeton University Press, 1984.

Bose, Subas Chandra. *Swadeshi and Boycott.* Calcutta: Liberty Newspapers, 1931.

Bourdieu, Pierre. *Outline of a Theory of Practice.* Cambridge: Cambridge University Press, 1981.

———. "Social Space and Symbolic Power." *Sociological Theory* 7, no. 1 (Spring 1989): 14–25.

———. *Language and Symbolic Power.* Cambridge: Harvard University Press, 1994.

Brown, Judith. *Gandhi's Rise to Power: Indian Politics 1915–1922.* Cambridge: Cambridge University Press, 1972.

———. *Gandhi and Civil Disobedience.* Cambridge: Cambridge University Press, 1977.

———. *Gandhi: Prisoner of Hope.* New Haven: Yale University Press, 1989.

Butler, Judith. *Gender Trouble: Feminism and the Subversion of Identity.* London: Routledge, 1990.

Chakravarti, Uma. *Rewriting History: The Life and Times of Pandita Ramabai.* Delhi: Kali for Women, 1998.

Chandra, Bipin. *The Rise and Growth of Indian Nationalism, 1919–1947.* Delhi: Chanakya, 1982.

Chatterjee, Partha. *The Nation and Its Fragments: Colonial and Post-Colonial Histories.* Princeton: Princeton University Press, 1993.

———. *Nationalist Thought in the Colonial World: A Derivative Discourse?* London: Zed, 1986.

Chatterjee, Partha, and Gyandendra Pandey, eds. *Subaltern Studies: Writings on South Asian History and Society.* Vol. 7. Delhi: Oxford University Press, 1992.

Chaudhurani, Sarladevi. *At the Tip of the Spindle.* Delhi: Cambridge University Press, 1921.

Chaudhuri, Nirad. *Thy Hand, Great Anarch! India, 1921–1952.* New York: Addison-Wesley, 1987.

Chudgar, C. P. *Khadi Tatha Lagna na Gito.* 1930.

Cohn, Bernard S. "Representing Authority in Victorian India." In Eric Hobsbawm and Terence Ranger, eds., *The Invention of Tradition.* Cambridge: Cambridge University Press, 1983.

———. "The Command of Language, the Language of Command." In R. Guha, ed., *Subaltern Studies: Writing in South Asian History and Society,* vol. 6. Oxford: Oxford University Press, 1985.

———. "The Census, Social Structure, and Objectification in South Asia." In *An Anthropologist among the Historians.* London: Oxford University Press, 1987.

———. "Cloth, Clothes and Colonialism: India in the Nineteenth Century." In A. Weiner and J. Schneider, eds., *Cloth and Human Experience.* Washington, D.C.: Smithsonian Institution, 1989.

————. *Colonialism and Its Forms of Knowledge: The British in India.* Princeton: Princeton University Press, 1996.

Cornelius, J. J. "Mahatma Gandhi and His Charka." *The World Review* 7, no. 17 (January 28, 1929).

Das, Taraknath. "Gandhi and the Spinning Wheel: A Sympathizer's View of the Indian Revolution." *Survey* 47 (October 1927).

Das Gupta, Satis Chandra. *Cotton (Khadi Manual. Vol. 2, Part 4).* Calcutta: Khadi Pratisthan, 1924.

Davis, Fred. *Fashion, Culture, and Identity.* Chicago: University of Chicago Press, 1992.

De Certeau, Michel. *The Practice of Everyday Life.* Berkeley: University of California Press, 1984.

Desai, Manibhai P. *Khadi ni Prasadi ane biji Ketlik Manoranjak Vato.* 1924.

Devji, Faisal F. "Gender and the Politics of Space." *South Asia* 14, no. 1 (1991).

Doshi, R. J. *Khadi Tya Lognno Gito.* 1930.

Duara, Prasenjit. *Rescuing History from the Nation: Questioning Narratives of Modern China.* Chicago: University of Chicago Press, 1995.

Dutt, Romesh C. *The Economic History of India.* Delhi: D. K., 1995.

Edney, Matthew. *Mapping an Empire: The Geographical Construction of British India, 1765–1843.* Chicago: University of Chicago Press, 1997.

Ezra, E. "The Colonial Look: Exhibiting Empire in the 1930s." *Contemporary French Civilization* 19, no. 1 (1995): 33–49.

Fischer, Louis. *The Life of Mahatma Gandhi.* New York: Harper and Row, 1983.

Fox, Richard. *Gandhian Utopia: Experiments with Indian Culture.* New York: Beacon, 1989.

Foucault, Michel. *Discipline and Punish: The Birth of the Prison.* New York: Vintage, 1979.

Fox, Richard. "Gandhi and Feminized Nationalism in India." In B. Williams, ed., *Women Out of Place.* New York: Routledge, 1994.

Freitag, Sandria. *Collective Action and Community: Public Arenas and the Emergence of Communalism in North India.* Berkeley: University of California Press, 1989.

————. "Introduction." *South Asia* 14, no. 1 (1991): 1–13.

————. "State and Community: Symbolic Popular Protest in Banaras's Public Arenas." In Sandria Freitag, ed., *Culture and Power in Banaras: Community, Performance, and Environment, 1800–1980.* Berkeley: University of California, 1992.

————. "The Visual Language of the Nation." Paper delivered at the Empire Studies Reading Group, Berkeley, Calif., November 1995.

————. "Visions of the Nation: Theorizing the Nexus between Creation, Consumption, and Participation in the Public Sphere." In Christopher Pinney and Rosalind Dwyer, eds., *Pleasure and the Nation.* Delhi: Oxford University Press, 2001.

Gallagher, John, Gordon Johnson, and Anil Seal. *Locality, Province and Nation: Essays on Indian Politics, 1870–1940.* Cambridge: Cambridge University Press, 1973.

Gandhi, Maganlal. *Charkha Shastra*. Sabarmati: All India Khadi Information Board, 1924.

———. *Ashramno Pran*. 1929.

Gandhi, Mohandas K. *An Autobiography: The Story of My Experiments with Truth*. New York: Beacon, 1957.

———. *Ashram Observances in Action*. Ahmedabad: Navajivan, 1955.

———. *Hind Swaraj, or Indian Home Rule*. Ahmedabad: Navajivan, 1987.

———. *Satyagraha in South Africa*. Trans. V. G. Desai. Ahmedabad: Navajivan, 1950.

———. *The Collected Works of Mahatma Gandh*. 100 vols. New Delhi: Ministry of Information and Broadcasting, 1994.

———. *The National Flag*. Lahore: Gandhi Publications League, n.d.

Gandhi, M. P. *How to Compete with Foreign Cloth: A Study of the Position of Hand Spinning, Hand-Weaving, and Cotton Mills in the Economics of Cloth Production in India*. Calcutta: G. N. Mitra Book Co., 1931.

Gellner, Ernest. *Nations and Nationalism*. Oxford: Basil Blackwell, 1983.

Glover, William. "Making Lahore Modern: Constructing and Construing Modernity in an Indian Colonial Metropolis, ca. 1860–1920." Ph.D. diss., University of California, Berkeley, 1999.

Goswami, Manu. "From Swadeshi to Swaraj: Nation, Economy, and Territory in colonial South Asia, 1870–1907." *Comparative Studies in Society and History* 40, no. 4 (1998): 609–636.

———. *Producing India: From Colonial Economy to National Space*. Chicago: University of Chicago Press, 2004.

Gramsci, Antonio. *Selections from the Prison Notebooks*. New York: International Publishing, 1971.

Grant, Kevin, and Lisa Trivedi. "A Question of Trust: The Government of India, the League of Nations and Mohandas Gandhi." In R. M. Douglas, Michael D. Callahan, and Elisabeth Bishop, eds., *Imperialism on Trial: International Oversight of Colonial Rule in Historical Perspective*. New York: Lexington Books, 2006.

Gregg, Richard B. *Economics of Khaddar*. Madras: S. Ganesan, 1928.

Guha, Ranajit. *A Rule of Property for Bengal: An Essay on the Idea of Permanent Settlement*. Paris: Mouton, 1963.

———. *Dominance without Hegemony: History and Power in Colonial India*. Cambridge: Harvard University Press, 1997.

Guha, Ranajit, ed. *Subaltern Studies: Writings on South Asian History and Society*. Vols. 1–6. Delhi: Oxford University Press, 1982–1989.

Hansen, Kathryn. "The Birth of Hindi Drama in Banaras, 1868–1885." In Sandria Freitag, ed., *Culture and Power in Banaras: Community, Performance, and Environment, 1800–1980*. Berkeley: University of California Press, 1993.

———. "Sultana the Dacoit and Harishchandra: Two Popular Dramas of the Nautanki Tradition of North India." *Modern Asian Studies* 17, no. 2 (1983): 313–331.

Hardiman, David. *Peasant Nationalists of Gujarat: Kheda District, 1917–1934*. Delhi: Oxford University Press, 1981.

Haynes, Douglas. "Imperial Ritual in a Local Setting: The Ceremonial Order in Surat, 1890–1939." *Modern Asian Studies* 24, no. 3 (1990): 493–527.

Hirschman, Charles. "The Making of Race in Colonial Malaya: Political Economy and Racial Ideology." *Sociological Forum* 1, no. 2 (1986): 330–361.

———. "The Meaning and Measurement of Ethnicity in Malaysia: An Analysis of Census Classification." *The Journal of Asian Studies* 46, no. 3 (August 1987): 555–582.

Hobsbawm, Eric. *The Age of Empire, 1875–1914.* New York: Pantheon Books, 1987.

———. *Nations and Nationalism since 1780: Programme, Myth, Reality.* Cambridge: Cambridge University Press, 1990.

Hobsbawm, Eric, and Terence Ranger, eds. *The Invention of Tradition.* Cambridge: Cambridge University Press, 1983.

Hoffenberg, Peter. *An Empire on Display: English, Indian, and Australian Exhibitions from the Crystal Palace to the Great War.* Berkeley: University of California Press, 2001.

Hunt, Lynn. *Politics, Culture and Class in the French Revolution.* Berkeley: University of California Press, 1984.

Irschick, Eugene F. *Politics and Social Conflict in South India: The Non-Brahman Movement and Tamil Separatism, 1916–1929.* Berkeley: University of California Press, 1969.

Israel, Milton. *Communications and Power: Propaganda and the Press in the Indian Nationalist Struggle, 1920–1947.* Cambridge: Cambridge University Press, 1994.

Iyengar, S., and W. J. McGuire, eds. *Explorations in Political Psychology.* Durham: Duke University Press, 1993.

Iyer, Raghavan. *The Moral and Political Thought of Mahatma Gandhi.* New York: Oxford University Press, 1973.

Jaju, Shrikrishnandas. *The All India Spinners' Association and Its Work: A Brief Account, Up to 1951.* Ahmedabad: All-India Spinners' Assoc., 1951.

Johnson, Gordon. *Provincial Politics and Indian Nationalism. Bombay and the Indian National Congress, 1880 to 1915.* Cambridge: Cambridge University Press, 1973.

Jordan, David. *Transforming Paris: The Life and Labors of Baron Haussmann.* New York: Free Press, 1995.

Joseph, Nathan. "Uniforms and Non-Uniforms: Communication through Clothing." *Contributions in Sociology,* no. 61 (1986).

Joshi, Pushpa, ed. *Gandhi on Women: Collection of Mahatma Gandhi's Writing and Speeches on Women.* Ahmedabad: Navajivan, 1988.

Kalelkar, Dattatruya Balkrishna. *Swadeshi Dharma.* Sabarmati Ashram, Satyagraha Ashram, 1920.

Khalid, Adeeb. *The Politics of Muslim Cultural Reform: Jadidism in Central Asia.* Berkeley: University of California Press, 1998.

King, Christopher. "Forging a New Linguistic Identity: The Hindi Movement in Banaras, 1868–1914." In Sandria Freitag, ed., *Culture and Power in Banaras: Community, Performance, and Environment, 1800–1980.* Berkeley: University of California, 1992.

Kishwar, Madhu. "Women and Gandhi." *Economic and Political Weekly* 20, no. 40 (1985): 1691–1702.

Kosambi, Meera. *Pandita Ramabai's Feminist and Christian Conversions: Focus on Stree Dharma-neeti.* Bombay: Research Centre for Women's Studies, S.N.D.T. Women's University, 1995.

Kosambi, Meera, ed. and trans. *Pandita Ramabai Through Her Own Words: Selected Works.* New Delhi: Oxford University Press, 2000.

Krishna, G. "The Development of the Indian National Congress as a Mass Organization, 1918–1923." *Journal of Asian Studies* 25, no. 3 (May 1966): 413–430.

Kroeber, A. L. "On the Principle of Order in Civilization as Exemplified by Changes in Fashion." *American Anthropologist* 21, no. 3 (1919): 235–263.

Kumar, Radha. *A History of Doing: An Illustrated Account of Movements for Women's Rights and Feminism in India, 1880–1990.* New Delhi: Sage, 1995.

Kuper, Hilda. "Costume and Identity." *Comparative Studies in Society and History* 15, no. 3 (June 1973): 348–367.

Kusamitsu, T. "Great Exhibitions before 1851." *History Workshop Journal* 9 (1980): 70–89.

Leadbeater, S. R. B. *The Politics of Textiles: The Indian Cotton-Mill Industry and the Legacy of Swadeshi, 1900–1985.* New Delhi: Sage, 1993.

Lelyveld, David. "The Fate of Hindustani: Colonial Knowledge and the Project of a National Language." In Carol Breckenridge and Peter van der Veer, eds., *Orientalism and the Postcolonial Predicament.* Philadelphia: University of Pennsylvania Press, 1993.

Limaye, Madhu. *Mahatma Gandhi and Jawaharlal Nehru: A Historic Partnership, 1916–1948.* Delhi: B. R., 1989.

Low, David A., ed. *Congress and the Raj: Facets of the Indian Struggle, 1917–47.* London: Heinemann, 1977.

Ludlow, J. M. *Thoughts on the Policy of the Crown towards India.* London: James Ridgeway, 1859.

Majumdar, R. C. *The History and Culture of the Indian People.* Bombay: Bharatiya Vidya Bhavan, 1969.

———. *An Advanced History of India.* London: Macmillan, 1953.

Mani, Lata. "Contentious Traditions: The Debates on Sati in Colonial India." In Kum Kum Sangari and Sudesh Vaid, eds., *Recasting Women: Essays in Indian Colonial History.* New Brunswick: Rutgers University Press, 1989.

Masselos, James. *Nationalism on the Indian Subcontinent: An Introductory History.* Melbourne: Thomas Nelson, 1972.

———. "Spare Time and Recreation: Changing Behavior Patterns in Bombay at the Turn of the Nineteenth Century." *South Asia* 7, no. 1 (1984): 34–57.

———. "Audiences, Actors and Congress Dramas: Crowd Events in Bombay City in 1930." *South Asia* 8, nos. 1–2 (1985): 71–86.

McCracken, Grant. "Culture and Consumption: A Theoretical Account of the Structure and Movement of the Cultural Meaning of Consumer Goods." *Journal of Consumer Research* 13 (June 1986).

McKendrick, Neil, John Brewer, and J. H. Plumb, eds. *The Birth of a Consumer Society: The Commercialization of Eighteenth-Century England.* Bloomington: Indiana University Press, 1985.

McLane, John. *Indian Nationalism and the Early Congress.* Princeton: Princeton University Press, 1977.

Mehta, Kalyani Vithalbhai. *Swaraj Namgito.* 1931.

Metcalf, Barbara D. *Perfecting Women: Maulana Ashraf 'Ali Thanawi's Bihishti Zewar: A Partial Translation with Commentary.* Delhi: Oxford University Press, 1992.

Metcalf, Thomas R. *The Aftermath of Revolt: India 1857–1870.* Princeton: Princeton University Press, 1964.

———. *An Imperial Vision: Indian Architecture and Britain's Raj.* Berkeley: University of California Press, 1989.

———. *Ideologies of the Raj.* The New Cambridge History of India, vol. 3, pt. 4. Cambridge: Cambridge University Press, 1994.

Metcalf, Thomas R., ed. *Modern India: An Interpretive Anthology.* Delhi: Sterling Publishing, 1990.

Middlekauff, Robert. *The Glorious Cause: The American Revolution, 1763–1789.* New York: Oxford University Press, 1982.

Miller, Barbara, ed. *The Powers of Art: Patronage in Indian Culture.* Oxford: Oxford University Press, 1992.

Miller, Michael. *The Bon Marché: Bourgeois Culture and the Department Store, 1869–1920.* Princeton: Princeton University Press, 1981.

Minault, Gail. *The Khilafat Movement.* New York: Columbia University Press, 1982.

———. *Secluded Scholars: Women's Education and Muslim Social Reform in Colonial India.* Delhi: Oxford University Press, 1998.

Mitchell, B. R. *International Historical Statistics: Africa, Asia & Oceania, 1750–1993.* London: Macmillan Reference, 1998.

Mitchell, Timothy. *Colonising Egypt.* Berkeley: University of California Press, 1988.

Morris, Morris David. *The Emergence of an Industrial Labor Force in India: A Study of Bombay Cotton Mills, 1854–1947.* Berkeley: University of California Press, 1965.

Murshid, Ghulam. *The Reluctant Debutante: Response of Bengali Women to Modernization, 1848–1905.* Rajshahi: Rajshahi University, 1983.

Nanda, B. R. *In Gandhi's Footsteps: The Life and Times of Jamnalal Bajaj.* Delhi: Oxford University Press, 1990.

Nanda, Gulzarilal. *Some Aspects of Khadi.* Allahabad: All-India Congress Committee, 1935.

Nandy, Ashis. *The Intimate Enemy: Loss and Recovery of Self under Colonialism.* Delhi: Oxford University Press, 1983.

———. *Traditions, Tyranny and Utopias: Essays in the Politics of Awareness.* Delhi: Oxford University Press, 1987.

———. *The Illegitimacy of Nationalism: Rabindranath Tagore and the Politics of Self.* Bombay: Oxford University Press, 1996.

Naoroji, Dadabhai. *Poverty and Un-British Rule in India.* London: S. Sonnenshein, 1901.

Natesan, G. A., ed. *Speeches and Writings of Sarojini Naidu.* Madras: G. A. Natesan and Co., [1925?].

Nehru, Jawaharlal. *Toward Freedom: The Autobiography of Jawaharlal Nehru.* New York: John Day Co., 1941.

———. *The Discovery of India.* New York: John Day Co., 1946.

Nunes, J. "Exploring Less Charted Terrains." *Nineteenth-Century Studies* 9 (1995): 99–126.

O'Hanlon, Rosalind. "Issues of Widowhood: Gender and Resistance in Colonial Western India." In D. Haynes and G. Prakash, eds., *Contesting Power: Resistance and Everyday Social Relations in South Asia.* Delhi: Oxford University Press, 1991.

Oldenburg, Veena. *The Making of Colonial Lucknow, 1856–1877.* Princeton: Princeton University Press, 1984.

Pande, B. N. *A Centenary History of the Indian National Congress, 1885–1985.* New Delhi: All-India Congress Committee, 1985.

Pandey, Gyanendra. *The Ascendancy of the Congress in Uttar Pradesh, 1926–1934: A Study in Imperfect Mobilisation.* Delhi: Oxford University Press, 1978.

———. *The Construction of Communalism in Colonial North India.* Delhi: Oxford University Press, 1992.

———. "In Defense of the Fragment: Writing about Hindu-Muslim Riots in India Today." *Representations* 37 (Winter 1992): 27–55.

Pandit, Vijayalakshmi. *The Scope of Happiness.* New York: Crown, 1979.

Paranjape, Makarand, ed. *Sarojini Naidu: Selected Letters, 1890s to 1940s.* New Delhi: Kali for Women, 1996.

Parker, J. S. "Salvation by Thread." *The Nation and the Athenaeum* (London) 31 (October 17, 1922).

———. "Gandhi's Spinning-Wheel and the Steel Plow." *Journal of the American Asiatic Association* 25 (July 1925).

Patel, Sujata. *The Making of Industrial Relations: The Ahmedabad Textile Industry, 1918–1939.* Delhi: Oxford University Press, 1987.

———. "The Construction and Reconstruction of Woman in Gandhi." *Economic and Political Weekly* 33, no. 8 (1988): 377–387.

Pateman, Carole. *The Sexual Contract.* Palo Alto, Calif.: Stanford University Press, 1988.

Pinney, Christopher. *Camera Indica: The Social Life of Indian Photographs.* London: Reaktion Books, 1997.

———. "The Nation (Un)Pictured? Chromolithography and 'Popular' Politics in India, 1878–1995." *Critical Inquiry* 23, no. 4 (Summer 1997): 834–867.

Prasada, Jitendra, ed. *Centenary Commemorative Volume Congress Varnika: Official Journal of the AICC (I)* 2, no. 12 (December 1985).

Punatambekar, Srikrishna. *Khadi Nibandha.* Ahmedabad: Navajivan, 1926.

Punikkar, Madhava. *The Working of Dyarchy in India, 1919–1928.* Bombay: D. B. Taraporevala Sons and Co., 1928.

Rabinow, Paul. *French Modern: Norms and Forms of the Social Environment.* Cambridge: MIT Press, 1989.

Ramaswamy, Sumathi. "Catastrophic Cartographies: Mapping the Lost Continent of Lemuria." *Representations* 67 (Summer 1999): 92–129.

———. "Maps and Mother Goddesses in Modern India." *Imago Mundi* 53 (2001): 97–114.

———, ed. *Beyond Appearances? Visual Practices and Ideologies in Modern India*. New Delhi: Sage, 2003.

Ramusack, Barbara. *The Indian Princes and Their States*. Cambridge: Cambridge University Press, 2004.

Ray, P. C. *Deshi Rang*. Calcutta, n.d.

Ray, Rajat Kanta. *The Felt Community: Commonality and Mentality before the Emergence of Indian Nationalism*. New York: Oxford University Press, 2003.

Risely, H. H. *The Tribes and Castes of Bengal*. 4 vols. Calcutta, 1891.

Rowe, William, and Vivian Schelling, eds. *Memory and Modernity: Popular Culture in Latin America*. London: Verso, 1991.

Roy, Anil Baran. *Khadi under Searchlight*. Bombay: G. G. Bhatt, Advocate of India Press, 1929.

Roy, Parama. *Indian Traffic: Identities in Question in Colonial and Postcolonial India*. Berkeley: University of California Press, 1998.

———. "Meat-Eating, Masculinity and Renunciation in India: A Gandhian Grammar of Diet." *Gender and History* 14, no. 1 (2000): 62–91.

Rudolph, Lloyd I., and Susanne H. Rudolph. *The Modernity of Tradition. Political Development in India*. Chicago: University of Chicago Press, 1967.

Rudolph, Susanne H. "The New Courage: An Essay on Gandhi's Psychology." *World Politics* 16, no. 1 (October 1963): 98–117.

Saalman, Howard. *Haussmann: Paris Transformed*. New York: G. Braziller, 1971.

Sangari, Kumkum, and Sudesh Vaid, eds. *Recasting Women: Essays in Indian Colonial History*. New Brunswick, N.J.: Rutgers University Press, 1990.

Sarkar, Sumit. *The Swadeshi Movement in Bengal, 1903–1908*. New Delhi: Peoples' Publishers, 1973.

———. "The Conditions and Nature of Subaltern Militancy." In R. Guha, ed., *Subaltern Studies: Writings on South Asian History and Society*. Delhi: Oxford University Press, 1984.

———. *Writing Social History*. Delhi and New York: Oxford University Press, 1997.

Seal, Anil. *The Emergence of Indian Nationalism: Competition and Collaboration in the later Nineteenth Century*. London: Cambridge University Press, 1968.

Sengupta, Padmini. *Sarojini Naidu: A Biography*. New York: Asia Publishing House, 1966.

———. *Pandita Ramabai Saraswati: Her Life and Work*. London: Asia Publishing House, 1970.

Shah, Keshavalal G. *Khadi Mahima*. 1924.

Singh, K. V. *Our National Flag*. New Delhi: Ministry of Information and Broadcasting, 1991.

Simmel, George. "Fashion." *The American Journal of Sociology* 62, no. 6 (May 1957): 541–558.

Sitaramayya, B. Pattabhi. *I Too Have Spun: Being a Collection of Notes on Spinning.* Bombay: Hind Kitab, 1946.

———. *History of the Indian National Congress, 1885–1935.* Delhi: Chand and Co., 1969.

Skaria, Ajay. "Gandhi's Politics: Liberalism and the Question of the Ashram." *South Atlantic Quarterly* 101, no. 4 (Fall 2002): 955–986.

Spear, T. G. Percival. *The Oxford History of India.* Oxford: Oxford University Press, 1981.

Spyer, Patricia. "The Tooth of Time, or Taking a Look at the 'Look' of Clothing in Late Nineteenth Century." In *Border Fetishisms.* New York: Routledge, 1998.

Sreenivasan, K. *India's Textile Industry: A Socio-Economic Analysis.* Coimbatore: South Indian Textile Research Assoc., 1984.

Swadeshi and Marriage Songs. Surat: 1930.

Swadeshi no Ghero. Ahmedabad: Navajivan, 1923.

Swan, Maureen. *Gandhi: The South African Experience.* Johannesburg: Ravan, 1985.

Tarlo, Emma. *Clothing Matters: Dress and Identity in India.* Chicago: University of Chicago Press, 1996.

Tallents, P. C. *Census of India, 1921.* Vol. 7. *Bihar and Orissa,* pt. 2: Tables. Patna: 1923.

Tenkotte, P. "Kaleidoscopes of the World: International Exhibitions and the Concept of Culture-Place, 1815–1915." *American Studies* 28, no. 1 (1987): 5–29.

Thompson, Mark. *Gandhi and His Ashrams.* London: Sangam, 1993.

Tomlinson, B. R. *The Political Economy of the Raj, 1914–1947: The Economics of Decolonization in India.* London: Macmillan, 1979.

Von Henneberg, Krystyna. "The Construction of Fascist Libya: Modern Colonial Architecture and Urban Planning in Italian North Africa (1922–1943)." Ph.D. diss., University of California, Berkeley, 1996.

Washbrook, David. *The Emergence of Provincial Politics: The Madras Presidency, 1920–1937.* Cambridge: Cambridge University Press, 1976.

Watson, James Forbes. *The Textile Manufactures and the Costumes of the People of India.* London: India Office, 1866.

Weber, Eugene. *Peasants into Frenchmen: The Modernization of Rural France, 1870–1914.* Stanford: Stanford University Press, 1976.

Williams, Gertrude Marvin. "Gandhi Sets India Spinning." *The Nation* (New York) 120 (February 25, 1925).

Williams, Rosalind. *Dream Worlds: Mass Consumption in Late Nineteenth Century France.* Berkeley: University of California Press, 1982.

Winichakul, Thongchai. *Siam Mapped: A History of the Geo-Body of a Nation.* Honolulu: University of Hawaii Press, 1994.

Wolpert, Stanley, *Nehru: A Tryst with Destiny.* New York: Oxford University Press, 1996.

Woodham, J. "Images of Africa and Design at the British Empire Exhibitions between the Wars." *Journal of Design History* 2, no. 1 (1989): 15–33.

Woodruffe, J. G., ed. *Criminal Procedure in British India (being a commentary on Act*

V of 1898 as amended up to date). Calcutta and Simla: Thacker, Spink and Co., 1926.

Wright, Gwendolyn. *The Politics of Design in French Colonial Urbanism.* Chicago: University of Chicago Press, 1991.

Yengoyan, A. "Culture, Ideology, and World's Fairs: Colonizer and Colonized in Comparative Perspectives." *European Contributions to American Studies* 27 (1994): 62–83.

Zaidi, A. M. *INC: The Glorious Tradition: Texts of the Resolutions Passed by the INC, the AICC and the CWC.* 3 vols. New Delhi: Institute for Applied Political Research, 1987.

Zaidi, A. M., ed. *The Story of Congress Pilgrimage. Event to event record of activities of the Indian National Congress from 1885–1985 emanating from official reports of the General Secretaries.* New Delhi: Indian Institute of Political Research, 1990.

INDEX

Page numbers in italics refer to illustrations.

LISA TRIVEDI
is Associate Professor of History at Hamilton College.